P9-DMH-195

THE ART OF
POLYMER CLAY
Creative Surface Effects

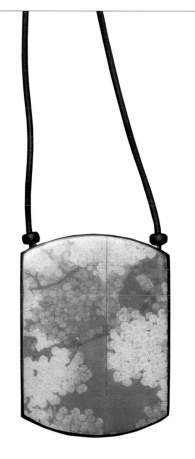

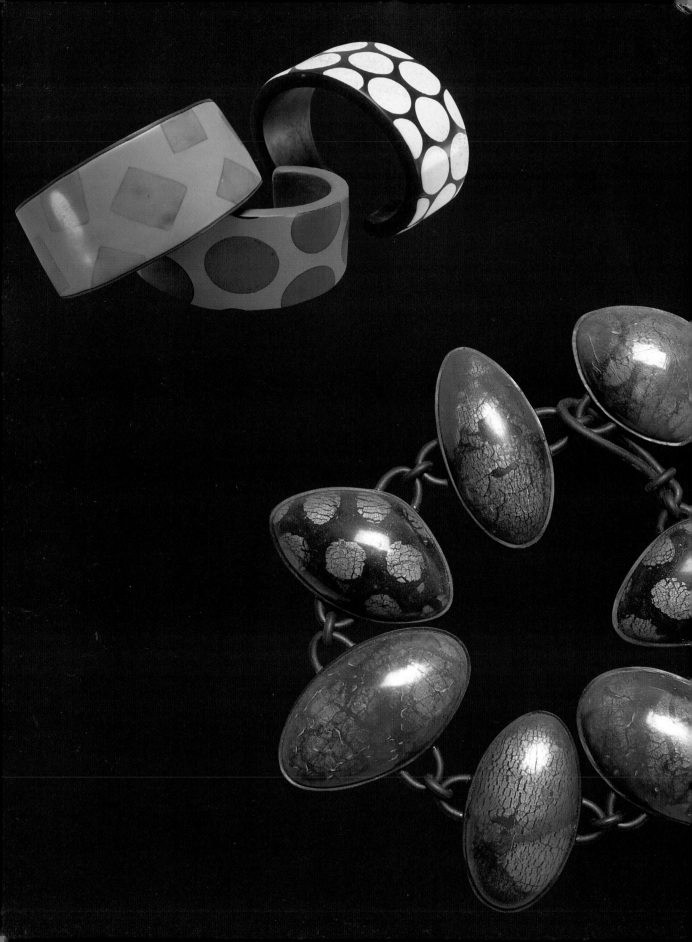

THE ART OF
POLYMER CLAY

Creative Surface Effects

Techniques and Projects Featuring
Transfers, Stamps, Stencils, Inks, Paints,
Mediums, and More

DONNA KATO

WATSON-GUPTILL PUBLICATIONS

NEW YORK

When working with polymer clay and other suggested products and tools, readers are strongly cautioned to follow the manufacturers' instructions and warnings. If you are pregnant or have any known or suspected allergies, you may want to consult a doctor about possible adverse reactions before using any suggested products or performing any procedures outlined in this book. The techniques and materials described in this book are not intended for children.

Copyright © 2007 by Donna Kato

First published in 2007 by Watson-Guptill Publications, Nielsen Business Media, a division of The Nielsen Company 770 Broadway, New York, NY 10003 www.watsonguptill.com

All rights reserved. No part of this publication may be reproduced or used in any form or by any means—graphic, electronic, or mechanical, including photocopying, recording, taping, or information storage-and-retrieval systems—without written permission from the publisher.

All photography by Vernon Ezell, unless otherwise noted.

Library of Congress Cataloging-in-Publication Data

Kato, Donna.
 The art of polymer clay creative surface effects : techniques and projects featuring transfers, stamps, stencils, inks, paints, mediums, and more / Donna Kato.
 p. cm.
 Includes index.
 ISBN-13: 978-0-8230-1362-3 (alk. paper)
 ISBN-10: 0-8230-1362-6 (alk. paper)
 1. Polymer clay craft. I. Title.
 TT297.K36 2007
 745.57'2—dc22

 2006030050

Senior Acquisitions Editor: Joy Aquilino
Editor: Michelle Bredeson
Art Director: Julie Duquet
Designer: Areta Buk/Thumb Print
Production Manager: Alyn Evans

Manufactured in Singapore

First printing, 2007

3 4 5 6 7 8 9 / 15 14 13 12 11 10 09 08

This book is dedicated to two special people . . .

On April 13, 2003, Paul K. Kato passed away. He was my father. He was a wonderful person and an inspirational example of the meaning of living a "good life"—a life in which being rich has little to do with one's financial condition.

My father was loving, humble, open-minded, and kind. He was trusting, gentle, and, decent. He was funny, honest, loyal, and giving to a fault. He loved fishing, the dime slots, and any adventure with Mom. He fancied watches and jackets and baseball hats and chocolate and sushi. He loved his family and friends, more than anything else. He always looked for the good in people and always gave the benefit of the doubt. He was a gentleman. He was one in a million.

The second is my mother, who taught me that all things are possible if you put your mind to it and believe you can get whatever it is you want. These days, she has become quite the polyholic, proving that it's never too late to dive into uncharted waters. It's never too late to learn and to discover another of life's joys.

Pop. Mom. This book is dedicated, with all the love in my heart, to both of you.

Paul Kuni Kato
January 17, 1921–April 13, 2003

CONTENTS

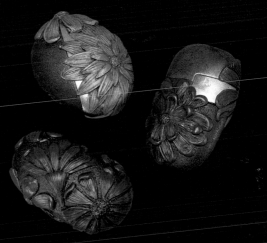

ACKNOWLEDGMENTS

THANK YOU TO Robert Augur, Tony Aquino, Ruben Castaneda, Amarlys Rodriguez of Van Aken International, Suzanne Hammond, and Bill Mangelson of Makin's Clay.

Lucky me, I have been blessed with great "craft" friends, old and new. In alphabetical order: Judy Belcher, Jana Roberts Benzon, Leslie Blackford, Maureen Carlson, Kim Cavender, Sarah Chinen, Darlene Clark, Helen Cox and Stephen Smith, Maria del Pinto, Nuchi Draiman, Kelly Ehrlich, Emi Fukushima, Kyle Ino and Dustin Ebesu, Priscilla Hauser, Carol Hess, Ellie Hitchcock, Tim Holtz, Cathy Johnston, Sue Kelsey, Susan Kocsis, Jacqueline Lee, Klew, Ellen Marshall, Rai Nelson, Mary O'Neill, Cheri Oshinsky, Carol Overmyer and Jan Estevez (both gone, but never forgotten), Lisa Pavelka, Gail Pniak and her (late) mom, the wonderful Lou, Varda Lev Ram, Eti and Moti Raz, Gail Ritchey, Lynne Ann Schwartzenberg, Lee Scott and Irene Niehorster, Connie (and Ken) and Alicia Sheerin, Shane Smith, Karen Thomas, and Barb VerniLau.

Many thanks to the artists who contributed their work to this book, too!

To Miss Carol Duvall, my great friend. Honestly, I don't think I'd have a career had it not been for you and your generosity, kindness, and support. Funny, honest, humble, loyal, and beautiful inside and out, Miss D., you've got it all. From my heart to yours, thank you.

I'd like to thank some polymer pioneers and friends, too. Thank you Sarah Shriver, Lindly Haunani, Nan Roche, Pier Voulkos, and Kathy Dustin for the great gift of inspiration.

Special thanks to Laurie MacIsaac for writing the section on color. Your contribution definitely enhanced and improved the content of this book.

Thank you to my siblings—Alan (and Gwen), Tina (and Harry), Mark (and Kathy)—and my oldest friends, my "sisters" Terri Silverstone (and David Lissner), Mary Prchal (and Jacque Ducharme), Helena Brown, and Mary Studebaker (and Tom Petroff). Can't leave out my nephews, Mitch, Eric, Aaron, Jake, Sam, and Joshie, and my one niece, Princess Hannah-face.

All thanks to Joy Aquilino, the most understanding editor on the planet. Thanks also to editor Michelle Bredeson and designer Areta Buk.

To the most understanding husband around: Vernon, thanks for your support, encouragement, and for letting me do what has to be done. Thanks for cooking, shopping, doing laundry, and shooting this book. I love you.

Finally, I'd like to thank all of you for your many kind and encouraging words over the years. Were it not for you, I might not have made this journey at all.

TOP TO BOTTOM: LESLIE BLACKFORD, SUE KELSEY, AND KIM CAVENDER
Three polymer clay masks by three wonderful artists and friends.

FOREWORD

BY CAROL DUVALL

DONNA KATO is one of the most surprising people I know. She is charming, soft-spoken, serious, incredibly talented, knowledgeable, and, in the language of old Hollywood, a screwball. She loves off-the-wall ideas and will enter into any goofy scheme that one of "the girls" comes up with. Everybody who knows her loves her. I know that I do. And as well as I think I know her, she continues to surprise me with her creativity, delight me with her humor, and amaze me with her generosity.

I first met Donna when I was attending the NAMTA (National Arts Materials Trade Association) convention some years ago and she was demonstrating polymer clay. After watching her make magic with a piece of green clay, my producer and I invited her to be on my television show. Donna turned up at the studio, taped her first segment, and we were smitten. The cameramen loved her, the stage crew loved her, and the viewers loved her. And so we invited her back again . . . and again . . . and again.

Through the years Donna not only taught thousands of viewers to appreciate the pleasures of working with polymer clay, but she was such an excellent teacher that we ended up having several of those viewers as guests on the show!

Although television is an incredible medium for teaching, it is also fleeting. When the show is over, it's over. Not so with a book. A book you can linger over, and Donna has written a book that you can linger over for hours . . . days . . . for as long as you like, whenever you like. I'm far from considering myself a "polymer clay person" beyond what I've absorbed by standing next to Donna and other guests, but I found *The Art of Polymer Clay Creative Surface Effects* fascinating. Donna clearly explains each technique and she not only answers your questions, she answers questions you didn't even know you had. She has managed to make a book that is basic enough for the beginner but with so many innovative suggestions and projects that even the most advanced artists will find it inspiring.

I was flattered and honored to be asked to write the foreword to Donna's book. I value her friendship, I respect her integrity and her devotion to her craft, and I am awed by her as a person. I am thrilled with this book and I hope and expect that you will be as well.

Enjoy!

Carol Duvall

INTRODUCTION

ABOVE: DOTTY MCMILLAN
Third Place

OPPOSITE: LORIE O. FOLLETT
First Place

SINCE THE PUBLICATION of my first book, *The Art of Polymer Clay,* in 1997, interest in polymer clay has continued to grow, and the level of proficiency of polymer clay enthusiasts is taking the medium solidly into the category of fine art. Polymer clay artists have witnessed the amazing diversity of the medium, have grasped the incredible possibilities it holds, and have shared their discoveries with the art and fine-craft community at large.

I think the possibility of new discovery is one explanation for the passion we feel about our medium. Of course, the tactile nature of polymer clay is another. There are so many reasons this medium inspires and excites. I hope this book provides some inspiration and a reason or two for you to dive in.

Polymer clay artists are experimenters who are likely to try anything with clay. We cover anything that can withstand its curing temperatures. We raid our kitchens and cruise the aisles of craft, art material, hardware, and hobby stores looking for anything that might work with clay. We stamp, paint, mix, mold, and sculpt polymer clay. We try to make our clay imitate other materials. The incredible diversity of entries in the "Feat of Clay" shoe show is a testament to polymer clay's amazing versatility.

THE FEAT OF CLAY SHOE SHOW

"Feat of Clay" was a secret competition sponsored by Van Aken International, the manufacturer of Kato Polyclay. Our goal in organizing this contest was to showcase the versatility of polymer clay as an art medium. Forty artists were invited to create polymer clay "shoes" for a surprise display at the annual Craft and Hobby Association's 2004 winter tradeshow in Dallas, Texas. There were no limits on subject matter, theme, or color. The only requirement was that the shoes be between size 5 and size 7½. The artists were asked not to discuss the competition until the shoes went on display. The exhibition was the talk of the convention, and the imagination and creativity that resulted from this challenge are evident in the results you see on these pages (see pages 172 to 176 for more entries). First, second, and third place prizes, along with several honorable mentions, were awarded for the most innovative designs. I hope you have as much fun looking at and get as much inspiration from these amazing creations as I did organizing the competition.

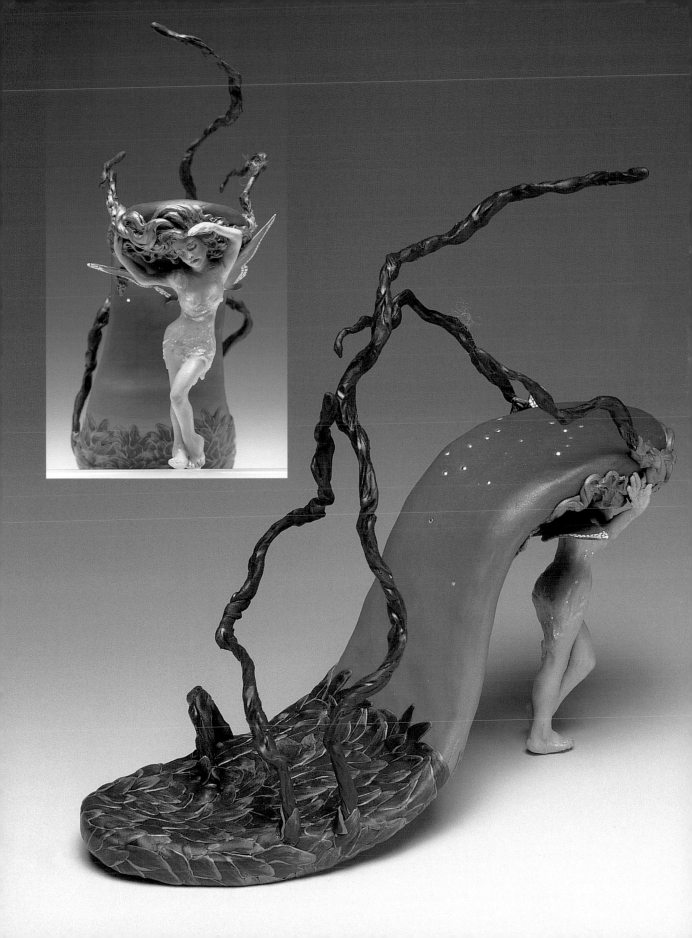

Beginning work in a new medium always presents question upon question. It takes time and work to integrate and organize all the bits of newly acquired information. When I began work on this, my second book, I wanted to fill in those blanks, but I also wanted to provide the reader with the means to solve problems. I've tried to organize the information so that one technique builds on information provided in a preceding technique, rather than repeating the same information in more than one place. It is my hope that this book might be used as a personal polymer clay class and that, when you have taken each step along the way, you'll acquire a deeper understanding of this incredible medium.

For experienced polymer clay enthusiasts, I hope I'll show you something you might incorporate into your work as you continue on your own polymer clay journey.

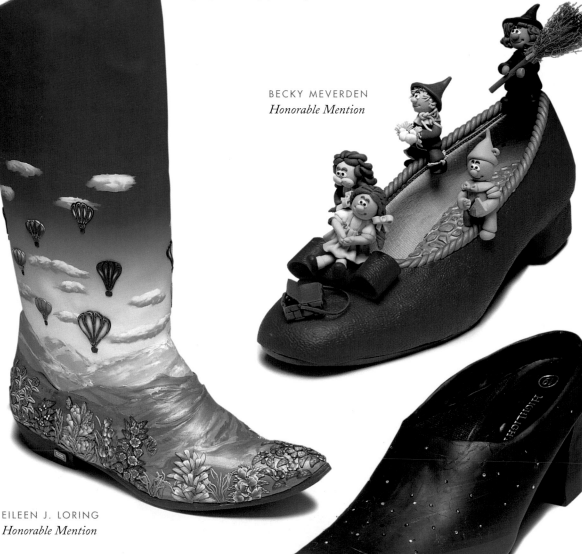

BECKY MEVERDEN
Honorable Mention

EILEEN J. LORING
Honorable Mention

ROBERT WILEY
Honorable Mention

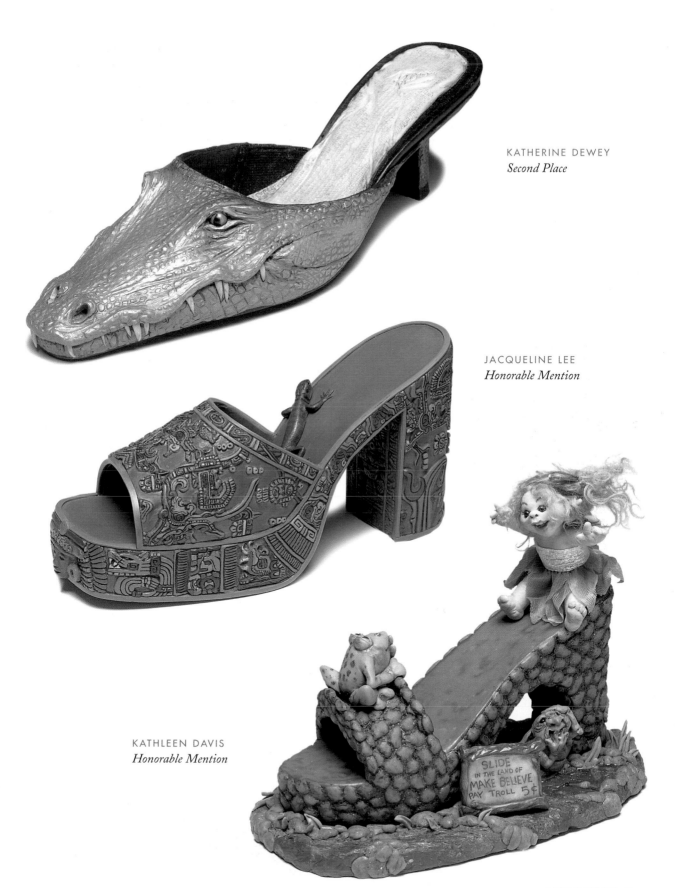

KATHERINE DEWEY
Second Place

JACQUELINE LEE
Honorable Mention

KATHLEEN DAVIS
Honorable Mention

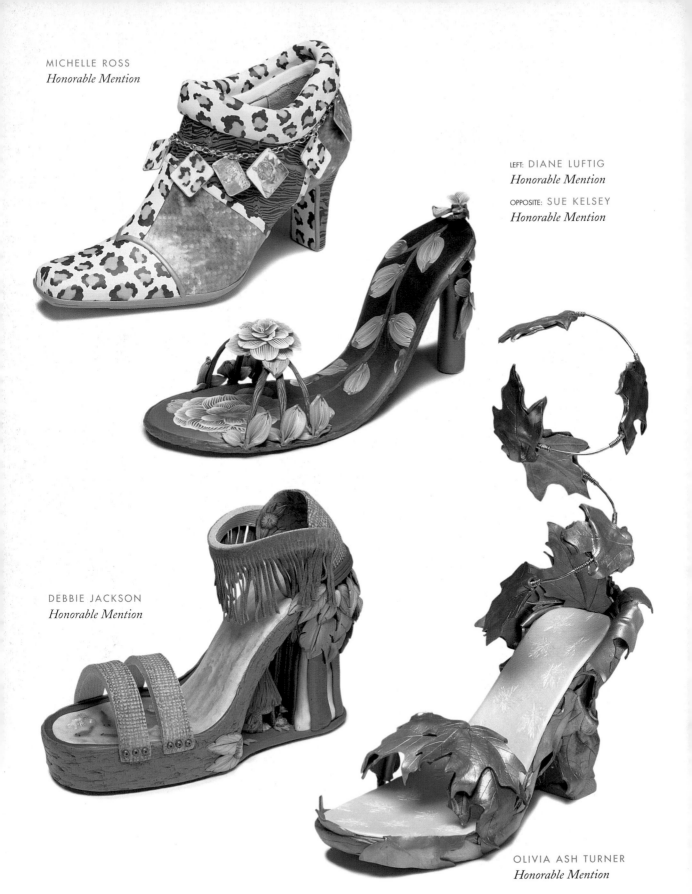

MICHELLE ROSS
Honorable Mention

LEFT: **DIANE LUFTIG**
Honorable Mention

OPPOSITE: **SUE KELSEY**
Honorable Mention

DEBBIE JACKSON
Honorable Mention

OLIVIA ASH TURNER
Honorable Mention

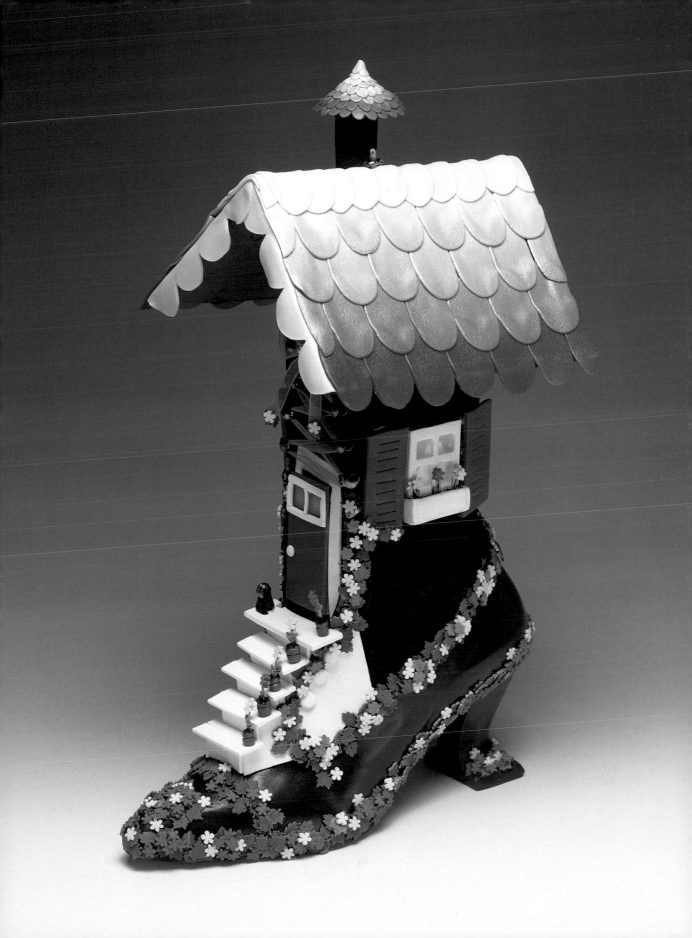

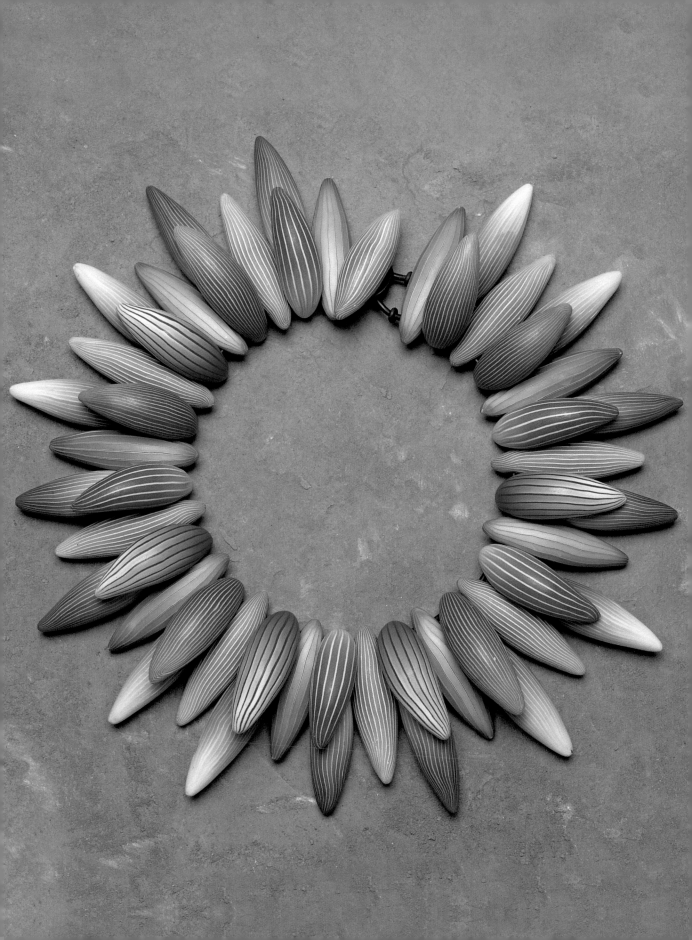

POLYMER CLAY BASICS

Polymer clay is often thought to be one of the most difficult art and craft mediums to master. This perception has led to a resistance to try it. I have never met anyone who has enjoyed immediate success with the medium, so don't be discouraged. Once you have acquired a basic understanding of polymer clay, you will find that proficiency comes very quickly. In this chapter, you will learn about the various brands of clay, which tools you need to work with polymer clay, how to prepare the clay, and how best to cure your pieces. And you will learn basic techniques for working with clay, including making beads and the all-important Skinner Blend.

CHARACTERISTICS OF POLYMER CLAY

POLYMER CLAY is a man-made modeling material composed of particles of polyvinyl chloride combined with gels, fillers, plasticizers, coloring agents, and resins. Like earth clays, polymer clay can be shaped and molded into almost any form imaginable. Unlike earth clays, polymer clays are produced in a great range of colors that may be mixed to create a custom color palette.

Bringing this malleable material to its permanent state requires exposure to temperatures from 215°F to 325°F, depending on the specific brand. This process is called *curing*. Once cured, the clay becomes a hard, durable plastic and is "fixed"—that is, it will not return to its original soft state.

Uncured polymer clay is subject to change when exposed to temperatures of 90°F or higher, but even at cooler temperatures, it will naturally "advance" and change over time. As the clay advances, it becomes stiffer, because the ingredients shift toward their original wet or dry states. When stored at cool temperatures and away from direct sunlight, though, polymer clay will last for years.

Polymer clay is an incredibly versatile material that, after curing, can be carved, punched out, and even sewn. Because of the low curing temperatures of polymer clay, there are many materials—including glass, ceramic, papier-mâché, and many plastics—that may be covered with clay and then cured in the oven.

JUDY BELCHER
Once cured, some brands of polymer clay are strong enough to withstand stitching on a sewing machine, as illustrated by this colorful purse.

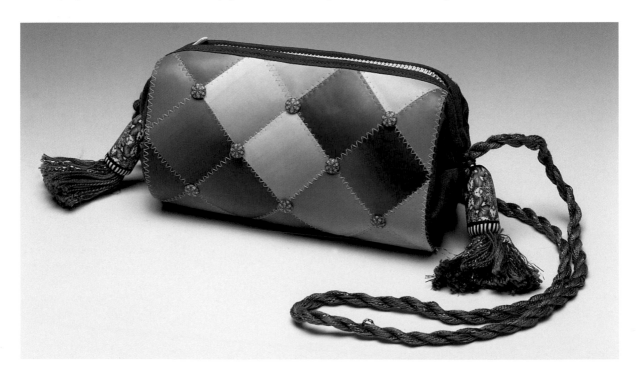

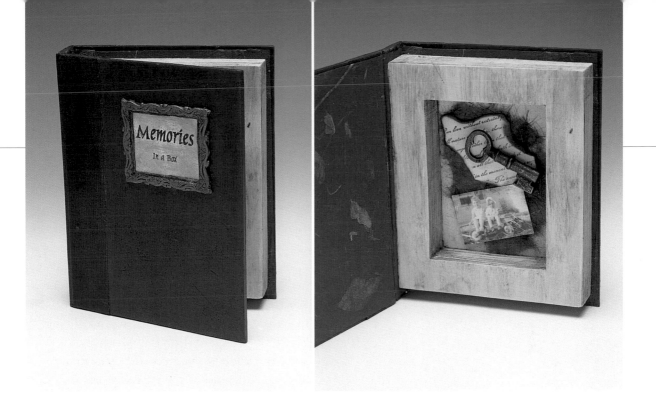

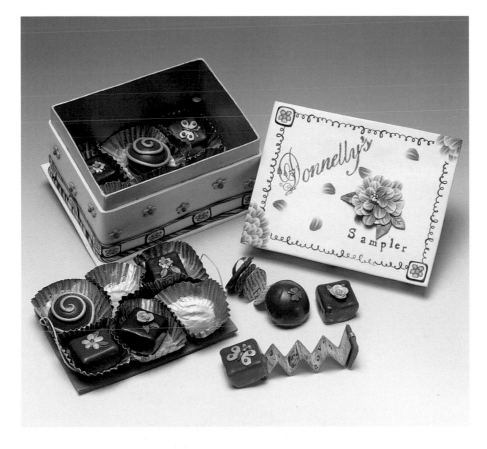

ABOVE: CATHY JOHNSTON
Artist Cathy Johnston combined her love of polymer clay and her passion for books in creating her "Memories" book. Each page was cut from sheets of cured clay. She joined the pages to make a window in which she placed memorabilia.

LEFT: MARGARET DONNELLY
This delightful candy sampler box was made for a Kato Polyclay–sponsored exhibition. The box itself is made of polymer clay with clay support rods in the corners. The walls are thick enough to maintain their shape and form. In the box are twelve "chocolates." Each one opens from the bottom, revealing a piece of accordion-pleated paper.

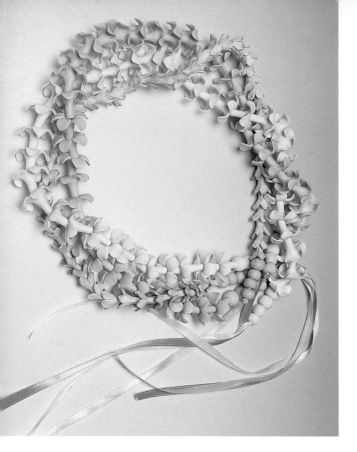

Covering pens is a very popular project, but not all pens will survive the curing process. Clear, hard plastic pens like the inexpensive BIC Round Stics will melt in the oven, while pens such as the Paper Mate Flex Grip can handle the curing temperature quite nicely with no resulting warping or shrinkage. Once again, experimentation is recommended before you invest time and energy in curing materials with polymer clay. For example, if you're unsure whether a pen may be safely covered, simply remove the ink cartridge and bake the pen for 10 minutes at the recommended curing temperature. When combining polymer clay with other materials, keep in mind that it does not bond permanently to anything but itself! For that reason, any other materials must be glued in place after curing with two-part epoxy or some other strong glue.

Glass will be unaffected by the low curing temperatures required for polymer clay, and you will find that the clay sticks easily to its smooth, untextured surface. Bear in mind, though, that clay and

ABOVE: LANI CHUN
Hawaiian native Lani Chun's delicate leis are made of hundreds of exquisitely shaped polymer clay flowers.

RIGHT: JUDY KUSKIN
Because polymer clay does not bond to other materials, the polymer clay and Precious Metal Clay elements in these elegant earrings were joined with glue.

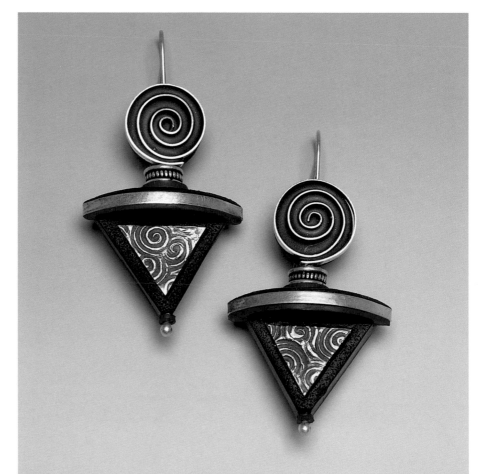

glass do not form a permanent bond, so the clay piece must be removed after curing and glued on with an adhesive, such as E-6000 (a silicone-based glue) or two-part epoxy. For this reason, it is best to trap the glass item in clay. For example, applying clay around a round votive candleholder whose sides curve out from a smaller diameter bottom and then curve in to a smaller diameter opening will trap the votive glass form. Decorative clay elements can be pressed to the clay itself.

Covering porous or textured pieces with clay requires the application of a sealer before covering with clay. I've used some heat-set paints for this purpose, and you may also use PVA glue or Sobo Glue. Wood can be difficult to cover, even when a sealer has been applied. Wood is prone to swelling, which may create cracks on the surface of the curing clay. Generally, I avoid covering wood objects, although I've had success with wood forms from Walnut Hollow. The wood is very fine grained and free of knots.

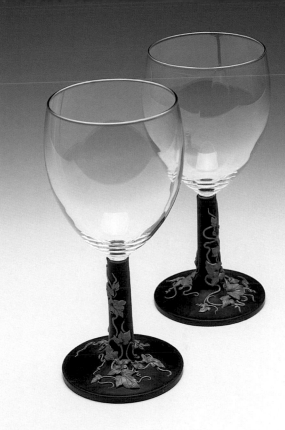

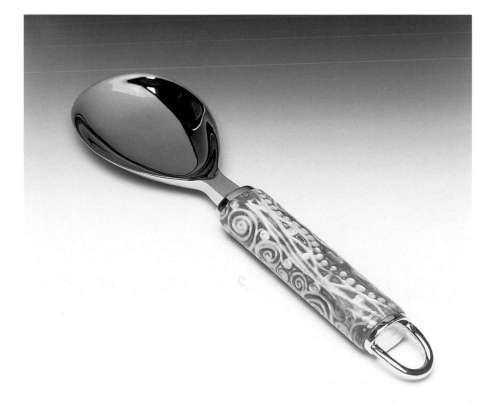

ABOVE: SHANE SMITH
Covering the stems and bases of these wine glasses with black clay has ensured that the delicate gold vines and leaves are secure.

LEFT: VALERIE WRIGHT
An ordinary serving spoon becomes something quite special when its handle is covered with polymer clay using the mokumé gané technique. Mokumé gané is a Japanese metalworking process, which can be imitated by layering many colors of clay and even paint and metal leaf. The clay is stamped, and the raised clay is sliced away, revealing the pattern.

TOP: SUZANNE IVESTER ABOVE: DAPHNE SEAMAN

Artists such as Suzanne Ivester and Daphne Seaman are using polymer clay as if it were paint itself, stretching the medium in unexpected and exciting directions. (Photos: TOP John Black BOTTOM Mara Ringo)

Although polymer clay comes in a great variety of colors, it may also be painted before or after curing. For overall coverage on cured clay, apply the paint in several thin layers with a damp (not wet) brush, allowing the paint to dry between applications. I've found that paint applied in this way before curing becomes permanently part of the clay after curing and will not chip or rub off. Polymer clay artists have used acrylic paints, heat-set airbrush paints (such as those produced under the Createx brand), heat-set artist oils (such as Genesis Heat-Set Artist Oils), and even tempera paints (I prefer the Jazz brand) to achieve interesting surface effects. (See "Paints, Inks, and Pigment Powders" on page 109 for more information on and ideas for painting polymer clay.)

Like earth clays, polymer clay can be sculpted into almost any form imaginable, including figures, vessels, and bas-relief designs. When making large forms, it is advisable to work the clay around support armatures. Common armature materials are foil and wire. Bulking out large forms with foil ensures that thick clay will adequately cure, as it reduces the overall weight of such pieces. Wire can be used to support arms and legs in doll and figure pieces and will minimize breakage from handling. These armatures remain in the piece. (See "Sculpture and Mold Making" on page 152 for more about sculpting polymer clay.)

One aspect of polymer clay that makes it such a popular medium is that it can imitate countless manmade and natural materials, such as wood, glass, stone, bone, and metal. Such attempts at creating convincing imitations in polymer clay can be interesting and challenging. When it comes to what you can do with polymer clay, the only limit is your creativity!

POLYMER CLAY BRANDS

THE VARIOUS BRANDS of polymer clays on the market differ in a great many ways. I would suggest you try them all and decide which brand works best for your situation and your applications. Do you live in a warm climate or a cool one? Do you have hot hands or cold? If you are making millefiori canes, a sticky clay will be difficult to manage in a hot environment; a clay that resists stickiness in the same environment will slice with less distortion. If you are a doll artist, clothing your dolls with polymer clay clothing, you may find it easier to work with a clay that tends to be a bit softer and less likely to crack when pleated. Many polymer clay artists use different brands, selecting a particular brand for a specific purpose.

The brands I discuss here are the most easily acquired polymer clays in the United States. There are other brands, such as Cernit, Modello, and Formello, but they are not as easy to come by.

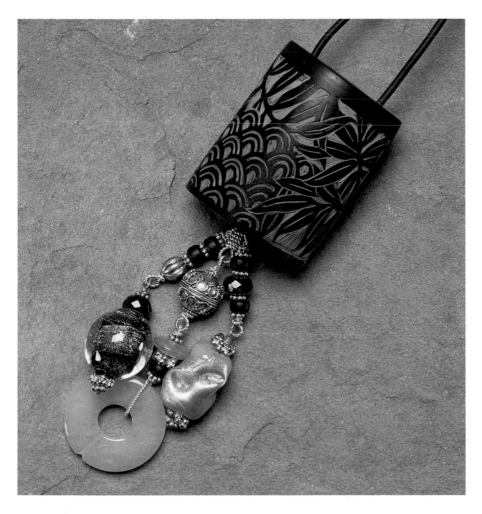

DONNA KATO
Clays that are very durable and also retain some flexibility after curing, such as Kato Polyclay, can be easily carved, as demonstrated by this detailed watch case.

KATO POLYCLAY

The newest brand of polymer clay, Kato Polyclay, is the first polymer clay designed by and named for an artist for artists and is the result of my collaboration with Van Aken International. After discussing the characteristics we wished to have in our clay, Tony Aquino and Van Aken vice president Robert Augur formulated Kato Polyclay.

Kato Polyclay features seventeen colors. Within the line are true complementary colors that make it possible to mix virtually any color. Recent additions to the line are concentrated colors designed specifically for color mixing. Kato Polyclay is sold in 3-ounce and 12.5-ounce bars. Unlike other brands, Kato Polyclay is vacuum extruded, a process through which most bothersome air pockets in the clay are removed. Kato Polyclay cures between 275°F and 325°F. Generally, I cure my pieces at 300°F, which reduces curing time by half. I have found that Kato Polyclay is the most durable polymer clay. All of the projects and all of my pieces in this book are made with Kato Polyclay.

TIP

Different brands of polymer clay may be combined. For example, if you are sculpting and wish to strengthen one brand of clay, you could mix it with a stronger brand. However, it's always a good idea to mix a small sample before combining large amounts of different brands, as all combinations won't work for all applications.

FIMO

Fimo Classic and Fimo Soft polymer clays are manufactured by the German company Eberhard Faber and distributed in the United States by the American Art Clay Co. (AMACO). Fimo Classic was introduced to the United States approximately forty years ago. Fimo Soft was formulated to address the difficulties users found in conditioning the original Fimo. Fimo clays are produced in a very controlled environment and to very tight specifications. For two years, I consulted on and marketed Fimo Classic and Fimo Soft clays to the U.S. market.

Fimo Soft polymer clay colors are bright and clear, but they do shift more than Fimo Classic because the colors are set in a translucent base. There are twenty-four colors of Fimo Classic and fifty-three colors of Fimo Soft. Both polymer clays are sold in 2-ounce and 13-ounce packages. Fimo Classic and Fimo Soft cure at 265°F. Fimo Soft is strong when newly cured, but over time it tends to become more brittle. Fimo Classic is a very strong clay that maintains its strength over time.

POLYFORM PRODUCTS

Before the introduction of Kato Polyclay in 2002, there was only one American manufacturer of polymer clay: Polyform Products Co. The brands they currently produce are Sculpey, Super Sculpey, Sculpey III, Premo! Sculpey, and several novelty clays. Original Sculpey comes in white and terra cotta; Super Sculpey is beige; Sculpey III is available in forty-four colors; and there are thirty-two colors of Premo! Sculpey. Sculpey III is sold in 2-ounce bars, and Premo! Sculpey is sold in 2-ounce and 1-pound bars. Original Sculpey and Super Sculpey clays are available in large bulk packages. Of all their clays, Premo! Sculpey is the most durable and Sculpey III is the weakest. All Polyform clays cure at 275°F.

LIQUID POLYMER CLAYS

In addition to solid modeling clays, some brands of polymer clay also offer liquid clay. All liquid polymer clays work in basically the same way and can be used in the same techniques. All will transfer inkjet images (see "Inkjet Transfer onto Liquid Polymer Clay" on page 98) and all may be tinted with oil paints, mica pigment powders, and solvent-based inks, such as Tim Holtz's Adirondack Alcohol Inks (Ranger Industries) and Piñata Colors inks (manufactured by Jacquard).

The first of these "polymer clay in a bottle" formulations came from Polyform Products. Translucent Liquid Sculpey is thick and milky. After curing, it does clear somewhat, but of all brands it is the least transparent.

Kato Clear Medium is almost crystal clear when it is cured at 325°F. In terms of consistency, it is thinner than Liquid Sculpey and so it is less prone to troublesome air bubbles. Kato Clear Medium is also easier to sand than Liquid Sculpey. When cured at a high heat (between 320°F and 340°F), the surface of Kato Clear Medium takes on a high gloss and reaches glasslike clarity.

Liquid Fimo Decorating Gel is the newest of the liquid polymer clays. Of all the liquid polymers, it is the most transparent, although cured Fimo Gel is rubbery, making it difficult to sand.

TIP
For all of the projects in this book I used Kato Polyclay. In the projects that call for liquid polymer clay, I used Kato Clear Medium. The curing times and temperatures in the instructions are for these products. If you use a different brand of clay or liquid clay, refer to the manufacturer's instructions.

DONNA KATO

"Special Effects with Liquid Polymer Clays" on page 140 demonstrates a number of techniques and projects for working with liquid polymer clay, including multilayered effects, as seen on these vessels.

TOOLS AND MATERIALS

PEOPLE WHO ARE NEW to polymer clay frequently ask me what tools and supplies they need to work with the medium. The most spare setup would be a good work surface, a pasta machine, and a clay blade. To begin, that's all one really needs. But, as I mentioned before, we polymer people are drawn to tools and anything else that we can use with our clay. Listed below are some tools and materials I regard as essential, as well as some others I use only incidentally in my work.

WORK SURFACE

Polymer clay may react with your furniture's finish, so you'll want to begin with a good work surface. The work surface I use most often is a piece of Formica that was cut out of a countertop to make a hole for a sink. On its lightly textured surface, even the thinnest sheet of clay may be easily lifted without risk of tearing or stretching.

There are times you might *want* your clay to stick to the surface. When cutting a stencil for example (see "Creating a Mold from a Stencil" on page 158), using a surface to which the clay sticks makes it possible to cut the finest of lines. A pane of tempered glass or a ceramic tile works well for this purpose. Another good all-around option is an acrylic board, which is lightweight and perfect for travel. If you teach classes or workshops, small ceramic tiles, index cards, or manila folders are easily accessible, inexpensive work surfaces for your students.

BELOW LEFT: *An array of work surfaces on a sheet of Formica. From left to right: a large ceramic tile, a glass sheet, a small ceramic tile, and a marble tile. A piece of rubber mat placed beneath any of these surfaces will keep them from sliding on your table.*

BELOW RIGHT: DONNA KATO *When applying paint with my finger, as I did for these cloisonné pendants, I use a piece of tempered glass or ceramic tile so that the clay will stick to the surface and not lift up with my finger. (See "Cloisonné Heart Pin" on page 149 for more on creating this effect.)*

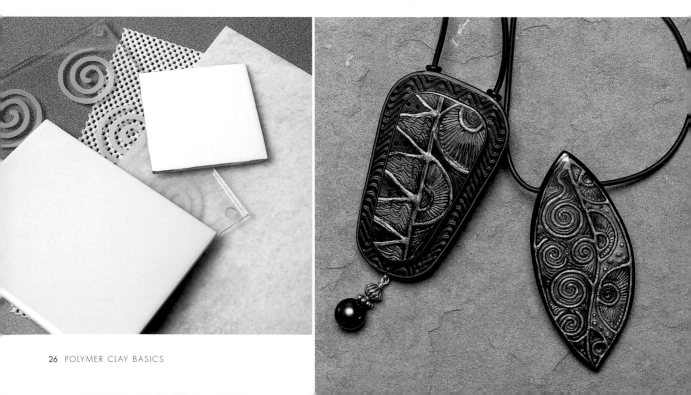

PASTA MACHINE

I think the most valuable tool for working with polymer clay, next to your hands, is a pasta machine. You can use it to condition clay, make Skinner Blends (see page 55), and roll out uniform sheets of clay. The type of pasta machine that can be used with polymer clay has a hand crank. (Do *not* use the type of pasta machine that mixes and extrudes pasta.) Some brands include Atlas, Al Dente, Imperia, Pasta Queen, and Makin's.

The Makin's Professional Ultimate Clay Machine was designed specifically for use with clays and features nonstick rollers. You can replace the handle with a motor (shown at left) to free up your hands while working.

Pasta machines have thickness settings. The thicknesses are numbered, but there is no standard for the way they are numbered. On some pasta machines, #1 indicates the thickest setting, while on others it may be the thinnest setting. I use the Makin's Professional Ultimate Clay Machine, which is a pasta machine made specifically for use with clay. It features 7-inch rollers that have a nonstick coating.

Most pasta machines are not made for polymer clay use. They are, of course, made to roll sheets of pasta. Clay is stiffer and firmer than pasta, so when we roll clay through these machines, we are subjecting most machines to greater stress than they are meant to withstand. For this reason, be kind to your machine and roll sheets of clay through that are close to a setting, rather than forcing very thick slabs of clay through radically thinner settings. Once you use a pasta machine for polymer clay, you should *never* use it for food preparation.

It is possible to disassemble and clean the machines, but I do not frequently do so. I do, however, take my machine apart to remove the top plates, as they are not essential to machine function. (Do *not* remove the bottom plates.) By removing the top plates, it is possible to gently remove clay that has collected there. To prevent damaging the plates, you should never use a metal tool (such as a needle tool) to pry out and remove clay from between the rollers and the plates. I use a bamboo skewer for this purpose, gently and carefully easing the clay out. Once the excess clay is removed, I roll light-colored scrap clay through to pick up any remaining bits of clay. The surface of the rollers may be cleaned by pressing an alcohol-saturated paper towel or alcohol wipe on them as you crank the machine. Frequently wiping the bottom plates also helps minimize color contamination from previously rolled clay.

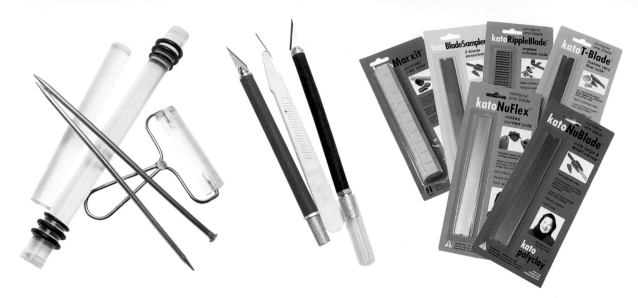

ABOVE LEFT: *Various tools that can be used for smoothing polymer clay: knitting needles (lying on top) and, from left to right, an acrylic rod, the Pro Clay Roller, and an acrylic brayer.*

ABOVE CENTER: *A surgical scalpel (center) and craft knives are handy tools for cutting out polymer clay shapes.*

ABOVE RIGHT: *Polymer clay cutting blades and the Kato Marxit measuring tool.*

TIP

When smoothing the surface of a piece, it is generally best to use a rolling motion—that is, to roll the rod back and forth—rather than a "scraping" motion.

Because I use my machine so frequently, I've connected a motor to it. This motor makes it possible for me to use both hands to handle the clay as it is fed into and out of the machine. There are several brands of motors. I use the Makin's Clay motor because it features two speeds and seems to be quieter than the others I've tried. Recently, I've added a foot pedal, so now I don't even have to turn the motor on and off by hand.

SMOOTHING TOOLS

Acrylic rods are used to flatten and compress clay, to condition it, and to smooth the surface of pieces you are working on. They are sold in most craft, art materials, and hobby stores. Thick double-pointed knitting needles are also excellent smoothing tools. Handled acrylic brayers are also useful for smoothing surfaces. Prairie Craft Co. sells the Pro Clay Roller, an acrylic rod that comes with three pairs of gaskets of various diameters so you can roll sheets of uniform thickness.

DELI PAPER

A sheet of deli or parchment paper comes in handy when working with polymer clay. You can use it as a temporary work surface on which to create a piece and then just peel it away before curing. It can also be used to protect the surface of clay that has been painted when rolling it with an acrylic roller or through a pasta machine.

CUTTING AND SLICING TOOLS

You can cut and slice clay with a craft knife, but a better option is a polymer clay blade. Before the introduction of polymer clay blades, the tool most used for cutting and slicing polymer clay was a medical tissue-slicing blade. This blade is 4 inches long, sharp, and flexible. The stiffer, longer, 6-inch Kato NuBlade was introduced to the polymer clay community by Prairie Craft Co. and has gained wide acceptance among polymer clay artists. Although this blade is more rigid, it is no less sharp. The increased rigidity makes it easier to cut and slice through large blocks with minimal torque, or twisting, as it moves through the clay.

The stainless steel Kato NuFlex Blade is also 6 inches long but is less rigid, more like a tissue blade. The 4-inch-long Kato T-Blade is comparable to the tissue blade, but like the NuFlex Blade is made of stainless steel.

Scalpels and craft knives are very useful for cutting shapes from sheets of clay. Very fine needle tools will also serve this purpose.

KATO MARXIT

The Kato Marxit is a tool I designed and, with my husband, Vernon, brought to market. It is a six-sided ruler, each side measuring a different millimeter increment. The ridges are raised, so that when pressed to a sheet of clay the measurements are transferred onto the clay. Among its many applications, it can be used to measure strips of uniform width on sheets of clay.

PIERCING AND DRILLING TOOLS

When making beads from polymer clay, I usually make the holes before curing. I have many needle tools of various bore sizes that I use for this purpose. The Kemper Pro Tool is an excellent basic needle tool. It is inexpensive and available at most craft and hobby stores. The needle is set in a thin metal handle and protrudes out of the handle perfectly straight—very important when "drilling" bead holes. I also use bamboo skewers. You may also make your own needle tools by inserting the eye of a carpet needle or doll needle into a mass of raw clay and baking.

There are instances when you will want to drill holes into your pieces after curing. For example, if you cure the piece first, it is less likely that the piece will become distorted or marred by handling. For drilling into cured clay, I use a hand drill (pin vise) and even drill bits alone. The electric Dremel tool, mounted to its own drill press, is commonly used. If you are going to drill your piece after curing, it is helpful to pierce the raw clay at the spot where you plan to drill.

TIP

Extreme caution should be taken when using any blades. These blades are intended for use by adults and should never be given to children. The most important rule is to look at the blade before picking it up. Do not place your fingers on any edge of the blade, sharp or dull; instead, grasp the sides of the blade and cut down.

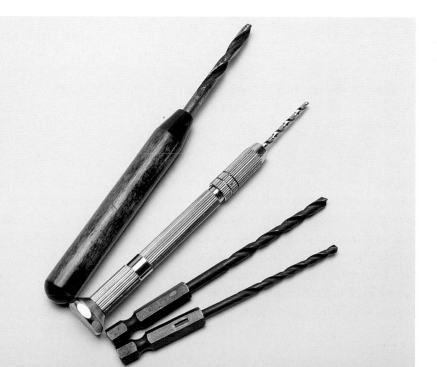

Various drilling tools. From left to right: a Kemper hand drill, a pin vise, and two drill bits.

SANDING TOOLS

Sanding your finished pieces with coarse-grit sandpapers, sanding sponges, or dishwashing scrubbies (coarse green and fine white) will give them a matte finish. To achieve a high sheen on finished pieces, you'll need several grits of wet/dry sandpaper. I use fine, medium, and coarse sanding sponges and 400- and 600-grit wet/dry sandpapers in my work. (See "Finishing Your Work" on page 48 for more about sanding polymer clay.)

There are a number of glues and adhesives that can be used with polymer clay. Which glue you choose will depend on the application.

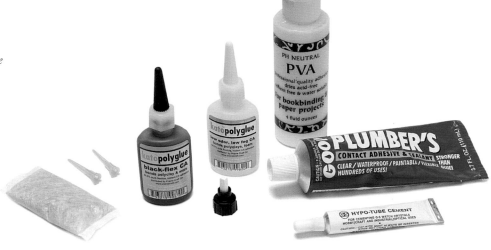

GLUES AND ADHESIVES

Cyanoacrylate (CA) glue bonds almost instantly with polymer clay and is what I use to secure buna cord to my jewelry and to glue pinbacks to pieces. There are many brands of CA glues; I use my own, Kato Polyglue, which is 99.5 percent pure, is almost odorless, and does not fog. CA glue loses its effectiveness when it is exposed to humidity, so to prolong its life the glue should be placed in an airtight jar (glass or food-safe plastic) along with a silica gel pack. We sell our glue with the gel pack and fine applicator tips.

PVA glues can be used to prepare porous surfaces before covering with clay. To glue cured polymer clay to metal and glass, I would recommend a silicone-based glue, such as E-6000 or Goop, or a two-part epoxy. Artist Jacqueline Lee favors Hypo-Tube Cement for most of her post-curing glue needs.

TEXTURIZING TOOLS

Uncured polymer clay accepts texture readily, and just about anything that has some texture can be used to add texture to your clay. See "Creating Texture" on page 100 for information on tools and materials for adding texture to polymer clay.

BEADMAKING TOOLS

Designed by Sue and Gale Lee, Poly-Tools Pro Bead Creation Rollers allow you to form perfectly shaped and uniform clay beads, including round beads, oval (barrel) beads, and bicones.

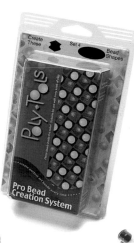

Sue and her husband, Gale, have also designed an ingenious and efficient bead-baking system, the Pro Bead Rack, in which raw clay beads are threaded onto pins. The pins are then placed in notches in the aluminum baking rack. By suspending the beads on the rack, they will not end up with flat, shiny spots.

CLAY GUN

A clay gun can make many tasks easier and produce more refined results. New on the market is the Makin's Ultimate Clay Extruder. This self-cleaning gun has a screw-in plunger that makes extruding even stiff clay a simple task. To use, select a stainless steel disc and screw it in place. Soften and roll a cylinder of clay and drop it in the barrel. Screw the plunger back onto the barrel and turn the screw to extrude the clay in various shapes. I most often use the simple round-hole disc to extrude snakes that I use for edging and other applications.

ABOVE: DONNA KATO
I created the perfectly rounded tiles used in these bracelets by pressing rods of clay into the Poly-Tools Bead Rollers, then slicing away the excess clay.

LEFT: *The Makin's Ultimate Clay Extruder comes with a variety of discs to enable you to extrude clay in a range of shapes and sizes.*

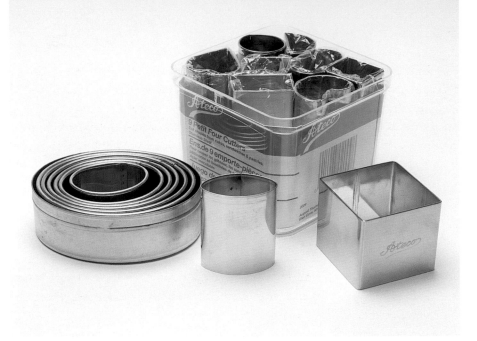

A selection of shape cutters, including a set of graduated circle cutters and tall cookie cutters.

DONNA KATO
These inro boxes were constructed over tall shape cutters.

SHAPE CUTTERS

I find that shape cutters can be a real time saver and make simple work of many tasks. Kemper manufactures a line of metal cutters in many sizes and shapes, including stars, squares, circles, leaves, flowers, and hearts, all with built-in plungers for expelling the clay. Open-backed metal cookie cutters are an inexpensive option and widely available. Plastic cutters, such as those manufactured by Wilton, also work well with polymer clay. I have some plastic cutters from Japan that I must clean after each use; otherwise a chemical reaction would occur and the cutters would melt! The shape cutters I use most frequently are my set of graduated circle and oval cutters and a set of Ateco cutters in simple geometric shapes that are particularly tall. I use the tall cutters for constructing bodies of small box vessels (see "Inro Box with Toner Transfer" on page 76 and "Inked Inro Box" on page 125).

PUNCHES

Small paper punches, commonly found in stamping and craft stores, and machines made by companies such as Sizzix and Accucut can be used to punch out shapes in thin sheets of cured clay. Select a less brittle clay, such as Kato Polyclay, Fimo Classic, or Fimo Soft, and certain colors of Premo! Sculpey if you plan to work with punches and cured clay.

MOLDS

Molds manufactured for use with polymer clay have been marketed and sold for many years, beginning with Maureen Carlson's character molds and Judy Maddigan's floral design molds produced by American Art Clay (AMACO). These were rigid molds made of resin. The newer soft molds can be twisted to expel the clay.

REPEL GEL

Repel Gel, which is formulated by Tony Aquino of Van Aken International, prevents clay from sticking to other clay. Repel Gel acts as an effective resist when it is both wet or dry. Because it is applied as a gel—by finger or with a brush—it is easy to target specific areas where clay-to-clay adhesion is unwanted. After an item on which Repel Gel has been applied has been cured, simply wash the Repel Gel off with water.

PAINTS, INKS, AND PIGMENT POWDERS

Acrylic and tempera paints can be applied to polymer clay to achieve a variety of colorful effects. Pigment powders may be used on clay to impart a metallic, iridescent, or faux dichroic glass finish. Inks can be stamped on clay in the same way you would stamp paper. There is a chapter devoted to these materials (see page 108), which gives detailed instructions for combining all of these materials with polymer clay.

In addition to acrylics and tempera paints, you can also get beautiful effects by painting polymer clay with Genesis Heat-Set Artist Oils. As the name implies, these high-quality paints do not set until they are exposed to heat, specifically 275°F. Although they are certainly not inexpensive, bear in mind that there is no waste; if you store the pots in a cool place, the paint will remain usable forever, making them quite economical. I sometimes use these paints when creating multilayered effects using Kato Polyclay Clear Medium (see page 145). In addition to paint, Genesis offers thinning and thickening additives.

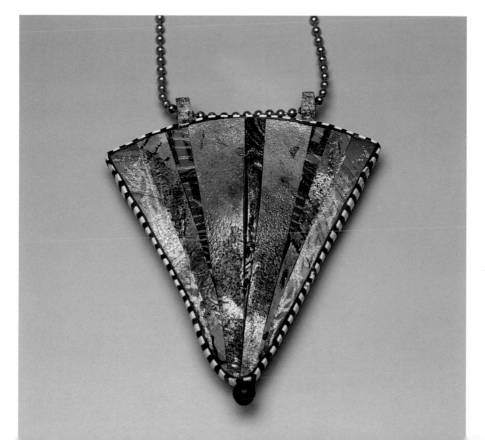

ELLEN MARSHALL
Ellen Marshall has spent countless hours studying the "crazing" effects possible when using various air-dry, heat-set, opaque, and transparent paints, pigments, and inks, some of which can be seen in this pendant. Ellen has written a book, Polymer Clay Surface Design Recipes *(Quarry Books, 2005), which I believe is a "must have" resource for anyone interested in surface treatments, paints, and dyes.*

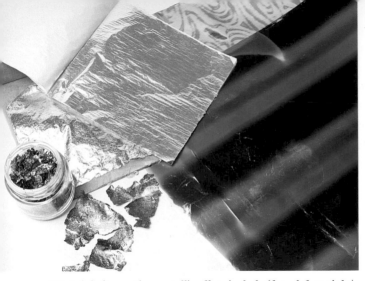

Materials for creating metallic effects include (from left to right) loose composition leaf, sheet composition leaf, and metal foils in "oil slick" and rainbow colors.

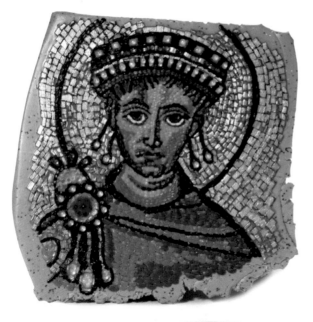

ABOVE: MARGARET REID
Margaret Reid skillfully and effectively uses metal leaf in her impressive micro mosaic art. (Photo by Michael Taylor.)

RIGHT: RON LEHOCKY
Artist Ron Lehocky has used patterned composition leaf and translucent clay in this beautiful mokumé gané brooch.

METAL LEAF AND FOIL

Metal leaf and foil can be applied to polymer clay to create beautiful metallic effects. The least expensive and most easily acquired type of metal leaf is called composition leaf. Composition leaf mimics gold, silver, and copper and also comes in patterns.

Genuine metal leaf is also available. When using metal leaf, I prefer 23-karat gold and genuine silver leaf in my work, rather than composition leaf. Genuine metal leaf is softer and less brittle and forms a finer crackle pattern. Bear in mind that no metal leaf, whether composition or genuine metal, forms a permanent bond with polymer clay and the leaf, once cured, must be sealed with glaze or a very thin layer of translucent clay to prevent it from chipping off the cured clay.

Foils, such as those from Jones Tones, offer polymer clay enthusiasts the possibility of creating brightly colored, patterned metal effects and imitating dichroic glass. The foil is made by coating clear Mylar with a metallic substance. The process for securing the foil coating to clay is simple. Place the foil on raw clay, pattern side up. (If you're looking at a matte silver sheet, you are looking at the coating side, so turn it over.) Using the side of a bone folder or credit card, quickly stroke the foil in a whipping movement. Grasp a corner of the foil and quickly rip it off the clay. The pattern should stick to the clay. Not all foils will work; holographic coating, for example, will not usually leave the Mylar backing unless it is heated.

TIP
You can create a "crackle" sheet by smoothing a sheet of composition leaf on a sheet of raw clay and then rolling it through a thinner setting on a pasta machine. The crackle pattern forms because the leaf does not stretch and the clay does. When you roll the clay through thinner and thinner settings, the size of the crackle becomes finer.

INCLUSIONS

In addition to treating the surface of raw and cured clay, you can also mix materials into the clay itself. We call these additives "inclusions." Artist Leslie Blackford grows her own lavender and other fragrant herbs and mixes them into her clay. I have added embossing powders and iridescent flakes to translucent clay for simple imitative effects, such as faux opal.

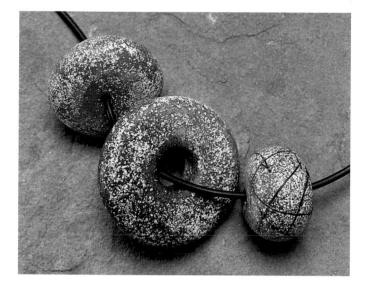

DONNA KATO
This necklace was made by mixing embossing powder into both opaque and translucent clays. The doughnut bead is translucent clay into which two colors (verdigris and red) were mixed, then used to create a Skinner Blend. The peach-colored bead was made by mixing orange embossing powder into translucent clay. The bead on the right is weathered white embossing powder mixed into black clay, to which thin strips of black clay were pressed. All of the beads were rolled in embossing powder before curing.

ABOVE: *Convincing imitations of opal can be easily achieved by mixing iridescent flakes (made by Arnold Grummer) into liquid clay, then spreading it on a ceramic tile and baking. The "opal" sheet can then be cut with scissors and used to cover forms.*

RIGHT: DONNA KATO
I made these pendants with sheets of "opal" clay.

ESSENTIAL TECHNIQUES

NOW THAT YOU HAVE a better idea of what you might need or want to have before you begin, it's time to get started! This section covers all the basic techniques you need to know, including conditioning the clay, rolling sheets of clay, storing unused clay, and curing your finished pieces, as well as safety concerns.

CONDITIONING

Simply put, conditioning is the act of restoring the clay to a state close to its original factory-mixed condition. All polymer clays must be conditioned. Conditioning may be accomplished by kneading and mixing the clay by hand or by repeated folding and rolling of clay through a pasta machine until it is soft and pliable. The pasta machine method is preferable, as kneading may introduce air pockets into the clay. There is some controversy about the importance of conditioning, but I have found that to achieve maximum strength and the strongest "piece to piece" adhesion, conditioning is a must.

The easiest clay to condition is Sculpey III, followed by Premo! Sculpey, then Kato Polyclay and Fimo Soft, then Fimo Classic. (Note: Ease of conditioning should not be the primary criterion used when selecting a brand of clay, as the easiest to condition may also be the weakest and/or most difficult to handle and work with.)

Softer brands such as Sculpey III and Premo! Sculpey may be cut in thick slices from the bar and put immediately through a pasta machine. Other clays require additional preparation. Because Fimo Classic is the most difficult clay to condition, many people cut the clay into small chunks and place it into a food processor to expedite its conditioning. A clay softener, such as Kato Clear Medium, Mix Quick, or Sculpey Clay Softener, may be added to the clay. Pulsing the machine mixes the softener with the clay as the chunks of clay are reduced to small nuggets. The clay is then removed from the food processor and pressed into a slab. It is then rolled with an acrylic rod to flatten and compress the bits before rolling through a pasta machine.

Kato Polyclay and Fimo Soft should be conditioned as follows:

1 Stand the bar of polymer clay up on one end and use a blade to cut it into two thick slices.

2 Using an acrylic rod, thin the clay to approximately $3/8$ inch. I stand up when I flatten the slices, pressing down on the clay as I roll with the rod. This "precompression" with the acrylic rod is extremely important, as it will minimize crumbling and shredding of the clay.

3 Roll the thinned slices through the pasta machine on the thickest setting. Reset the machine to a thinner setting, skipping one setting. Without folding, roll the clay through the new setting. Fold the clay and roll the clay through the machine. Continue folding and rolling the sheet at this setting until it is soft and pliable. Upon inspection, the surface of the clay should have a soft sheen and be free of surface imperfections.

Dark streaks caused by a chemical reaction between the nickel plating on the rollers and the clay may appear. With continued machine use, these streaks should lessen. The Makin's clay machine, with its nonstick rollers, does not create streaks on sheets of clay.

The phrase "open time" refers to the period of time in which the clay remains soft and pliable after conditioning. Certain clay brands "cool down" more rapidly than others and might require reconditioning as you work. There appears to be a relationship between open time and ease of conditioning, as the clays that are the easiest to condition seem to have the longest open time. Fimo Classic, which is the most difficult to condition but has a fairly long open time, is the exception.

ROLLING SHEETS OF CLAY

Many projects begin with a sheet of clay. There may be times when you need a very thin sheet or a sheet that exceeds the thickness of the thickest setting on a pasta machine. Here are guidelines for rolling sheets with a pasta machine and with an acrylic rod.

Rolling Sheets with a Pasta Machine

When you condition clay with a pasta machine, you automatically end up with a sheet of clay. If you wish to roll the sheet to the thinnest setting of the machine, roll the clay through all of the settings in succession. Do not jump from a thick setting to a thin setting, as doing so might lead to the clay shredding, wrinkling, or tearing. It is also helpful

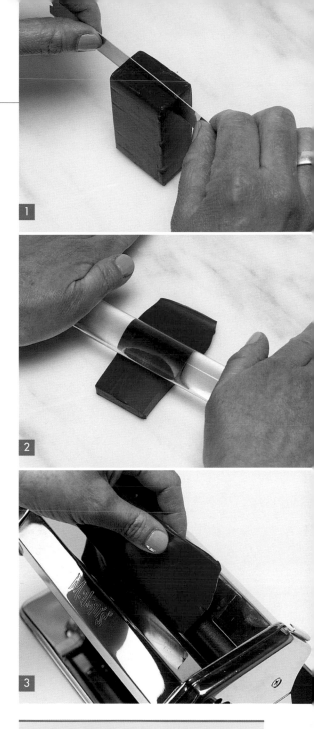

TIP
When you use a pasta machine to condition clay, always place the folded sheets so that the fold rests on the rollers or the fold is perpendicular to the rollers and then roll through. This way, you won't introduce air pockets into the clay.

to hold the clay above the rollers, maintaining tension in the sheet as you roll through. If you find that the clay still shreds, try cleaning the plates beneath the rollers by rubbing an alcohol wipe back and forth until any collected clay is gone. If the machine is exceptionally clogged with clay between the rollers and the bottom plates of the machine, gently dislodge the clay with a bamboo skewer. If the clay still tears and shreds, the problem might be that the edge of a lower plate has been damaged or nicked. If the plates have been damaged, don't immediately discard the machine, because replacement plates alone might be available.

If you wish to create a sheet of greater thickness than the machine allows, simply roll two sheets and press them together beginning at one edge and working toward the other, pressing air pockets from between the sheets as you move from one edge to the other.

You may also wish to make a sheet that is wider than the rollers on your pasta machine. In that case, you'll have to roll two sheets, trim the sides where they will be joined, and then slightly overlap one over the other. Finish by rolling over the seam with an acrylic rod.

Rolling Sheets with an Acrylic Roller

If you do not have a pasta machine, you'll have to roll your sheets with an acrylic brayer or rod. First, flatten the conditioned clay by hand, and then lay the clay between two flat items of the same thickness that are the thickness you want your sheet to be. For thicker sheets, you could use two magazines with the spines facing each other. For thinner sheets, you might use Popsicle sticks. Roll the acrylic rod or brayer over the magazines or Popsicle sticks to create an even sheet of clay. The 12-inch Pro Clay Roller from Prairie Craft Co. comes with three pairs of gaskets of various diameters that allow you to roll sheets of even thickness.

JOINING PIECES

In its raw state, polymer clay will adhere to itself, which means that you don't have to use any adhesive agents to join two pieces together. Applying firm but gentle pressure will join the pieces, and curing will bond the pieces together. The bond between raw and cured clay can be strengthened by brushing a thin layer of liquid polymer clay at the site where two pieces will be joined. While raw polymer clay will adhere to itself, certain designs that have minimal clay-to-clay contact may still require the use of a structural armature, such as thick wire, to hold the pieces together.

OLIVIA ASH TURNER
This stunning mask was created by pressing raw clay into real leaves, then layering the polymer clay leaves on top of each other before curing.

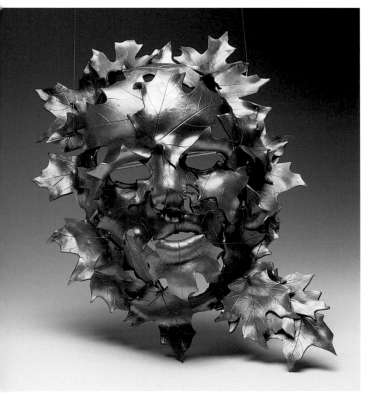

STORING YOUR CLAY

Polymer clay begins curing at approximately 90°F, so the location you choose to store your clay is important. Make sure that the clay will not be exposed to heat or direct sunlight and is in a place where the ambient temperature is low.

Raw clay may be wrapped with plastic wrap or placed in zippered plastic bags that will keep the clay clean. Certain plastics create a chemical reaction with raw clay. These tend to be hard, rigid, clear plastics. If such a chemical reaction occurs, the clay will "melt" into the plastic, making a sticky mess. I store my projects in progress wrapped in plastic wrap and placed in plastic boxes that bear the recycling number 5 (look at the bottom of the container to find the number), such as a translucent, flexible fishing tackle box. Some people prefer to wrap their work in waxed paper, but I find that the clay dries up as the plasticizer leaches out of the clay into the waxed paper.

CURING POLYMER CLAY

Curing polymer clay transforms it from a soft clay into a rigid plastic. Clay is cured by exposing it to temperatures ranging from 265°F to 325°F. Each brand has its own recommended time and temperature, and these recommendations should be followed to the letter. To achieve the maximum strength, the recommended temperature must be reached. For this reason, I no longer recommend mixing brands with different curing temperatures unless absolutely necessary, and unless their curing times are the same.

It is a good idea to invest in an oven thermometer and timer. With the thermometer, you can determine the accuracy of your oven temperature dial. You should do this before you cure anything! When I cure my pieces, I leave the thermometer in the oven, checking it occasionally.

Many ovens do not require a separate timer; rather, they are turned on and off with a timer. When the time runs out, the oven stops. Other ovens do not have this helpful feature, so if your oven does not, you'll want to use a separate timer to ensure that your pieces are not cured too long. In some brands, extended curing will have little to no affect on your work. (Kato Polyclay is largely unaffected by extended curing time, while certain colors of Polyform clays will darken and change the most.)

I have a dedicated convection oven that I use only for curing polymer clay. I believe that occasional use of one's home oven poses no threat to one's health, but there are those who would disagree! Toaster ovens are a last resort. The cooking chamber of your average toaster oven is small and narrow, placing the clay in close proximity to the heating elements. They are also prone to temperature spiking. I have used an electric frying pan to cure flat pieces with fair results. Specific temperatures may be set when using electric fry pans. If you use a frying pan, place items on a Teflon sheet when curing. The Melt Art Melting Pot, made for Suze Weinberg by Ranger Industries, is perfect for travel and for partially curing small pieces. (Such pieces should be completely cured in an oven at a later time.)

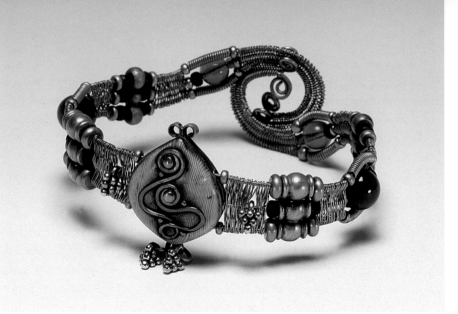

DESIREE MCCROREY

Desiree McCrorey incorporated hammered wire into the polymer clay focal piece of her lovely wire-wrapped bracelet. One of the advantages of working with polymer clay is the ability to cure it with other materials, such as metal, that can withstand the curing temperatures.

TIP

Nesting or supporting large polymer clay pieces in either polyester batting or cornstarch when curing will help prevent cracks that may be caused by the sheer weight of the clay as it cures.

If you must use your home oven, I'd recommend constructing the following curing chamber to be placed within the oven itself. Place polyester batting inside a baking pan or fill it with several inches of cornstarch, then place items in the batting or cornstarch. Nesting in this way prevents flat, shiny spots in your finished work. Place the entire pan into a turkey roasting bag (do not pierce the bag). Essentially, you will have created a sealed chamber within the oven, and any residue from polymer outgassing will collect inside the cooking bag, not on the sides of your oven. You may find it necessary to lengthen the curing time.

Most brands cannot withstand prolonged exposure to temperatures of over 300°F, with the exception of Kato Polyclay, which cures from 275°F to 325°F. If Kato Polyclay is cured between 300°F and 325°F, the recommended cooking time should be reduced by half. Kato Polyclay cured at this temperature is even stronger than clay cured at 275°F. Certain colors, such as translucent, may yellow at these higher temperatures. The curing instructions given in this book are based on a curing temperature of 300°F, unless otherwise specified.

In most brands, the clay is at its most fragile state, and most likely to break when handled, when it is warm out of the oven. Sculpey III, Premo! Sculpey, Fimo Classic, and Fimo Soft clays should be allowed to completely cool before handling. Kato Polyclay can be handled and even reshaped slightly when warm with no breakage or cracking.

Although polymer clay may be cured many times, you might find that color shifting may occur, depending on the brand of clay you are using. If the brand is prone to color shift, you may need to shield parts with foil that have been previously cured in order to minimize this color change.

Certain brands of polymer clay are more prone to this color change from raw to cured state, some becoming up to three shades darker. Most colors of Kato Polyclay do not change at all. Fimo Classic and Fimo Soft change minimally. If you use a clay brand whose colors are subject to radical darkening, you may want to experiment with adding white to compensate for this color change.

The presence of air pockets in solid clay items, such as beads, can cause cracks, so it is important to expel air from the clay when you are conditioning it. Should you find a crack in a cured piece, you can heal the crack by pressing the sides of the crack together (while the clay is still warm) until the bead is cool or by plunging the hot piece into ice water while pressing the crack closed. Artist Leslie Blackford recommends wrapping a cracked piece in a towel and allowing it to cool very gradually.

AVOIDING CHEMICAL REACTIONS

You should avoid exposing polymer clay to other polymers, as a chemical reaction might occur. If you drop raw clay on your carpet and leave it there, you might find it melting into your carpet! If you work on fine furniture, you might find the raw clay melting and ruining the finish. So be aware and take proper precautions. Similarly, applying certain glazes that contain polymers to a cured item may actually create a chemical reaction between the glaze and the clay. Should this occur, the glaze won't dry and harden and your work will eventually dissolve into a sticky mess. This reaction usually takes about a week to reveal itself, so if you're unsure about whether a reaction might occur, be patient and test a piece first, before glazing all of your work.

CLEANUP

I keep a spray bottle of isopropyl alcohol for cleaning up my work surface, tiles, and tools. Simply spray and wipe.

After working with polymer clay and definitely before eating, hands should be cleaned thoroughly. Wipe hands with baby wipes or hand lotion, and then finish with soap and warm water. It is also helpful to coat your hands with a barrier cream, such as Gloves in a Bottle, before working with clay. This "lotion" seals moisture in, while it creates a light barrier on your skin. It makes it much easier to remove clay, paint, or any other messy material from your hands.

POLYMER CLAY AND SAFETY

When it is used properly, following the manufacturer's curing recommendations, polymer clay is perfectly safe. The only time it might possibly pose a hazard is if it is burned. Most everyone I know has, at one time or another, burned a batch of polymer clay. If this should happen, take the burnt clay items outside, open the windows, and let the air clear before returning. Certain animals, such as birds, are particularly sensitive to fumes. If you have birds, you'll want to make sure they are not near your oven when curing clay.

Generally, it is best to segregate your polymer clay tools from any tools that might be used in food preparation. And although polymer clay is certified as nontoxic and has passed rigorous testing, it is not meant to be used to make food-bearing items. This means no mugs, plates, cups, or bowls—at least not those that you'd eat out of. Decorative items only, please. If you follow these simple precautions, polymer clay should pose no health risks.

MAKING BEADS

MAKING YOUR OWN polymer clay beads is a great way to try out the surface effects described in this book. Transfers, paints, inks, pigment powders, polymer clay enamel, and bas-relief are just a few of the techniques and mediums that can be applied to beads. Because beads are small and quick to make, you can feel free to be creative and experiment with new effects without fear of ruining a larger or more intricate piece.

After you have shaped your clay bead, you can pierce a hole in the bead with a needle tool before curing, or drill a hole with a hand drill after baking. The advantage to drilling the hole after curing is that you have less risk of distorting the shape of the bead.

DONNA KATO
I decorated these polymer clay beads using the direct toner copy transfer technique on page 74.

FORMING THE BEAD CORE

When making beads that are thicker than 2 inches at their widest point, you'll want to make the bead core from aluminum foil, because the center of a solid clay mass this thick might not cure. To make an aluminum foil core, loosely crumple and then tightly compress a sheet of foil to achieve the basic desired bead shape and to eliminate crevices in the surface of the foil. When I make beads, I compress the shape by rolling and pressing the foil against my work surface.

Once you have made the basic foil core, cover it with a sheet of clay rolled through the thickest setting of the pasta machine. The thickness of the clay will make it easier to add decorative embellishments and will allow for some surface movement without danger of exposing the foil beneath.

For smaller beads, you can either use a solid piece of clay or make a core from bits of scrap clay and cover it with clay. The way you form the core of scrap clay is very important, as it is possible to introduce air pockets into the core material. Internal air pockets could lead to cracked beads as the trapped air heats and expands during the curing process. Follow the steps below to make a bead core out of scrap clay.

1 Begin by mixing your scrap clay and rolling it through a pasta machine until it is a uniform color and the surface of the clay is smooth. Starting at one end, roll the sheet up tightly to form a cylinder. Smooth the edge of the sheet to the sides of the cylinder.

Roll a sheet of clay to wrap around and conceal the scrap clay. The greater the diameter of the cylinder, the thicker the wrapping sheet should be. For a 4-inch-diameter cylinder, I would use a medium-thick sheet, whereas I would wrap a 1-inch-diameter cylinder with a very thin sheet.

Beginning at one of the cylinder, stretch the clay to reduce the diameter to the thickness you want your bead to be.

2 With a blade, cut a piece of the polymer clay to the length you want the bead to be.

3 To cover the scrap clay exposed at the ends of the cylinder, grasp the cylinder with the thumb and first finger of both hands and gently depress the ends. Working one end at a time, smooth the white clay from the sides over the scrap ends, rotating as you go until the scrap has been covered. If any of the core is still showing, press it in with a pointed but blunt tool, such as a large-gauge knitting needle or crochet hook, and then smooth the white clay over to cover.

4 Repeat the above step to cover the other exposed end. The core is now ready for shaping.

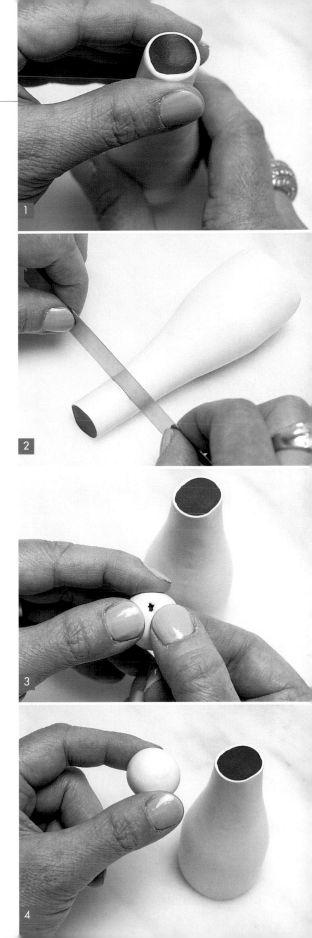

SHAPING THE BEADS

After you have made your bead core, you can then form it into any number of shapes. Here are a few typical bead shapes to try:

Round Beads

Place the clay between your palms and roll in a light, tight circular motion. Open your palms and reposition the ball of clay. Continue lightly rolling and repositioning until the clay is perfectly rounded. Increased pressure will form a rounded, disc-shaped bead.

Rondelle Beads

Roll a round bead. If the bead is large, place the ball between your palms and press. Lift one palm and reposition the flattened bead and then press again. Repeat until the bead is the desired thickness. Finish by refining the edges with your fingers. For small rondelle beads, roll a round bead and then squeeze the ball to flatten and create the shape. You may also place the round bead on your work surface and flatten it with a piece of acrylic or other solid, flat item.

Barrel Beads

Instead of rolling in the tight circular motions used to make a round bead, exaggerate the circular movement, rolling in larger circles.

Teardrop-shaped Beads

To make a teardrop-shaped bead, roll a barrel shape and then taper one end of the barrel.

Almond-shaped Beads

Make a teardrop bead, then flip the bead to the other side and pull a tapered point from the opposite end. Finish by refining the shape with your fingers.

Bicone Beads

Artist Tory Hughes devised this method for creating bicone beads, in which the clay is worked not in your hands but between your work surface and a rigid, smooth, flat piece of metal or acrylic. Begin by making a round bead. Place the round bead on your work surface, then, with a flat item, roll in loose, circular motions, exerting light pressure. You can also make lentil-shaped beads in this way by flattening the points of the bicone.

Left to right: round bead, rondelle bead, barrel bead, teardrop-shaped bead, almond-shaped bead, bicone bead.

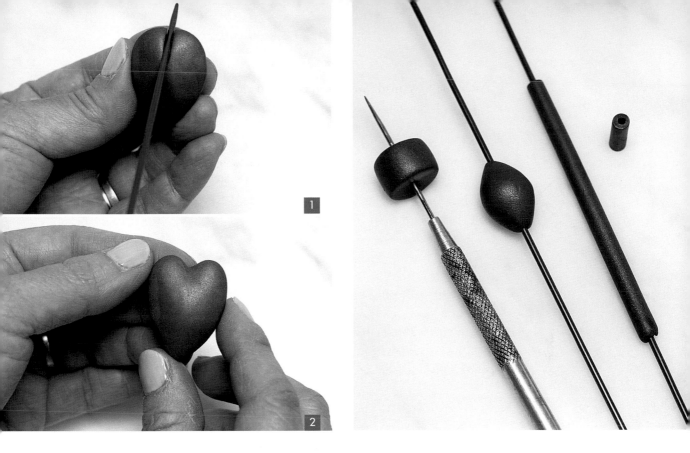

Heart-shaped Beads

You can also make more intricate beads starting with the same basic bead. Follow the steps below to make a heart-shaped bead:

1 Roll a teardrop-shaped bead. Place the bead between your palms and press. Continue until the piece is the desired thickness. Refine the edges by pinching with your fingers. Indent the space between the lobes of the heart with a needle tool or a fine knitting needle.

2 With your fingers, refine the shape of the lobes. Pinch again around the entire bead to set the shape.

Tube Beads

Tube beads are formed on a skewer or on stiff, straight wire or tubing. As you make the tube beads, the holes are automatically formed. Prepare a cylinder of clay or, if you made a core with scrap clay, cut a piece from the cylinder. It isn't necessary to close the scrap ends. "Drill" through the center of the cylinder with the skewer. You can also use a needle tool to make a hole, then place the clay on a skewer. Pinch the ends around the skewer and then roll the clay against your work surface, moving your hands out from the center toward the ends as you roll. To loosen the clay from the skewer, gently rotate the clay on the skewer. The tube may be cured on the skewer or it may be removed from the skewer and cured flat. Once cured, the tube may be cut with a blade to make tube beads.

This photo shows the making of a tube bead at various stages, from piercing the clay with a needle tool (far left) to a finished tube bead (far right).

TIP
If you bake the clay on a bamboo skewer and allow it to cool, you might find you can't remove the clay. Should this happen, place the skewer and clay back in the oven to warm the clay. Pull the clay off the skewer while the clay is still warm.

CABOCHON SHAPING

CABOCHONS ARE pieces with rounded tops that slope and taper to flat bottoms. They can be used to create pendants, earrings, pins, and other jewelry pieces. When making cabochons, it is helpful to work on a ceramic tile on which the cabochon may also be baked. If you are planning on working the cabochon further, it is best to work on deli paper. To remove the cabochon from the paper, simply turn it over and peel away the paper.

To make a basic cabochon, roll a ball of clay twice the desired size of the finished cabochon, then cut the ball in half. Cutting has probably slightly flattened the piece, so with your fingers restore one half to its original shape. Place the flat side onto the ceramic tile. Inspect the cabochon from the side. The curve of the cabochon should begin at the tile, rise and curve to its highest point at the middle, then descend down to the tile again, forming an even arc. You have just made a high-dome cabochon!

To make a low-dome cabochon, flatten the high dome, pushing the clay down toward the tile. Oval, barrel-shaped, almond-shaped, heart-shaped, and teardrop-shaped cabochons can be made by making beads in the desired shape as shown on pages 44 and 45, cutting them in half, and flattening the halves onto a ceramic tile.

DONNA KATO
This bracelet is made from cabochons that have been covered in clay decorated with metal leaf and alcohol inks, then linked together with buna cord and O-rings. (See "Inked Cabochon Pendant" on page 133 for instructions on making the cabochons.)

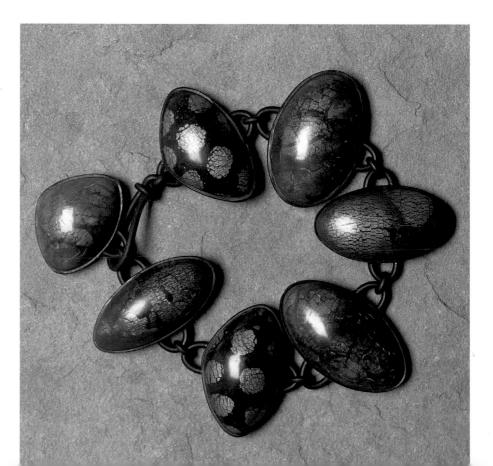

To make a triangle-shaped cabochon, roll a ball of clay and press the ball flat between your palms. Place the flattened ball on a tile and cut a triangle shape with a blade. Use your fingers to refine and push the edges to the tile.

To make a ridged cabochon, make a bead of the desired cabochon shape and then cut it in half. With your fingers, pinch a ridge along the center of the cabochon. Refine the ridge by rolling along both sides of the ridge with an acrylic rod or other smoothing tool.

The shaped cabochons may be used as they are or as draping forms, serving as temporary armatures for shaping and baking polymer clay. If they are to be used as temporary armatures, they must be baked before draping with raw clay. When draping clay over cured polymer clay cabochon forms, begin by applying a coat of Repel Gel or another dry release agent and letting it dry—in this case I wouldn't use water. Cover the form with a sheet of clay rolled through a medium-to-thick setting of the pasta machine, making sure there are no air pockets. Using your blade, trim any excess clay from the bottom of the cabochon, embellish, and bake. When this is cured, you will be able to remove the cured clay top from the cabochon. You can also bake the clay sheet covering first, remove the cabochon armature, then add your embellishments and bake again.

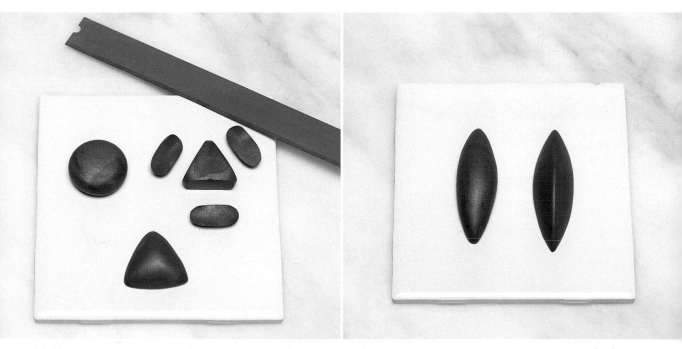

Making a triangular cabochon. Clockwise from top left: the original rounded cabochon; cutting the edges off to form a triangle; the finished cabochon.

Making a ridged cabochon: before forming the ridge (left) and after (right).

FINISHING YOUR WORK

SOMETIMES THE BIGGEST difference between a really superior piece and one that is only average can be found in the manner in which it is finished. Are the sides even and smooth? Are the corners sharp where they should be? Does a piece of jewelry satisfy the tactile and visual senses? If your answer to any of these questions is no, you have some more work to do.

The first thing you must decide is whether you want an extremely matte, matte, glossy, or satiny finish to your pieces. There are times when the techniques used, the opacity or transparency of the clay, or other conditions may dictate how you proceed. Translucent overlays benefit from a high-gloss finish: The sheen enhances the clarity of the clay. A piece whose surface is irregular will not benefit from a high-gloss finish as it magnifies surface imperfections.

Cured items will naturally exhibit matte, satin, or even shiny finishes, depending on the brand you are using. Sculpey III is the most matte; Premo! Sculpey, Fimo Classic, and Fimo Soft cure to a satin-type sheen; and Kato Polyclay is the shiniest. A dusting with cornstarch before baking or rubbing with a soft cloth when the piece is warm will reduce the sheen of Kato Polyclay.

JANA ROBERTS BENZON

As this piece illustrates, Jana Roberts Benzon is a master at finishing, dedicating time and attention to the smallest detail. Not only are the front of her pieces perfect, the backs are as well.

SANDING BASICS

I sand 99 percent of the pieces or parts of pieces that I make to give my work a "finished" appearance. Sanding sponges are available in three general grits: fine, medium, and coarse. I use fine-grit sponges for pieces with minimal surface irregularity and to achieve a matte finish. Occasionally, I use medium-grit

sponges with a light touch to sand bumpy surfaces. Coarse-grit sponges can create more problems than they solve, but worked lightly they will quickly smooth the roughest surface.

Sanding sponges usually work best if you use them wet and slightly soapy. Squeeze a drop of dish soap onto the exposed sponge end and, under running water, squeeze the sides to wet the sponge. The wet sponge traps the clay particles. Sponges may be cleaned in the same manner: Squeeze a drop of dish soap onto the sponge and squeezing the block under running water. To lengthen the life of the sponge, do not wring the water from it; squeeze the flat sides of the sponge between your palms to remove excess water.

For finer sanding and to achieve a higher-gloss finish, you should use automotive or wet/dry sandpapers, which are manufactured in specific grit sizes: The larger the number, the finer the grit. These papers are gray to dark gray in color. After sanding, return the piece to the oven briefly to "heal" some surface scratches.

USING AN ELECTRIC BUFFER

To achieve a glassy, high-gloss finish, you'll need an electric buffer fitted with unstitched muslin wheels. I use a Foredom buffer. It's quiet and compact and has variable speed settings. A buffer from your local hardware store will do, but they are big and noisy.

Here are a few safety tips to keep in mind before using your buffer:

- Don't wear loose clothing.
- Tie your hair back.
- Wear protective eyewear.
- Make sure the area around the buffer is clear.
- Relax.

Look at the spinning wheel from the side. Now, imagine that the wheel is a clock face. The top is twelve o'clock, the bottom six, and so forth. As my machine spins in a counterclockwise direction, I buff against the area occupied from six to nine o'clock—in the center of the side of the muslin wheel and at its edge. This might not be critical when buffing round items with no edges, but if you're sanding something with an edge, you must pay attention. Edges are easily caught by the spinning wheel, and before you know it the piece is on the loose. By holding it low on the wheel, if it should escape, it won't be sent flying back at you. Everyone loses control of a piece now and then. If that should happen, stop and collect yourself. Turn off the machine and then retrieve the piece.

TYPES OF FINISHES

Once you have determined the type of finish you'd like your piece to have, follow these directions to achieve it.

Extreme Matte Finish

If you want your piece to have an extreme matte finish, first dry-sand the sides and back with a fine-grit sanding block to completely even the sides and refine the edges. With the tip of a fine metal file, gently rough up the surface.

Matte Finish

For a matte finish, lightly sand your piece with a medium-grit sanding sponge. Return the piece to the oven for a few minutes.

Satin Finish

To achieve a satin finish, sand your piece with a damp medium-grit sanding sponge, followed by a fine sanding sponge, or wet-sand the piece (in water in which you have added a few drops of dishwashing liquid) first with 400-, then 600-grit wet/dry sandpaper.

ABOVE: CAROL BLACKBURN
You don't have to limit yourself to one type of finish per piece. This brooch by artist Carol Blackburn exhibits both a matte (left) and a glossy (right) finish.

RIGHT: DONNA KATO
The extreme matte finish on these box pendants makes the black clay look almost frosty.

Rinse the piece in clean water and then dry it on a soft towel. Finish by lightly buffing the piece on worn denim, polar fleece, or finely woven cotton.

Glossy Finish

For a glossy finished piece, begin by wet-sanding the piece in one direction with 400-grit, then sand in the opposite direction with 600-grit wet/dry sandpaper. Some people continue to sand down through 800 and even finer grits. Using circular motions, lightly buff the piece against the muslin wheel of an electric buffer. You may opt to apply a surface glaze such as Varathane Diamond Gloss, Future Floor Wax, or another water-based glaze. You could also use liquid clay, such as Kato Clear Medium. If a liquid clay is used, you must cure the piece again. If you do decide on a glossy finish or a surface glaze, make sure that the surface of the piece is smooth and even. Remember, a glossy finish amplifies any surface irregularities.

SIGNING YOUR PIECE

This is something I frequently forget to do! Be sure to sign each of your pieces in some manner, such as by inscribing your name in the clay.

TIP

If you are using sand-papers with a very high grit for a high-gloss finish, don't skip grits. In other words, don't sand with 400-grit and then 800-grit without sanding with 600-grit.

JACQUELINE LEE
To sign her artwork, Jacqueline Lee makes a mold from her name on a credit card and then presses raw clay into the mold. She then presses the clay to the piece.

ONE OF THE MOST appealing aspects of polymer clay is the great variety of colors available. Bear in mind, however, that you can also custom mix your own colors. In this way, you can create you own "look," using color to add your own distinctive touch. My color choices tend to be more intuitive, less academic, so artist Laurie MacIsaac graciously agreed to lend her expertise and write about this sometimes confusing subject.

THE COLOR WHEEL

One of the key elements in design is color. Artists use color theory to ensure that their color choices bring out the best in their work. Some artists have a built-in color sense; others have developed it over time. Still others use a color wheel as a tool to make the best possible color choices.

A standard color wheel is made up of twelve colors, all derived from the three primary colors: red, yellow, and blue. Primary colors cannot be created from other colors. Mixing two primary colors creates a secondary color. The secondary colors are orange, green, and violet. When you combine two secondary colors you get a tertiary color. There are six tertiary colors: blue-green, blue-violet, red-violet, red-orange, yellow-orange, and yellow-green.

ABOVE: LINDLY HAUNANI
RIGHT: MAGGIE MAGGIO

Why work with only packaged colors when simple mixing can create subtle, complex, and distinctive colors such as these? Artists Lindly Haunani and Maggie Maggio are master color theorists in the polymer clay community.

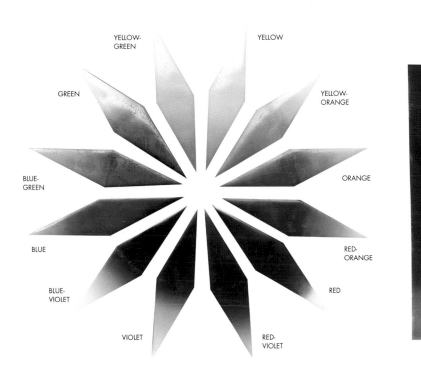

MIXING COLORS

Even with all the colors of polymer clay on the market, somehow we never seem to be able to find exactly the color we need. Here are some tricks to adjust your colors to get the perfect color and shade for your project.

Neutralizing with Complements

If you equally mix two colors that are opposite each other on the color wheel, known as complementary colors, you get mud. While we don't generally have a need for a lot of mud-colored clay in our work, we can use this principle to our advantage. If you ever have a need to tone down, or neutralize, a color, simply add small amounts of its complement to the clay mix until you achieve the hue or color that you are looking for. Try adding small amounts of red to green (or vice versa) and watch how the color changes.

Tints, Tones, and Shades

How light or dark a color is is called its value. Adding white to a color lightens it, or increases its value, creating a tint of the original color. Adding black to a color darkens it, or decreases its value, creating a shade of the original color. Sometimes a color does not need to be lightened or darkened but needs to be a little more "earthy." Create rustic tones by adding small amounts of brown to your mix. Dusty colors are achieved by adding white and a small amount of black to the mix.

ABOVE LEFT: *A color wheel, such as this one made from polymer clay, helps us to understand the relationships between colors and to create color schemes and palettes.*
ABOVE CENTER: *Look at this Skinner Blend (see page 55 for more on Skinner Blends) made with red and green clay. Note how intense the colors are at each end and how they gradually neutralize to brown in the middle.*
ABOVE RIGHT: *Red clay mixed with other colors to create various, tints, tones, and shades. Clockwise from the bottom: red; red mixed with black; red mixed with brown; red mixed with gray; red mixed with white.*

TIP

When experimenting with mixing clay colors, it's a good idea to keep a record of any color recipe that you like. Making color chips is a fun way to create a valuable tool that will help you choose color schemes for your projects.

COLOR SCHEMES

Color schemes are tried-and-true combinations of colors that work together. They are based on research and experimentation. Don't think of these schemes as color "rules," but consider them as starting points for your design when you've hit a creative block. Develop your own color schemes and palettes that will make your work unique. A *monochromatic* color scheme uses just one color, any color, on the color wheel. Various tints and shades of the color will create excitement and interest. A *complementary* color scheme is made up of two colors that are opposites on the color wheel. Projects using this scheme may have one dominant color, with the other color providing an accent. A *split complementary* color scheme uses one color plus the two colors on either side of its complement, such as blue with yellow-orange and red-orange. An *analogous* color scheme includes colors that lie next to each other on the color wheel, such as yellow-orange, orange, and red-orange. Analogous colors make wonderful Skinner Blends. The *triadic* color scheme uses any three colors that are equidistant on the color wheel. The three primary colors—red, blue, and yellow—form a triad.

CONTRAST

Another important factor to consider when selecting colors to use in a piece is contrast. You may or may not want to have a lot of contrast in your design. Placing two complementary colors, such as yellow and purple, next to each other creates the greatest contrast. You can also increase (or reduce) contrast by varying the values (the lightness or darkness of colors) in a piece. And keep in mind that warm colors (reds, oranges, and yellows) tend to advance, while cool colors (greens, blues, and purples) tend to recede.

ELLIE HITCHCOCK

The warm orange and red elements on this cool blue mask seem to pop out. Orange and blue are complementary colors, which enhances the contrast. (Photo by Lucy Wang)

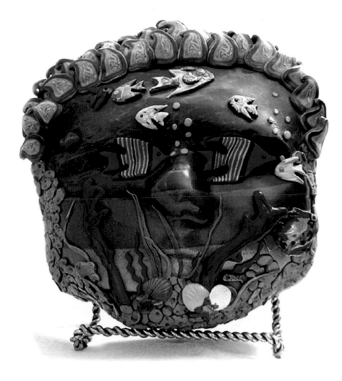

THE SKINNER BLEND

INTRODUCED TO the polymer clay community by artist Judith Skinner, this simple method to create sheets of perfectly graded color forever changed the face of polymer clay art by adding subtle shading and visual complexity. As this book is dedicated to surface treatment, I have not used Skinner Blends in the techniques or projects, but it is such an important technique that I have included a brief explanation of a two-part Skinner Blend here. As easy as it is to make a Skinner Blend, it is also possible to roll the sheet through incorrectly. If you follow these few simple instructions, you won't make that mistake.

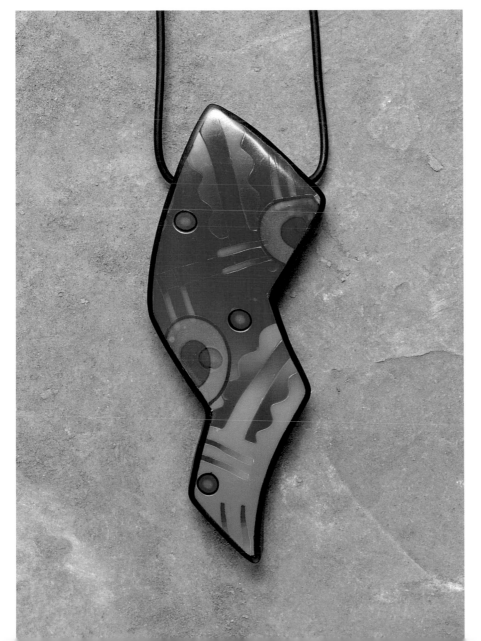

DONNA KATO
For this lightning bolt pendant, I cut out shapes from several sheets of Skinner Blends, then pieced them together.

1 A simple, two-color blend begins with two right-angle triangles of clay of the same size. After selecting and then separately conditioning the colors that you wish to blend, roll each color through the thickest setting of your pasta machine. You will end up with a more or less rectangular or square sheet. Grasp a corner of the sheet and fold it to its opposite corner. Do the same with the other color.

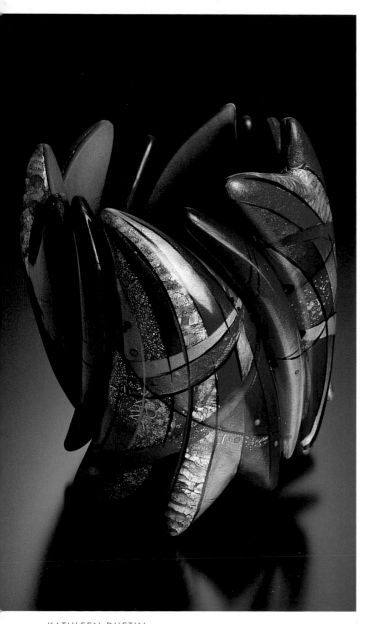

KATHLEEN DUSTIN
The subtle color variations in this striking cuff bracelet were achieved with Skinner Blends. (Photo by Robert Diamante)

2 Place one folded sheet atop the other, matching the folded sides. With a Kato NuBlade, trim the other two sides to form a 90-degree angle that lies opposite the folded edges.

3 Separate the two triangles and butt the folds (diagonals) together to form an overall rectangular or square shape. Note that the corners should not meet up exactly. There should be triangular tabs of clay extending beyond the edges as shown in the photo. If the corners were to meet, the sheet would be entirely graded, and there would be no evidence of the original colors used in the blended sheet. Trim the tabs with the blade.

4 Roll the clay through a pasta machine on the thickest setting, making certain that the two colors physically touch the rollers.

5 Fold the sheet so that two edges of the same color meet.

6 Place the fold on the rollers and roll the clay through. Fold the sheet again so that two edges of the same color meet and roll the clay through again. There is no set number of times you must roll the clay through to make a streak-free Skinner Blend; it depends on the opacity or translucency of the clay, with translucent colors requiring fewer runs through the machine as the translucent clay conceals streaking. Keep the machine at the thickest setting. This photo shows a completed two-part Skinner Blend.

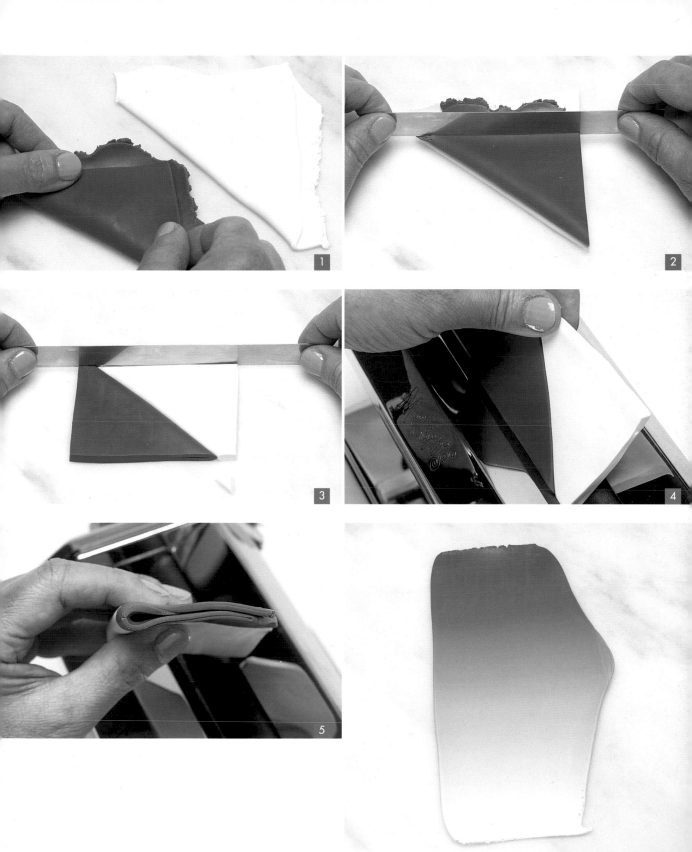

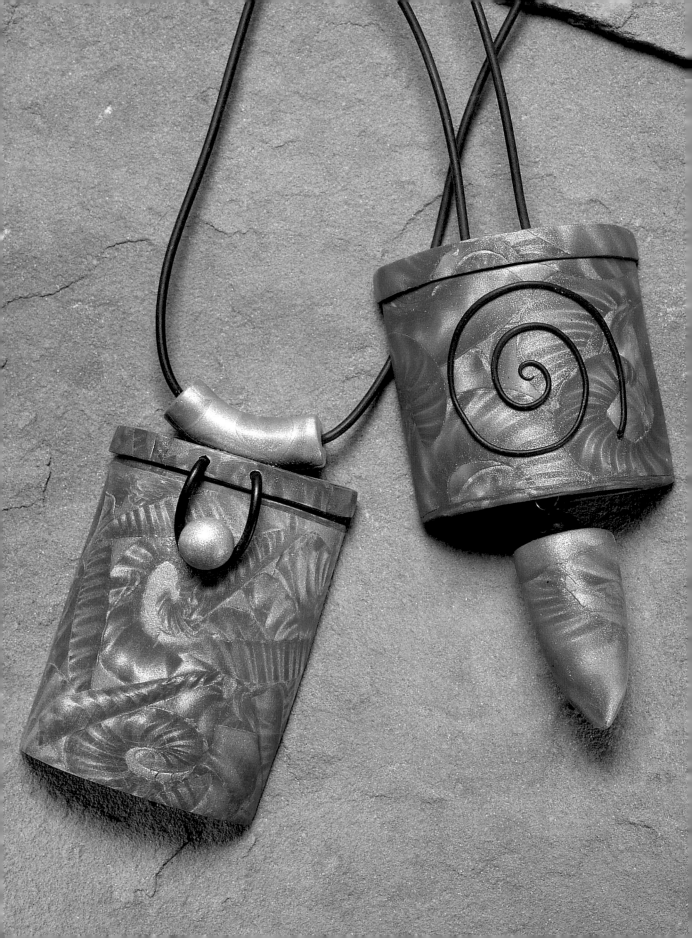

MICA SHIFT TECHNIQUES

Certain metallic-colored polymer clays contain reflective particles of mica. When mica-laden clay is rolled through a pasta machine multiple times, the particles flatten, so that when viewed from the top the clay gives one appearance and when viewed from the side, another. It could be said that the clay has a "grain." Artist Pier Voulkos took this perceived negative characteristic and, as only she could, developed techniques to create magical effects with the clay. The look of depth created with these techniques is called "mica shift," or chatoyancy, from the French *chatoyer*, meaning "to shine like a cat's eye."

MIXING CHATOYANT COLORS

METALLIC POLYMER CLAYS are made up of mica particles added to a tinted translucent clay base. The transparency of the clay enhances its holographic appearance when used in certain techniques. Adding more translucent clay (for example, two to four parts translucent clay to four parts metallic clay) will increase the illusion of depth. If the metallic clay you are using is very white, as in pearl-colored Kato Polyclay, there will be very little contrast when using mica shift techniques. Adding a bit of color to the clay will increase the contrast and improve chatoyancy.

You can also mix custom colors by adding either dry pigments (such as mica powders) or wet pigments (such as alcohol inks) to a metallic base clay. The process of mixing dry or wet pigments into the clay can be messy and requires large amounts of pigment to achieve a deep metallic color. You can mix other colors of clay into the metallic base clay, but you run the risk of reducing the chatoyancy, as the colors are not transparent but opaque. Kato Color Concentrate Clays are ideal for coloring translucent base clay, as less clay is needed to achieve deep color in your clay without adding opacity.

RIGHT: *In the top row you see the cutter and the clays with circles removed to mix a chatoyant color. In the bottom row is a tapered, striped spear from which pieces were cut and placed on a sheet of the same metallic clay. The cutout on the right has been cured to illustrate the effect curing has on the chatoyancy.* OPPOSITE: *Cured tiles made from pearl mixes. Top row: samples using various colored pearl mixes. Middle row, left to right: orange pearl, red pearl, golden red pearl. Bottom row, left to right: blue–violet pearl, teal blue pearl, teal green pearl, green-gold pearl.*

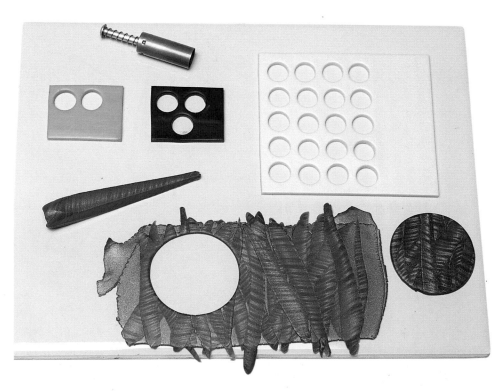

Begin by mixing a metallic base clay. We'll use pearl-colored Kato Polyclay metallic clay. Combine the pearl clay with an equal amount of translucent clay. Roll the mixed clay through the thickest setting of a pasta machine.

We're going to make teal blue pearl clay. Roll some Color Concentrate Clay in blue and some in yellow through the thickest setting of a pasta machine. Select a clay cutter (the shape is not important), which you'll use the through the entire process. Begin by cutting one piece of blue and one of yellow. Mix them together. If the clay is too green, add another piece of blue. To this concentrated base, add pieces cut from the pearl mix. Continue adding pieces as necessary. Stop when you have achieved the color you want. Count the holes you've cut and you have a formula for this color that you can now reproduce. Bear in mind you may also use regular colored clay—but only to mix pale metallic colors.

If you wish to impart a golden cast to colors, mix equal parts gold and translucent clays to make a gold metallic base clay. Add parts of this to your color mixes. Copper base and silver base clays may also be used.

At the right are some formulas for color mixes you can try.

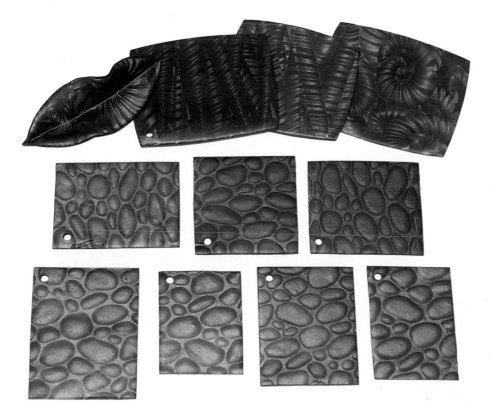

TEAL BLUE PEARL
2 parts yellow Color Concentrate
3 parts blue Color Concentrate
20 parts pearl base clay

RED PEARL
3 parts red Color Concentrate
10 parts pearl base clay

GOLDEN RED PEARL
2 parts red Color Concentrate
2 parts gold base clay
5 parts pearl base clay

ORANGE PEARL
1 part red Color Concentrate
2 parts yellow Color Concentrate
2 parts gold base clay
5 parts pearl base clay

GREEN-GOLD PEARL
2 parts blue Color Concentrate
3 parts yellow Color Concentrate
4 parts gold base clay
8 parts pearl base clay

TEAL GREEN PEARL
1 part blue Color Concentrate
2 parts yellow Color Concentrate
6 parts pearl base clay

BLUE-VIOLET PEARL
1 part blue Color Concentrate
2 parts magenta clay (not Color Concentrate)
10 parts pearl base clay

PIER VOULKOS
Artist Pier Voulkos laminated this box with sheets of clay with a different chatoyant pattern on each plane.

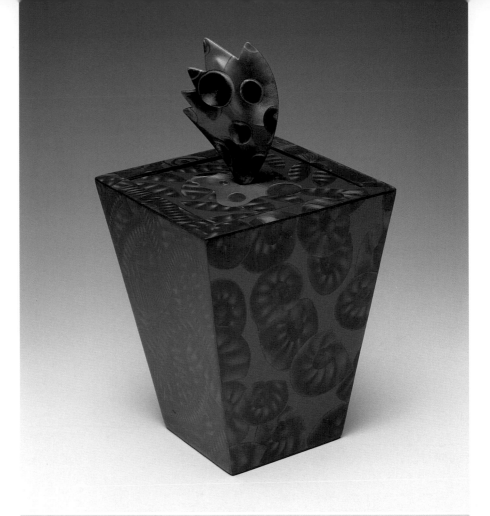

CAROL SIMMONS
This dazzling butterfly by artist Carol Simmons features a number of chatoyant colors.

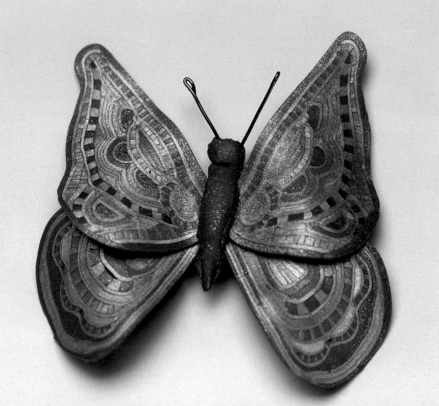

CREATING A CHATOYANT SNAIL

THIS SIMPLE MICA SHIFT snail is, in fact, a small cane. In her work, many of Pier Voulkos's special effects begin with a cylinder. To be honest, I couldn't tell you much more about it, but I know about Mike Buesseler's mica shift technique, in which he slices away at the sides of a cylinder. So, by taking a bit of information from Pier and Mike, I was able to make a chatoyant "snail," which I call "When Pier Met Mike."

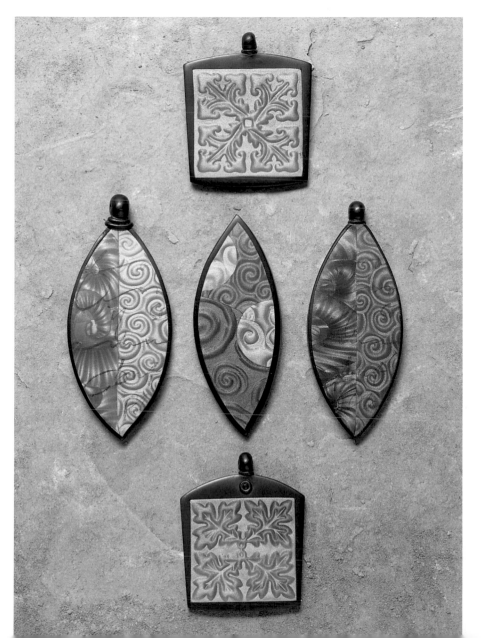

DONNA KATO
I used the rubber stamping technique (see page 66) and the chatoyant snail technique to create these pieces. Although the stamped patterns appear to be three-dimensional, they are actually smooth.

1 Begin by folding and rolling a sheet of clay at least twenty times. From one edge, roll the sheet up tightly and then roll to smooth. Trim the cylinder ends and stand the cylinder up on one end. Make four cuts from the sides of the cylinder to create a standing square.

2 Lay the square piece on its side, then roll it to restore the rounded, cylindrical shape. Working in only one direction, roll the clay; then lift your hand, reposition the clay, and roll again. As you roll, you'll see the cylinder twisting. Apply pressure at one end to form a tapered, striped spear. Continue rolling and twisting.

3 To make the snail, begin by curling the tapered end of the snake and wrapping the large end around it. Stand the snail up and slice away from both sides. As you cut, lay the pieces before you. You'll see that as you near the midpoint of the snail, the chatoyant effect begins to concentrate, becoming a single bright line.

4 Place a few of the slices that do not exhibit the best chatoyancy onto another sheet of metallic clay. Roll them in with an acrylic brayer or rod. Continue placing slices on the sheet, saving the best slices for last. Roll in all directions so that the slices spread evenly.

5 This finished sheet can now be used to cover any form, such as the box and watch case on page 58, or cut out to create a focal piece for a pendant.

DONNA KATO

An alternative to the snail is a simple tapered shape. To create this effect, do not curl the twisted and tapered clay. Lay it out and cut from its side. Lay the piece on the flat side and cut again. Continue, rotating the piece onto the next flat side as you cut thin pieces. Follow the instructions above to cover a sheet of clay with the slices. I used this technique to make this purse.

> **TIP**
>
> To create even more subtle color variations, you can begin with a Skinner Blend sheet (see page 55) of metallic colors, then follow the steps above, rolling the sheet up from one color edge to the other, to create a chatoyant snail.

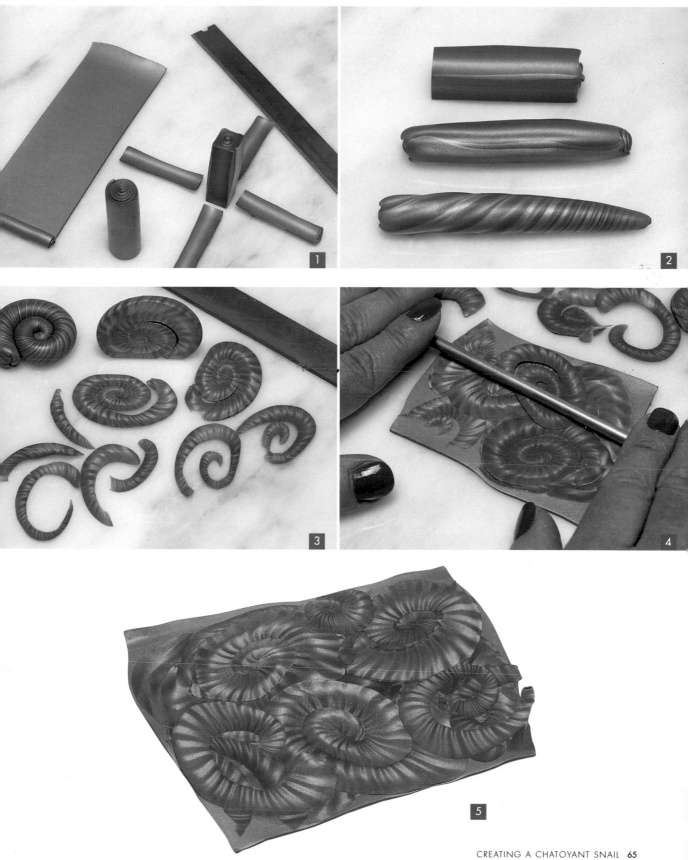

RUBBER STAMPING TECHNIQUE

THIS VERY SIMPLE mica shift technique utilizes deep-cut rubber stamps. Pressing a stamp into a sheet of polymer clay forces the metallic particles out of alignment. The raised clay is then sliced away and you are left with the illusion of three-dimensionality in the clay. (See page 103 for more information about working with rubber stamps.)

1 Fold and roll some metallic clay through the thickest setting of a pasta machine at least twenty times. Follow steps 1 and 2 on page 105 to stamp an impression onto the clay.

Lightly press the back of the impressed clay to a nonporous surface, such as a ceramic tile or piece of marble. Using a clay blade, arc the blade and slice off the raised part of the impression. It is not necessary to achieve this with a single cut; work slowly, slicing off a little bit at a time.

2 Continue cutting until the surface of the impressed clay is flat. Roll lightly across the clay with an acrylic rod to smooth the surface further. You may be tempted to roll the sheet through the pasta machine, but that would distort the mica shift patterns, so be patient and roll with the rod. The example on the left shows the clay after the raised areas have been sliced away; the example on the right shows the clay after it has been smoothed with the acrylic rod and cured.

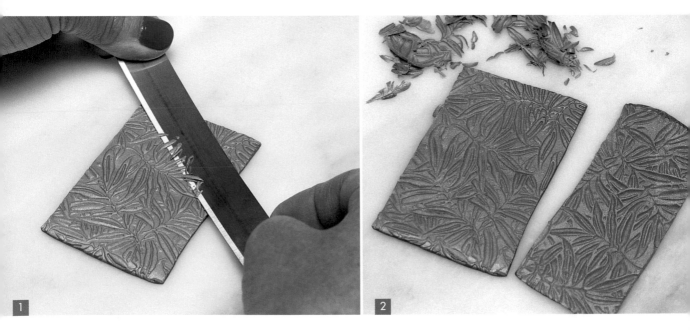

1

2

Mica Shift Cuff Bracelet

FOR THIS BRACELET, several sheets of different colors of metallic clay are prepared with the rubber stamping technique, then pieced together for a jigsaw puzzle–like pattern. You can follow my design or create your own. To construct this bracelet, you'll need a heavy brass cuff bracelet. This form is a temporary armature and will be removed.

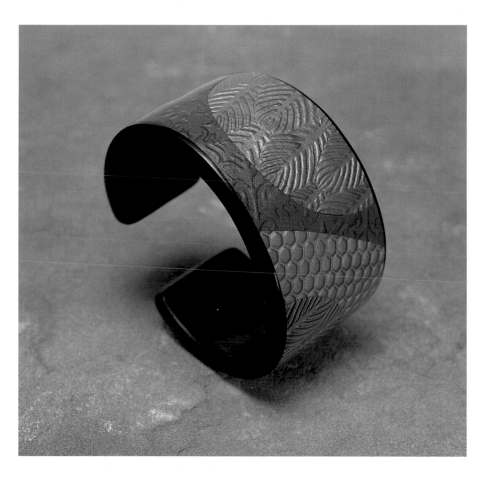

TO MAKE ONE CUFF BRACELET, YOU WILL NEED:

Heavy brass cuff bracelet

Gridded quilting plastic

Pasta machine

Black polymer clay

Three shades of metallic polymer clay

Knitting needle or other blunt, pointed tool

Needle tool

Brass tube

Scalpel

14- or 16-gauge wire

Wire cutters

Translucent clay

Rubber stamps

Polymer clay blade

Acrylic rod

Large round cutter

Coarse- and fine-grit sanding sponges

Kato Clear Medium

400- and 600-grit wet/dry sandpapers

Piece of polar fleece or denim

1 Bracelet template: Measure the circumference of the cuff from opening to opening. Cut a strip of paper the length and the width you'd like the bracelet to be at its widest point. Fold the paper in half lengthwise and cut an arc that is thin at the ends and peaks at the fold. Open the paper and trace the cut side onto quilting plastic. Turn it over and draw the other side. Cut out the plastic.

Channel template: Cut a simple strip that is 1/2 inch narrower than the width of the bracelet template at the ends. Cut notches in the center of the ends of each piece. These will make it easier to center the templates later in the project.

Roll a sheet of black clay through the thickest setting of the pasta machine.

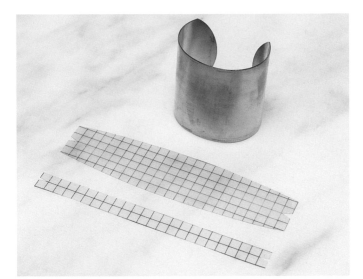

2 Lay the channel strip on the sheet of clay, and with a blunt but pointed tool (like a knitting needle) lightly score both sides of the channel template. Continue scoring to deepen the channels. The goal is to score deeply enough for the wire to lie completely inside the channels. With a knitting needle or needle tool, make an indentation in the notches. Remove the template and roll with a knitting needle or brass tube to smooth the channels.

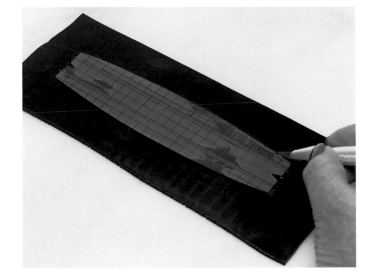

3 Lay the bracelet template on the clay, matching the notches in the template with the indent in the clay. With a scalpel, cut out the bracelet shape.

Wrap the cut and scored clay, channels up, around the brass bracelet form. Make sure the clay is sticking to the form. Bake this clay on the cuff for the full curing time recommended by the manufacturer. I baked mine for a half hour at 300°F, which is longer than the recommended time.

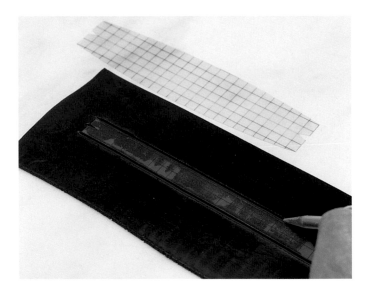

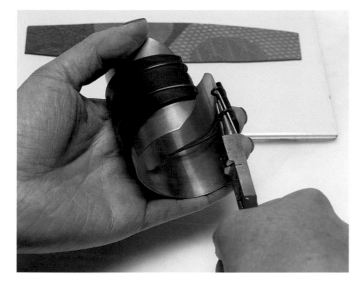

4 When the clay is cool, lay a piece of wire into each channel, bending the ends into the opening of the brass cuff. Tighten the wire by bending it with pliers. You want the wire to be snug, not loose. Do *not* cut the wires yet!

5 If the wire is not completely submerged in the channels, you'll need to add a thin sheet of clay over the bracelet to even out the surface. The thickness depends on how high the wire is above the surface of the cured clay. Place the thin sheet on the bracelet. Trim the excess clay with a polymer clay blade. Roll the entire surface of the clay against your work surface. The surface should be perfectly flat.

TIP

If the additional layer of polymer clay is not flat, remove the clay, roll a thicker sheet, and repeat the process.

6 To create the decorative layer, begin by mixing three shades of metallic clays. Remember to add at least one-quarter translucent clay to pure metallic-colored clay. (You can also use packaged metallic clay.) Roll each piece through a medium thickness of your pasta machine.

Impress textures into the clay and shave off the raised parts of each sheet. With an acrylic rod, roll each sheet smooth. They should be the same thickness. Lay one sheet on top of another. Do not press them together. Arc a blade and cut through both sheets. Remove the "scraps" from the two sheets. Press the sheets together.

7 Select a cutter, then cut and remove a shape from the base sheet. Using the same cutter, cut a piece from the third sheet and place it in the hole. Repeat this step for the other side of the base sheet. Roll the assembled sheet smooth with an acrylic rod to join all pieces of clay.

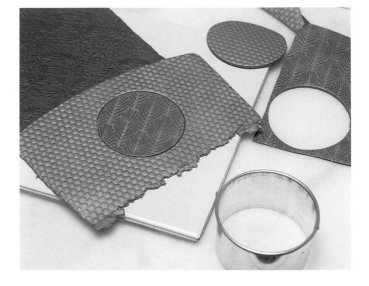

8 Position the original bracelet template on the assembled sheet. This template is now too small to cover the clay on the bracelet form; the additional layers of clay have increased the cuff diameter and slightly increased the width required to cover the clay on the bracelet form. For this reason, add ½ inch at each end of the template and approximately ¼ inch to the width when you cut the piece.

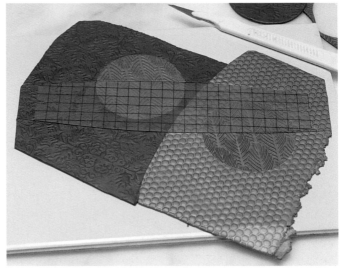

9 Slide a blade beneath the cut decorative layer to remove it from the tile. Place it onto the clay on the cuff. With a blade, trim away excess clay. Press the sheet to eliminate any air pockets. Bake for 15 minutes at 300°F.

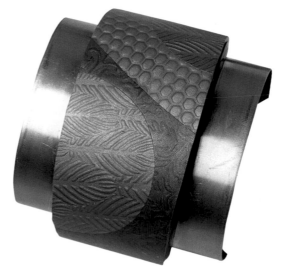

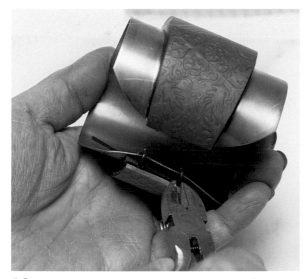

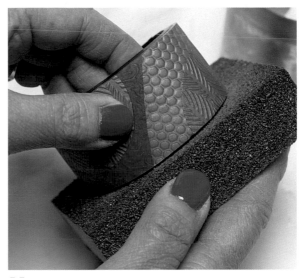

10 When the clay is cold, cut the wires as shown and remove the clay from the brass cuff.

11 Against a coarse-grit sanding sponge, sand all sides and clay at the cuff opening.

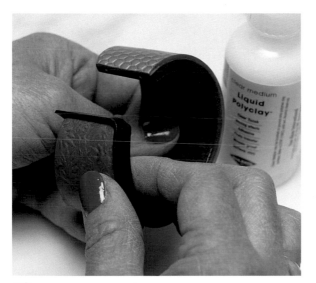

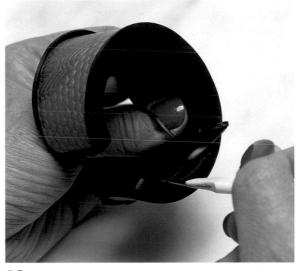

12 Apply a light coat of Kato Clear Medium to the sanded edges of the cuff. Roll a sheet of black clay through a medium-thin setting on the pasta machine and cut several long strips (wide enough to cover the cuff edge). Beginning at an opening, press the strip clay to the edge. Wrap it around a corner, then ease it around. Inspect the edging, making certain that it is sticking well to the cuff.

13 With a scalpel, trim any excess clay away from the inside and outside of the cuff. Bake for a final time for 15 minutes at 300°F.

Sand the outside of the bracelet and the edges with a fine-grit sanding block. Follow with wet sanding, first with 400- and then 600-grit wet/dry sandpaper. Sand inside and outside the cuff. Buff on polar fleece or worn denim for a satin sheen.

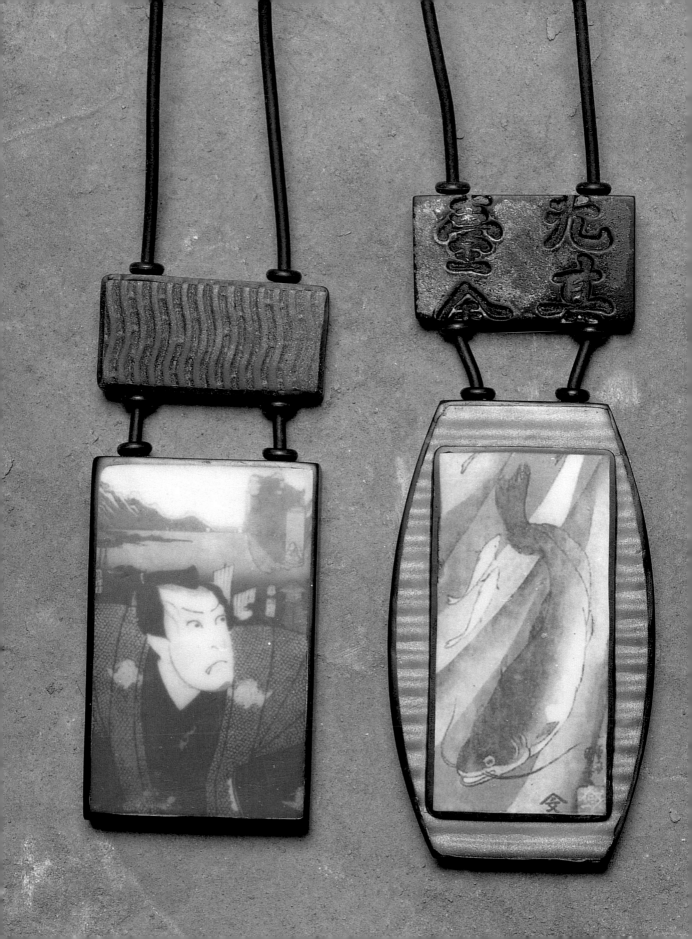

TRANSFERRING IMAGES ONTO POLYMER CLAY

Making transfers was always an uneasy proposition for me. There are so many variables, beginning with the type of transfer. Toner-based? Lazertran? Inkjet? Each type requires a different method to successfully complete a transfer. Special thanks to Jacqueline Lee, who showed me the simplest way to transfer a toner image, and to Gail Ritchey and Michelle Ross, who enlightened me about inkjet transfers. As you try these various methods, you might wonder why you need so many options. Why not simply choose one and leave it at that? The answer lies in your ultimate use of the transfer. In this chapter, you'll find an image-transfer method to fit any situation.

DIRECT TONER COPY TRANSFERS

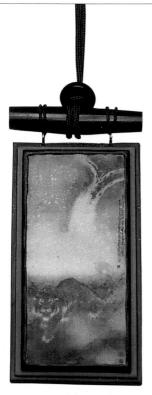

COLOR TONER COPIES need to be made on a toner-based copier, like the one at your local copy store, not printed on your inkjet printer at home. (See page 86 for techniques and projects that use inkjet printers.) At one time, toner copiers seemed to be relegated to professional copying outlets and were financially out of reach for most people to own, but recently, relatively inexpensive black-and-white and color toner copiers have been introduced into the home market.

Before printing many pages, print one and test it. If the transfer is successful, you will know that the toner in that particular machine is suitable for polymer clay. Keep in mind that for the image to read correctly, it must be reversed. This is especially important for images that include text. As these transfers are not opaque, the best results are achieved by transferring onto light-colored clay.

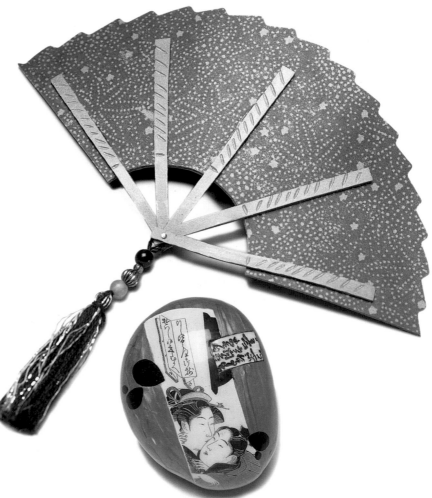

ABOVE: JACQUELINE LEE
Image transfer master Jacqueline Lee used a toner transfer to create this Asian-influenced pendant.

TOP RIGHT: ELISE WINTERS
The delicate pattern on this fan was created with a toner transfer.

BOTTOM RIGHT: KYLE INO
Artist Kyle Ino covered an actual rock with polymer clay, then transferred an image to the clay.

There are many methods for releasing toner, and thereby transferring images, onto clay. Gin and isopropyl alcohol will soften the toner ink and, once softened, merge the ink to the clay. Although others successfully use those methods, I have not had much success with either gin or alcohol. It was not until Jacqueline Lee showed me her method of transferring that I was able to achieve sharp, clear toner transfers on a consistent basis. Her secret ingredient is water!

1 Copy an image on plain copy paper on a toner-based copier. I used a black-and-white image, but the process is the same for a color image. Cut and trim the paper image, leaving a narrow border. Roll a sheet of light-colored clay and place it on a tile. Lay the image on the clay and burnish with a bone folder or the back of a spoon.

2 Lightly spray the back of the paper with water and gently rub the paper to remove it from the clay. Continue wetting and rubbing the paper until all traces of it have been removed, leaving the image on the clay. There should be no traces of paper on the ink. As you get close to the ink, use a lighter touch.

3 This photo shows the completed toner copy transfer. To remove the clay from the tile, spray a polymer clay blade with water and slide the blade beneath the clay. The toner ink will become sticky over time, so use these transferred pieces quickly.

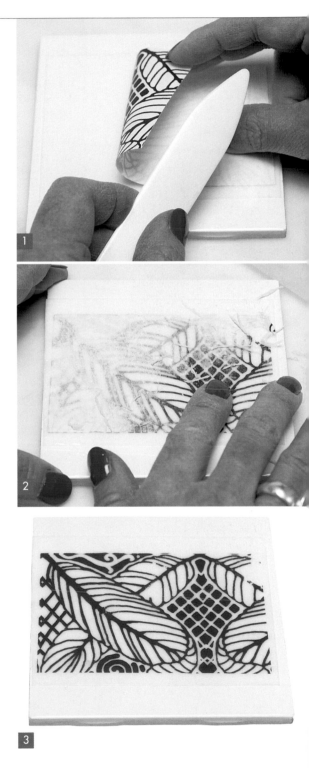

TIP
If there are areas on your transfer that have rubbed off (as in this example), it may be caused by insufficient burnishing before spraying with water or rubbing too vigorously to remove the paper backing. These imperfections are not necessarily undesirable. You may feel they add character to the piece.

Inro Box with Toner Transfer

**TO MAKE ONE
INRO BOX, YOU
WILL NEED:**

Tall cylindrical shape
 cutter

Black clay

Pasta machine

Polymer clay blade

Deli paper

Rounded tool, such as
 the end of a
 paintbrush

Image copied with a
 toner-based copier

Colored clay

Polyester batting

Repel Gel

Brush

Clay gun

Kato Clear Medium

Bamboo skewer

Buna cord

O-rings

Hand drill

Cyanoacrylate (CA)
 glue

INRO BOXES come from Japanese traditions. They were strung on cord and hung from an obi (thick waistband). They were frequently carved or painted, or both, and a netsuke (decorative bead) served as a counterweight. Our inro box features a direct toner transfer. This is the first of two methods shown in this book for making an inro box. To compare them, see the other method on page 125. This inro box is made using a two-wall construction: The first layer is the inside of the box, and the second is the decorative layer. I've used a tall shape cutter as the structure around which to build the box.

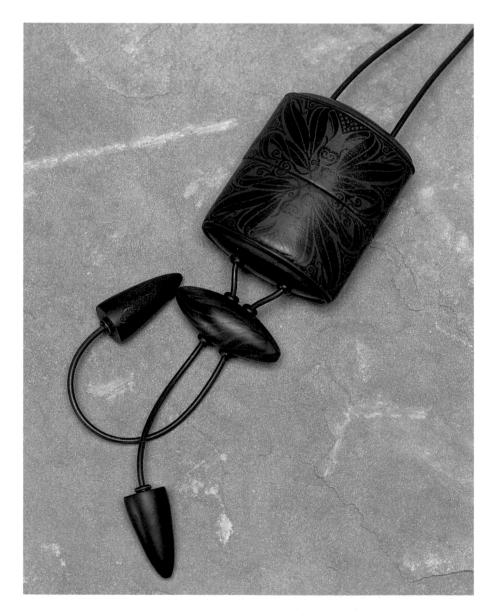

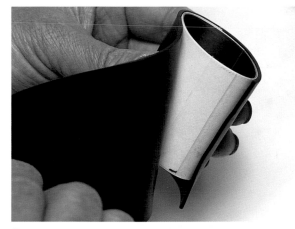

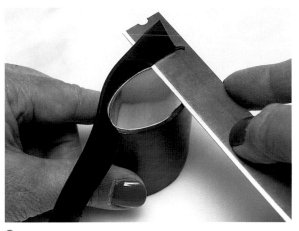

1 Cut a strip of paper wide enough and long enough to wrap the sides of the cutter. Secure the ends of the paper around the cutter with tape. You are now ready to begin making your clay box.

Roll a sheet of black clay through a medium setting of a pasta machine. Wrap the form with the black sheet, making a butt joint and smoothing the joint with your fingers.

2 Trim the top and bottom with a polymer clay blade and remove excess clay.

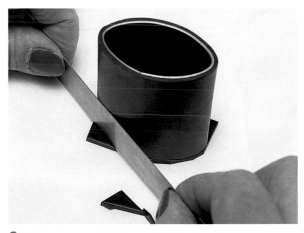

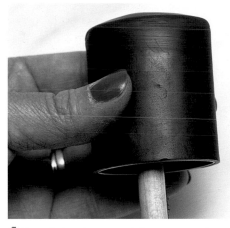

3 Roll a medium thick sheet of black clay. Place it on a sheet of deli paper. Place the wrapped form on the sheet. With a blade, cut around the bottom of the form. Remove the cut piece and place it on the bottom of the clay-covered cutter. To round the bottom, press the perimeter of the cutout with your fingers. This will force the clay to round up.

4 Smooth the clay around the cut out to the sides of the inro. Insert a rounded tool, such as the end of a paintbrush, into the box and gently stroke inside to further round the bottom.

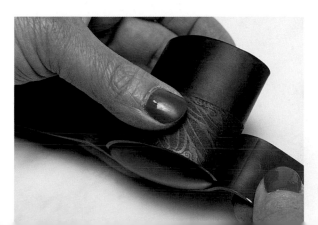

5 Make a toner transfer onto a medium-thick sheet of clay. Here I've used a deep red. This sheet must be as tall as the inro box and long enough to wrap around. I made two transfers so that the pattern would be centered on the front and the back. This means that the pattern will be spliced at the sides of the inro. Whether you use one piece to wrap all the way around or use a separate piece for the front and back, cut the pieces in half lengthwise to make strips that will cover first the bottom and then the top half of the box.

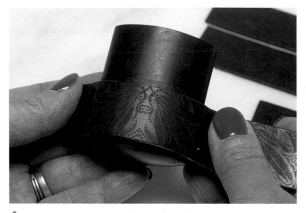

6 Center one strip on the front of the box at the bottom, then cut the pattern sheet at the sides of the inro. (If you used one piece in the first place, you might only need to wrap around the entire box and trim at one side or the back of the piece.)

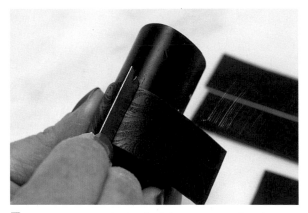

7 Repeat, covering the back of the inro. Press the clay from the back gently against the cut edge of the front clay. This will transfer a mark. Cut at that mark and the pieces will join perfectly. Smooth the seams at the sides of the box.

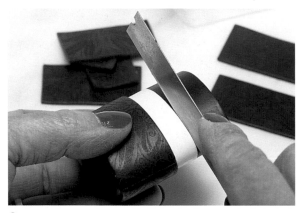

8 Cut a thin (mine was about ¹/₂ inch) strip of paper. Wrap and tape it around the box as shown. With a blade, cut the clay along the top edge of the paper. Bake for 15 minutes at 300°F.

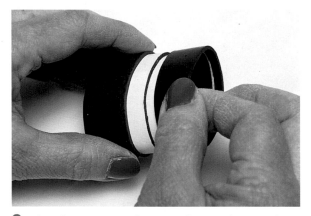

9 When the piece is cool, remove the inner box top clay from the cutter. Do not remove the paper! You might have to recut the clay with a scalpel above the paper to get it off.

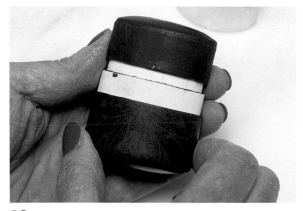

10 Follow step 3 to make a rounded top. Remove the cutter, leaving the paper in the clay. The paper will help secure the top when you add the decorative layer. Loosely fill the box with batting. Gently place the top back over the paper.

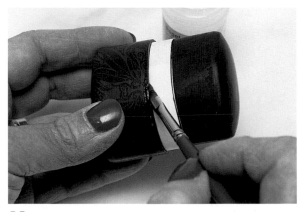

11 Brush Repel Gel on the lip of the cured clay and onto the paper as shown.

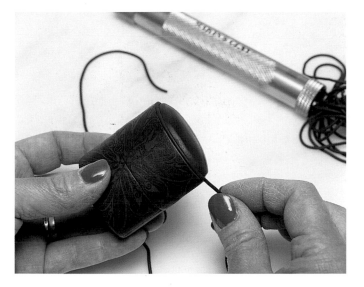

12 Wrap the top of the box with the decorative clay as in steps 6 and 7, matching the pattern on top to the bottom. Extrude thin snakes of black clay using a clay gun. Wrap a snake around the top of the box. Apply a thin coat of Kato Clear Medium and press a snake around the corresponding bottom edge. The liquid clay will improve the adhesion of the raw snake to the cured clay.

Nest the box in loose batting. I usually place the batting in an aluminum box to make what's called a "sagger" box. Set the box aside.

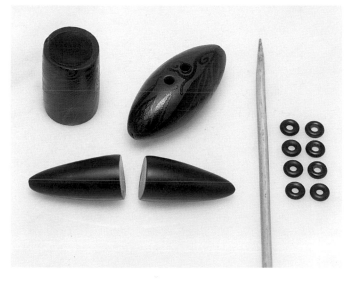

13 To make a closure, roll a cylinder of scrap clay. Wrap it with a piece of the decorative clay and close the ends and reshape to make an almond shape. Roll an almond shape of black clay, cut it in half. These are the cord ends. With a bamboo skewer, drill two holes in the decorative piece and drill halfway into the center of each of the cord ends.

Bake the box, closure, and cord ends for 15 minutes at 300°F. When the box is cool, remove the paper from the inside and clean it with soapy water.

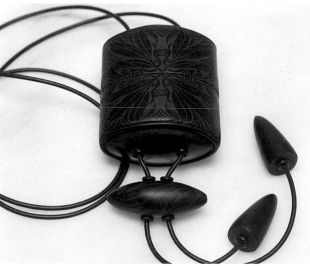

14 With a hand drill, drill two holes in the top and two holes in the bottom of the inro box. Thread the ends of the buna through the holes in the top of the box and down through the holes in the bottom of the box. Determine where you want the inro to hang. Slide O-rings up to the bottom of the box and glue them to the cord and the bottom of the box. Determine where you want the decorative bead to be placed. Glue O-rings beneath the bead to the cord and the bead. Finish by gluing the cord ends into the black cones.

Curved Pendant with Toner Transfer

TO MAKE ONE PENDANT, YOU WILL NEED:

Image copied with a toner-based copier

White polymer clay

Black polymer clay

Pasta machine

Polymer clay blade

Curved armature, such as a flask

Deli paper

Gold foil

Square shape cutter

Coarse- and medium-grit sanding sponges

THIS PROJECT FEATURES a transfer of a color toner copy as the focal point. As you will be using the direct toner transfer method, the image must be reversed when copied if it contains text. Constructing the pendant over a metal flask creates a gentle curve that adds subtle interest to this simple design.

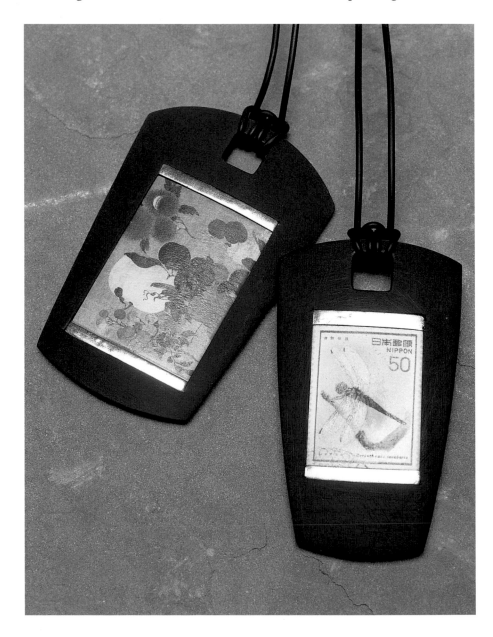

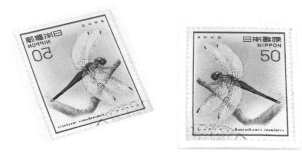

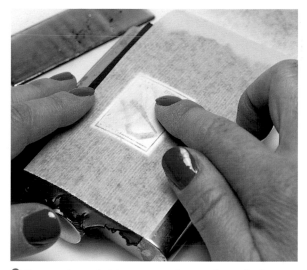

1 Make an image transfer onto a medium thin sheet of white polymer clay using the method described on page 74 for direct toner transfers. With a polymer clay blade, trim the four sides of the clay transfer.

Roll a sheet of black clay through a medium setting of a pasta machine. Place the clay transfer on the sheet. Place both sheets on a curved armature, such as a flask.

2 Place a sheet of deli paper on the transfer and rub to make sure there is no air between the clay and the flask. Roll another sheet of black clay through a medium setting of the pasta machine. Transfer gold foil to the clay (see page 34).

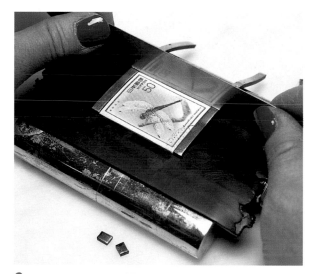

3 Cut two thin strips of foil-covered clay. Place one on top of the clay transfer and one along the bottom edge. With the blade, cut off the excess, cutting only through the foiled clay, not the black clay base.

4 Roll a sheet of black clay through the thickest setting of the pasta machine. Cut four strips: Two strips will be placed next to the top and bottom of the transfer and two will be placed at the sides of the transfer. Turn each strip over to the sharp-edged sides before placing. Press one strip along one side. Place one next to the opposite side. Trim away the excess clay from the black strips. Lay the remaining two strips along the top and bottom of the transfer. With your fingers, smooth the seams so they are not visible.

5 Spray the blade with water and cut the sides, top, and bottom into your desired shape.

6 Using a square shape cutter, cut a square in the black clay above the transfer. Remove the clay cutout. Bake the clay and the flask for 20 minutes at 300°F.

7 Sand the black clay framing the transfer with a coarse-grit sanding sponge and then a medium-grit sanding sponge. Try not to sand the foil and the transfer itself. Return the piece to the oven for an additional 5 minutes. This will matte the surface of the black clay.

LAZERTRAN TRANSFERS

THIS VERY POPULAR method of transferring images onto polymer clay is similar to the direct toner transfer method, but you copy the toner image onto Lazertran Silk instead of paper. As you will be reversing the image when you make the transfer, bear in mind that the original print must be reversed for the image and any text to read correctly.

Place the image face down on raw clay. Burnish the image lightly with a bone folder or the back of a spoon to force any air pockets from between the paper and the clay. Saturate a sponge with water and wet the back of the paper. When the paper is saturated, slowly slide the paper backing off the clay; the image will remain on the clay. Once the transfer is cured, it will not peel up.

As simple as the technique is, the difficulty lies in making the copies. Many copy shops resist copying onto paper that they are not familiar with, for fear that the paper will damage their very expensive copying machines. The paper itself is also not inexpensive.

Lazertran also makes a "decal" type paper. Decal papers do not bond to the clay and tend to peel up from the cured clay, so I would not recommend using them with polymer clay.

BELOW LEFT: DONNA KATO
This Lazertran transfer was made onto faux polymer clay bone.

BELOW CENTER: EILEEN J. LORING
Artist Eileen Loring scanned and printed playing cards, then copied them onto Lazertran Silk to create this whimsical bracelet.

BELOW RIGHT: JANIS HOLLER
Janis Holler added Swarovski crystals to her Lazertran transfer inro box.

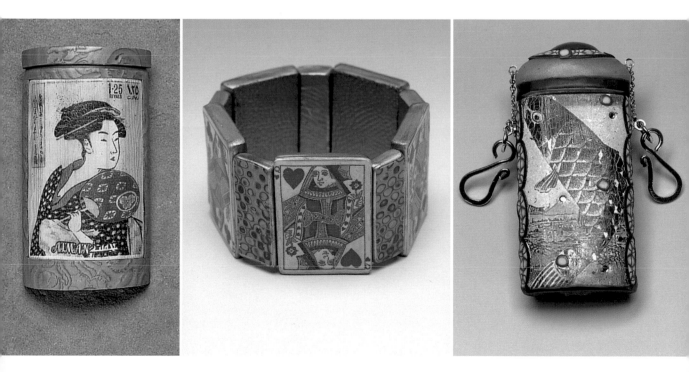

ENCASED TONER TRANSFERS

I DEVISED THIS METHOD of transferring images to solve a problem I was having in making a large vessel. Once the ink transferred onto the clay, it became sticky and difficult to handle. The solution was to transfer the image onto a very thin sheet of translucent clay and then wrap the clay-covered vessel so that the sticky ink was contained, leaving the translucent clay on the outside. This method also makes it possible to sand the cured piece. You do not have to reverse the image when making an encased toner transfer.

If you are using a black-and-white image, you can color and tint it after transferring it onto the transparent clay. There are many inks and powders that may be used. Alcohol inks from Ranger will yield a deep brilliant color. Simply brush the ink onto the clay. Perfect Pearls pigment powders can be used, but, because of the metallic quality of the powder, the color will be less intense. Try adding details with Yasutomo Gel Pens after tinting. In the demonstration below I am using Decorating Chalks from Craf-T Products that have been brushed on the transfer. Tint and color until you have achieved the desired effect.

GEORGANA GERSABECK

Artist Georgana Gersabeck made encased toner transfers then covered a cabochon and a bead with the clay.

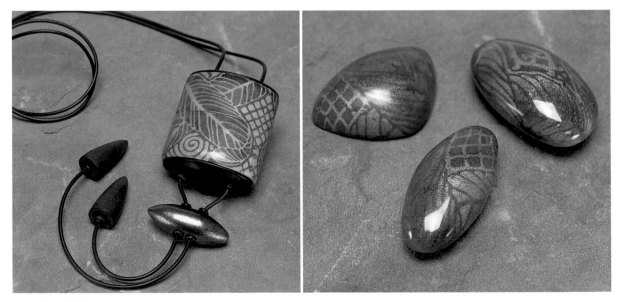

DONNA KATO

LEFT: *This inro box features an untinted encased toner transfer that was pressed to a sheet of clay covered with gold leaf.*
RIGHT: *Sheets of clay prepared with encased toner transfers may be used as you wish. Here are two beads and a cabochon that were made using a sheet similar to the one made in the instructions. They were all sanded after curing. The two beads were polished with a buffer, while the cabochon was buffed against denim.*

1 Press the thinnest possible sheet of translucent clay onto a ceramic tile. Follow the instructions on page 74 to make a black-and-white toner transfer onto the clay. If desired, add color to the image using one of the methods mentioned above.

2 Dab a light coat of Kato Clear Medium or other liquid clay onto the surface of the tinted clay. Roll a sheet of black clay through a medium-thin setting. Place the clay on a sheet of composition leaf or prepare a sheet of clay with a foil surface as described on page 34. If you use metal leaf, crackle it by rolling with an acrylic rod. The crackling exposes clay directly to the tinted clay and will therefore improve the adherence between the two sheets of clay.

3 Place the leaf/foil side of the sheet on the tinted image. Place a sheet of deli wrap on the clay and roll lightly several times with the acrylic rod.

To remove the clay from the tile, take a polymer clay blade and, pressing the sharp edge to the ceramic tile, slide the blade beneath the translucent clay. Turn the piece over and place it on a piece of deli wrap. Place another piece of deli wrap on the top side. Roll gently but firmly with the acrylic rod in all directions.

4 The piece can now be used as you like. Here, you can see the original piece on the left. The piece on the right has been rolled through the pasta machine to thin, baked, sanded with a fine-grit sanding sponge, and buffed against denim.

> **TIP**
> If the translucent polymer clay that lies on top of the transfer is too thick and mutes the image, you can remove much of that clay by sanding.

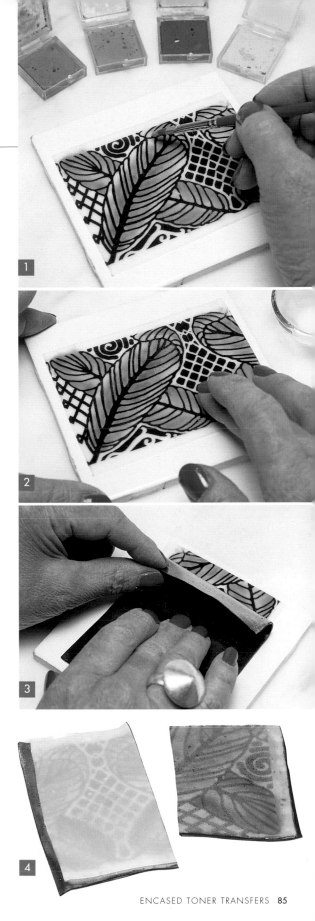

DIRECT INKJET TRANSFERS

DONNA KATO

This purse and case were created by covering a metal cigarette case and a metal lunchbox with polymer clay. Both pieces feature direct inkjet transfers in their designs.

WHEN MAKING an inkjet transfer, the specific paper you print on is very important, as not all papers will release the ink onto the clay. I use Epson Glossy Photo Paper (not Premium Photo Paper—it won't release the ink). Epson Matte Photo Paper will also work.

For inkjet transfers, a liquid clay, such as Kato Clear Medium, and heat are used as catalysts to remove the ink from the paper and transfer it to the clay. These transfers are not opaque, so you will see whatever you transfer onto; for this reason, I always transfer onto a light-colored polymer clay. Remember to reverse the image in a graphics program before you print it so that the image and text read correctly in the finished transfer.

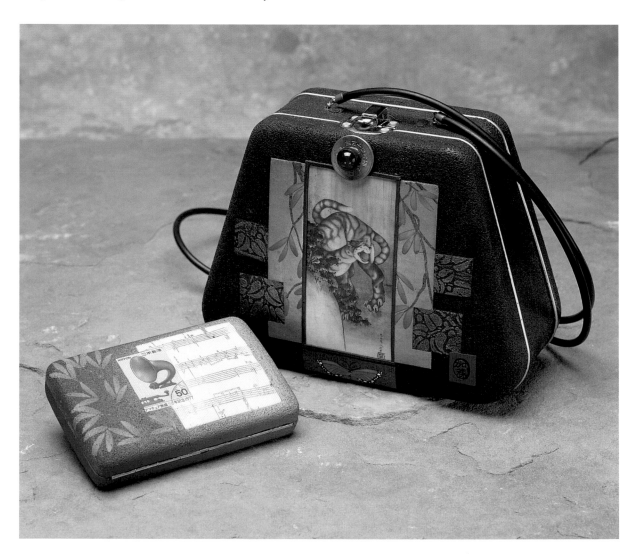

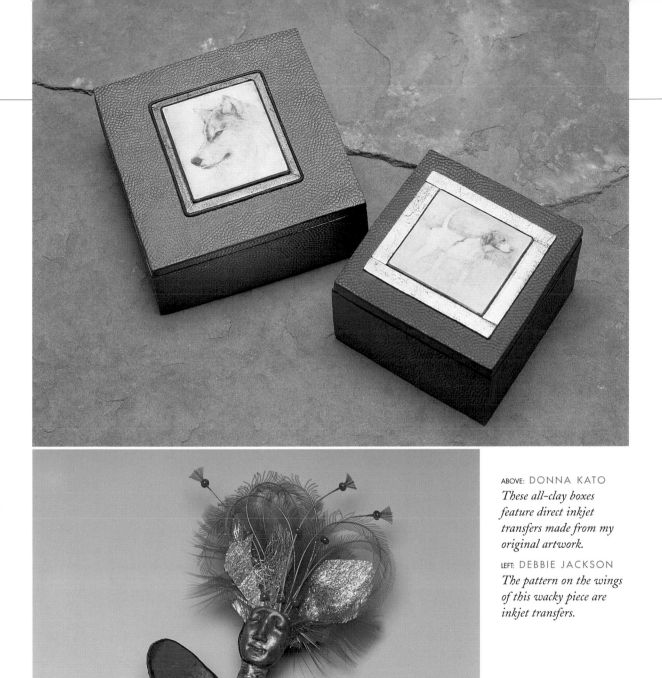

ABOVE: DONNA KATO
These all-clay boxes feature direct inkjet transfers made from my original artwork.

LEFT: DEBBIE JACKSON
The pattern on the wings of this wacky piece are inkjet transfers.

TIP

If you are simply making a transfer to be used in a flat piece, any of the methods in this chapter will work. If, however, you intend to curve and round a piece, the inkjet methods would, in some cases, not work as well as the toner methods.

1 Roll a sheet of light-colored clay through a medium-thin setting of a pasta machine. Cut out your image that has been printed on an inkjet printer, leaving a 1/4-inch border around. Squeeze Kato Clear Medium onto the image and smear it over the entire image with your fingers.

2 Lay the image onto the clay, face down. With a blade, cut away the excess clay from around the paper. (I have marked an X on the paper so you can see which side is paper and which is clay.)

3 Fold a sheet of deli paper in half and then place the fold between the rollers of the pasta machine. The machine should be at the same setting as it was in step 1. Place the clay and the image in the fold of the paper and roll *slowly* through. Rolling slowly will minimize the chances that the clay will wrinkle.

4 Open the paper and trim away the excess clay with a polymer clay blade. Peel the deli paper from the clay. If the paper is stuck to the clay, spray the back of the deli paper. The water will be absorbed by the paper, and the paper will easily release from the clay. Bake the clay and paper for 20 minutes at 300°F.

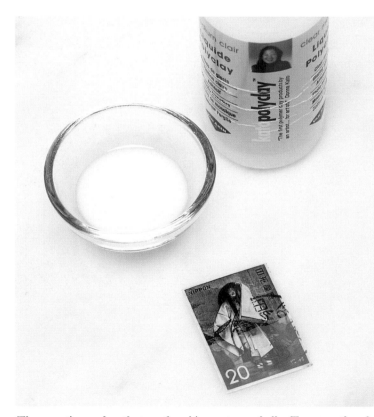

There are times when the transferred image turns chalky. To restore the color, just dab liquid polymer clay onto the transfer and bake for 10 minutes. The color intensity will return, as you can see on the top half of the image.

5 With sharp scissors, trim the four sides of the transfer, cutting through both clay and paper.

6 Drop the transfer in water and wait 15 minutes. Starting with one corner, gently pull the paper from the clay. If it is not easy to remove, drop the transfer back in the water for a few minutes; the paper should lift easily from the clay. Gently rub any paper from the wet image.

7 Here you can see the original inkjet image on paper on the left. In the center is the paper after it has been transferred and removed from the clay. The piece on the right is the actual transfer on the clay. The white spot in the lower right corner indicates that contact was not made between the clay and the image on paper or that there was no Clear Medium in that spot.

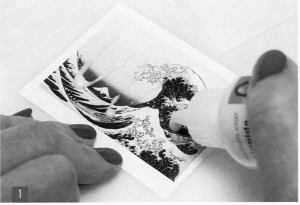

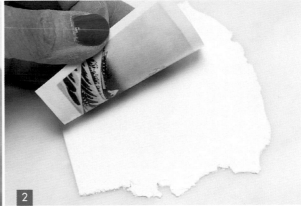

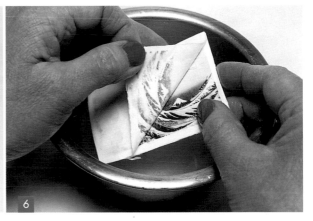

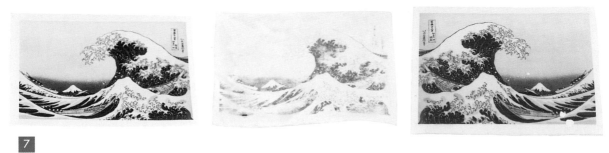

Inkjet Transfer Wave Pin

TO MAKE ONE PIN, YOU WILL NEED:

Light-colored polymer clay

Pasta machine

Image printed on inkjet printer

Kato Clear Medium

Polymer clay blade

Deli paper

Scissors

Black polymer clay

Scalpel or craft knife

Knitting needle or other smoothing tool

Ceramic tile

Fine-grit sanding block

Denim or polar fleece

Pinback

Cyanoacrylate (CA) glue

TO MAKE THIS PIN, you will first need to transfer an image printed on an inkjet printer onto light-colored polymer clay following the instructions for a direct inkjet transfer on page 86. Remember that you will have to reverse the image in a graphics program before printing or it will be reversed. This is especially important if there is text. You can make the pin any shape you want and can customize it to complement the image you choose. The irregular rectangular shape of my pin works well with this bold image from a Japanese print.

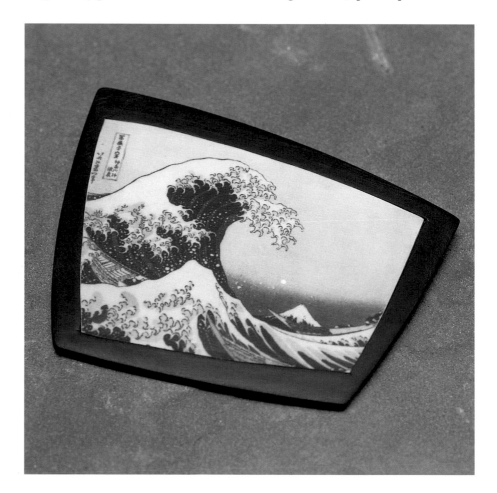

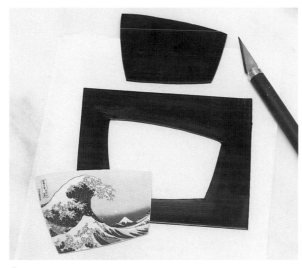

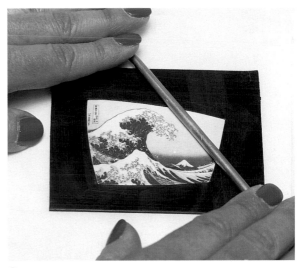

1 Follow the steps on page 86 for transferring an image onto light-colored polymer clay. With scissors, cut the transfer to the desired shape. Roll a sheet of black clay the same thickness as the transfer and place the clay on a sheet of deli paper. Place the transfer on the clay and cut around it with a scalpel or craft knife. Remove the clay cutout.

2 Place the transfer in the cutout and roll gently with a smoothing tool to even the surface and attach the clay frame to the transfer. Place a sheet of deli paper on the frame and turn the piece over. Gently peel the deli paper from the back of the piece. If the sides of the frame have pulled away, stroke the clay back in place.

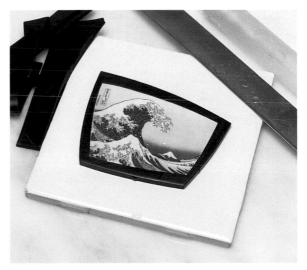

3 Roll a medium-thick sheet of black clay. Apply Clear Medium to the back of the transfer. Lay the black clay on the transfer layer. Press the layers together to expel any air between them.

4 Press a ceramic tile onto the back of the piece. Turn it over and carefully remove the deli paper. Spray a blade with water and cut out the finished shape. Bake the piece on the tile for 15 minutes at 300°F. Finish by sanding with a fine-grit sanding block and buffing against denim or polar fleece. Glue a pinback to the back of the piece.

ENCASED INKJET TRANSFERS

ABOVE: DONNA KATO
This inro box features imagery taken from a postage stamp.

BELOW: DONNA KATO
All of the individual tiles in this bracelet were made using the encased inkjet method.

FOR THIS METHOD, you transfer the image onto the thinnest possible sheet of translucent clay so that the image is visible through the clay. In this case, the image should *not* be reversed when printed; otherwise, it will read backward. One advantage of this method is that the image transferred may be sanded without risk of sanding the image itself away.

1 Print an image using an inkjet printer. Cut around the image, leaving a narrow border. Roll a sheet of translucent clay through the thinnest setting of a pasta machine. Apply a light coat of Kato Clear Medium onto the image, lay it on the translucent clay, and cut around.

Fold a sheet of deli paper in half and drop the image and the clay in the fold. Reset the pasta machine down two settings thinner. Holding a business card behind the folded deli paper, slowly begin to roll it through the pasta machine.

2 When you feel the rollers grab, open the deli paper and pull the paper and business card back as shown. Continue to roll slowly.

3 Burnish the clay over the paper image as shown with a bone folder or the back of a spoon. Spray the deli paper with water. The paper will absorb the water and release the paper from the clay.

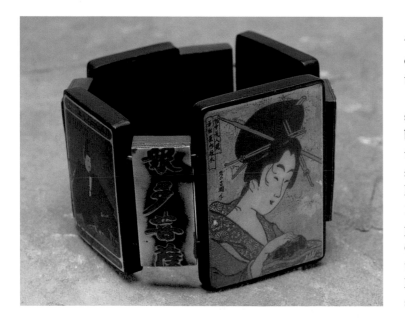

4 Slowly peel the deli paper from the clay. Trim the excess translucent clay from around the image. Bake the clay for 15 minutes at 300°F.

With sharp scissors, trim the four sides of the transfer, cutting through both clay and paper. This is to ensure that the Clear Medium is not sealing and holding the paper to the clay. Drop the transfer in water and wait for 15 minutes. From one corner, gently pull the paper away from the clay. If it does not easily release, drop it back in the water and wait; the paper should lift easily from the clay. Gently rub any paper from the wet image.

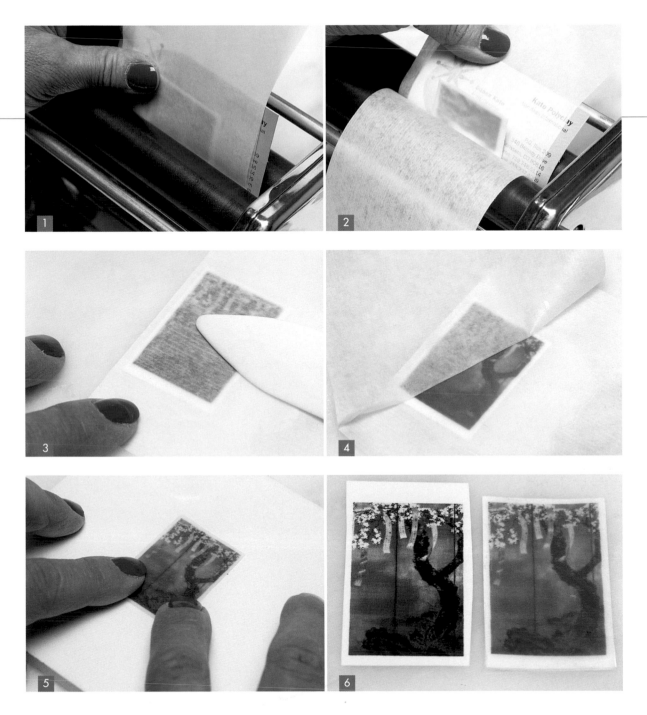

5 Apply a thin coat of Clear Medium to the side of the transfer that was in contact with the paper. This will ensure that the transfer will readily adhere to a raw clay backing. Press this side to a clean ceramic tile. Make certain there are no air pockets between the transfer and the tile and bake for 5 minutes at 300°F.

6 The transfer is now ready to be used in a project. This photo shows the original inkjet image on the left and the encased transfer on the right.

Encased Inkjet Transfer Tile Bracelet

**TO MAKE ONE
BRACELET, YOU
WILL NEED:**

Images printed with
an inkjet printer

Translucent polymer
clay

Pasta machine

Kato Clear Medium

Deli paper

Bone folder or spoon
for burnishing

Ceramic tile

Light-colored polymer
clay

Acrylic rod or knitting
needle

Polymer clay blade

Black polymer clay

Scrap clay

Gridded quilting
plastic (optional)

One brass tube
approximately
1/8 inch in diameter

Coarse-grit sanding
sponge

Fine-grit sanding
sponge

Needle tool

400- and 600-grit
wet/dry sandpapers

Elastic cord or
Powercord

Cyanoacrylate (CA)
glue

FOR THIS PROJECT, you'll be using multiple images. They need not be the same height and width, and there is no exact number of images you'll need. It all depends on the size you want the finished piece to be and the number of tiles you'll need to reach that size. I usually make many tiles and then arrange them to make the finished piece. These instructions show how to make one tile. Remember: Because this is an encased transfer, there is no need to reverse the image when printing it.

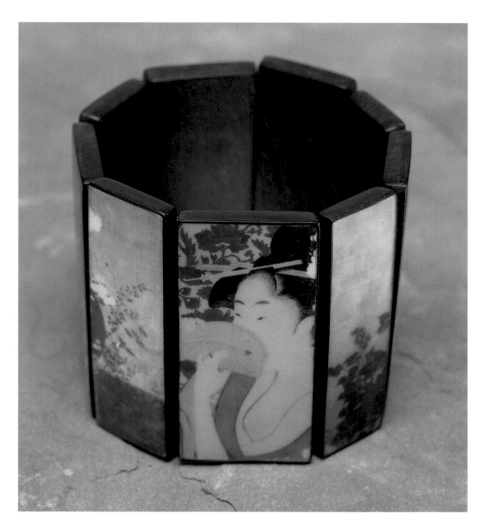

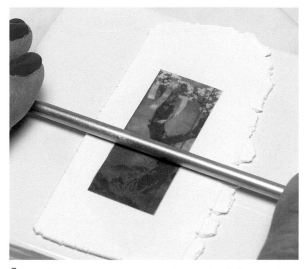

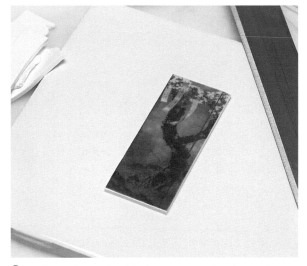

1 Transfer your images onto translucent clay following the instructions for an encased inkjet transfer on page 92. Since the transfers are translucent, they must be backed with a light-colored clay. I used white, but you could also use pearl or ecru.

Roll the backing clay through a medium setting of your pasta machine. With scissors, trim the transfer. Apply a light coat of Kato Clear Medium to the back of the transfer. Press it onto the white clay and roll over with an acrylic rod or knitting needle to force air from between the layers.

2 With a polymer clay blade, cut away the clay at the sides of the transfer. Bake the clay 10 minutes at 300°F.

Roll a sheet of black clay through a medium-thin setting of the pasta machine. Roll a sheet of scrap clay through the same setting.

3 Measure the height of the shortest tile. Divide that measurement by 3. Cut a template of this width out of gridded quilting plastic or paper. This will ensure that the holes in the tiles will be properly spaced. My tiles are very tall, so my template is ³/₄ inch wide. Use the template to cut three strips from the sheet of scrap clay.

4 Place a strip along the center of the black sheet of clay. Lay the brass tube next to one side of the scrap clay strip and lay another strip next to the tube. Repeat, placing a third scrap clay strip on the black sheet. The tubes mark the channels in the tiles. You will use these channels to string the tiles together.

5 Using the quilting plastic or a ruler, cut a straight edge perpendicular to the strips. Lightly draw a line down the center of the middle strip of scrap clay.

6 When the backed transfers are cured and cool, mark the center of each side of each piece with a marker. Apply a light coat of Clear Medium to the back of a transfer. Line up the mark on the side of the transfer with the center line on the middle strip. With a blade, cut around the transfer. Make all of your tiles in this way. Bake for 10 minutes at 300°F.

7 When the tile is cool, sand the sides with a coarse-grit sanding block. Apply a light coat of Clear Medium onto the sanded sides. Roll a thin sheet of black clay. Cut a strip and wrap it around the sides of the tile.

8 As you wrap around the tile, you'll cover the channel holes. When you cover one, take a needle tool and enter the channel from the opposite side to poke a small hole through the strip. Withdraw the needle tool and enter the hole again from the near side. Make sure you pierce the position of each of the holes. Finish wrapping and cut the strip to make a butt joint (no overlapping). Smooth the joint with your fingers.

9 With a blade, cut away excess clay from the front of the tile. Hold the blade against the surface of the front as you slide the blade around. Turn the tile around and cut the excess from the back. Bake the tiles for the last time for 15 minutes at 300°F.

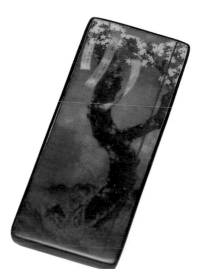

10 Finish by sanding the front, back, and sides with a fine-grit sanding block. Follow up with wet-sanding, first with 400- and then 600-grit sandpaper. Buff lightly on denim or polar fleece.

String the tiles on elastic cord or Powercord (a clear elastic cord). If necessary, enlarge the holes with a hand drill. Finish off with square knots. Onto each knot (there will be two) apply CA glue. Pull the knots back into one of the adjacent tiles.

INKJET TRANSFER ONTO LIQUID POLYMER CLAY

IN ADDITION TO transferring inkjet images on clay, you can also transfer them directly onto Kato Clear Medium or Fimo Gel. This method will ensure the maximum clarity of the image. As with all inkjet transfers, the paper on which the image is printed is important; I use either Epson Glossy Photo Paper or Epson Matte Photo Paper for this technique. In the finished piece, the image will be seen through the layers of liquid polymer clay; therefore, the image should not be reversed when printed.

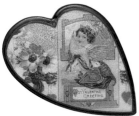

ABOVE: DONNA KATO
These three pins were made using images transferred onto Kato Clear Medium.

RIGHT: DONNA KATO
Two pendants featuring images transferred onto Kato Clear Medium.

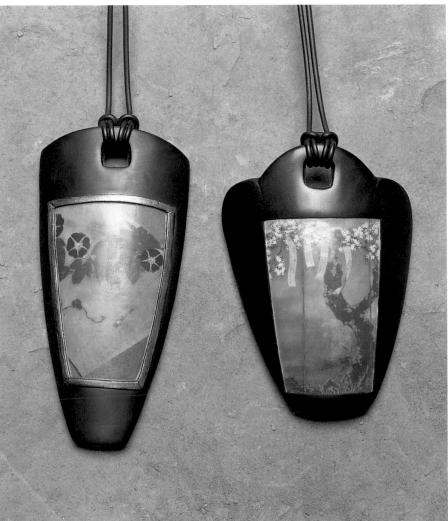

1 Cut around the image, leaving a ½-inch border. Tape the image to a ceramic tile; this will make the process easier. With a large flat brush (the flat brushes by Silverado are perfect—they do not introduce air bubbles into the medium) apply a coat of Clear Medium. Cure the image for 5 minutes at 300°F. If the medium is milky, continue to cure it until it is clear. You can also cure the piece with a heat gun as I have done.

2 When the tile and medium are cool, stroke another layer of medium on the image. Cure this layer as before. (Note: If you've used a heat gun, turn the piece over and heat the back of the paper.) Repeat these steps two to three more times. Remove the image and the medium from the tile and cut off the border.

3 Drop the image into water and wait 15 minutes. The paper should be soft and may even lift off the medium. If it does not, you'll have to roll the damp paper off the medium. Just keep wetting and rolling until all traces of paper are gone. Here, you see one transfer soaking and, in the lower right corner, a finished transfer and the paper from which it was made. As you can see, all the ink transferred to the liquid clay.

Before using the image, apply a light coat of clear medium to the ink side of the transfer and bake. When using this type of transfer, the backing clay should be a light color as a dark color will be seen beneath it. The transfer is so thin that it can be applied to a curved surface with little risk of cracking.

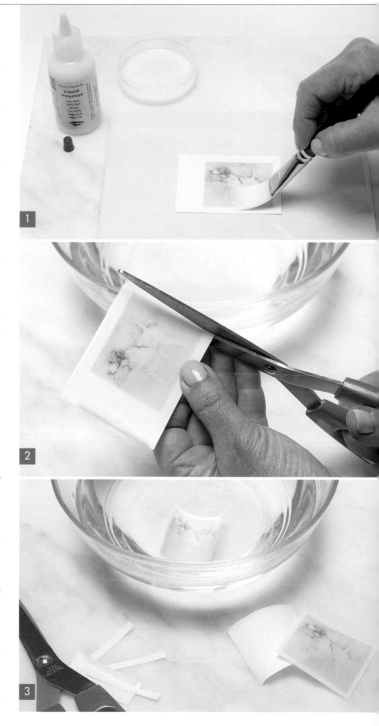

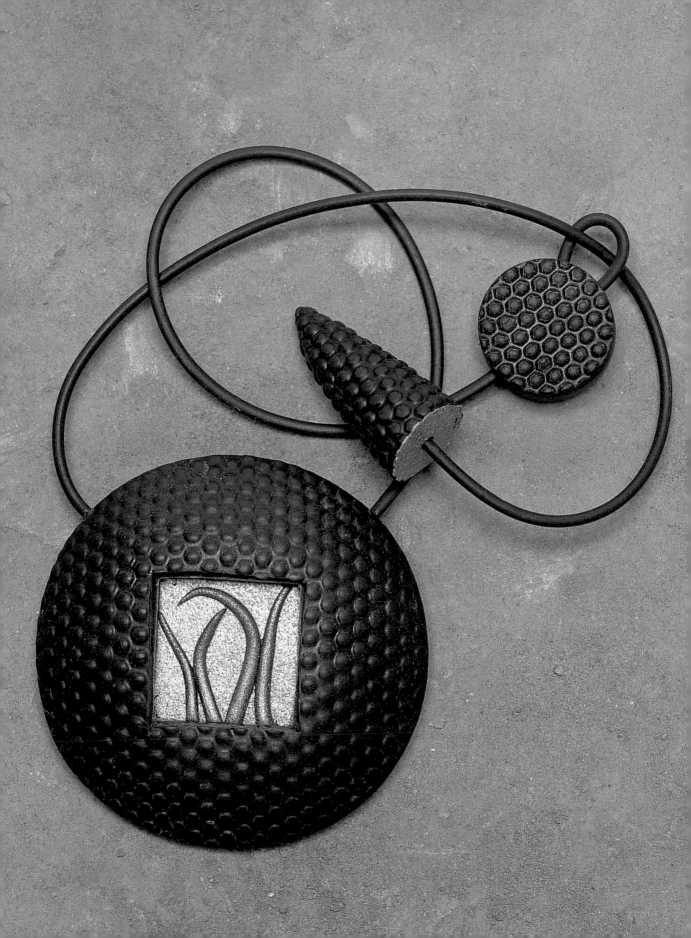

CREATING TEXTURE

An easy way to create exciting surface effects in polymer clay is by adding texture. Raw polymer clay readily accepts textures. The textures you apply to polymer clay can be deep or shallow, simple or complex. Texturizing polymer clay can be the first step in other polymer clay techniques, such as mica shift, brocade effect, and faux cloisonné, all of which are covered elsewhere in this book. This chapter covers the basics of working with rubber stamps, one of the easiest and most popular ways to add texture; creating a polymer clay stamp negative for crisper impressions; and making your own texture plates to create unique textures and patterns.

TEXTURIZING MATERIALS AND TECHNIQUES

BELOW LEFT: CATHY JOHNSTON
Artist Cathy Johnston decorated these two books with stamping, antiqued them with acrylic paint, and applied polymer clay embellishments.

BELOW RIGHT: KAREN J. SEXTON
The texture on this little gold pouch was created by impressing polymer clay with lace.

JUST ABOUT ANYTHING that has a texture can be used to add texture to clay. A light overall texture can conceal flaws in the clay surface as it adds visual interest. Texture may be achieved by simply pressing a coarse sanding sponge or dish scrubbie. Even very fine textures can be applied to polymer clay; discernable texture may be obtained from lace and skeletonized leaves.

Plastic texture plates, such as Shade-Tex texture plates, can be rolled through the pasta machine. They come in many patterns and produce clear, clean, and uniform impressions.

Rubber stamps may also be used to texturize clay, and many manufacturers produce stamps with patterns and images.

Using stamps and texture plates with raw clay requires the use of a "resist" agent to prevent clay from sticking to them and becoming embedded in the texture. Cornstarch (not baby powder or talc, both of which will leave a residue on the clay) and Armor All are just two you can use. I find that water in a small spray bottle is all you really need for most situations.

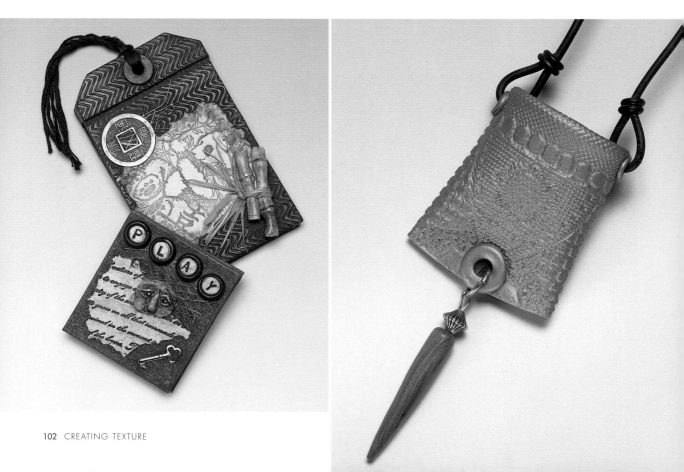

WORKING WITH RUBBER STAMPS

THERE ARE SEVERAL brands of rubber stamps manufactured to be used with polymer clay. Clearsnap markets a line of unmounted molding mats that work well with clay. I have my own line of unmounted stamps designed for polymer clay. The patterns are purposely small, making them more suitable for jewelry. Artists such as Barbara McGuire, Mari O'Dell (Polymer Clay Express), Lisa Pavelka, and Michael Strong also have their own stamp designs.

Both shallow, finely patterned stamps and deep, bold stamps will work with polymer clay. For techniques like the mica shift rubber stamping technique (see page 66) and many highlighting treatments (see page 115), bold designs yield the best end result. Remember that when you stamp polymer clay, the raised parts of the stamp design (that would ordinarily be inked) will create a depression in the clay, and the depressed parts will create raised areas in the clay.

To impart a fine texture—to the backs of jewelry pieces and for faux brocade (see page 116) and pattern overprinting effects (see page 117), for instance—shallow stamps and texture plates are preferable. When impressed and highlighted clay is rolled flat in these techniques, the shallow texture does not enlarge as it would if deeper stamps were used. Some of my favorite patterns have been pulled from laser-cut pieces of thick paper (see "Making Texture Plates from Paper" on page 106).

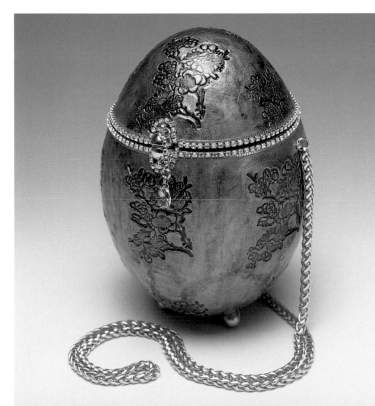

ABOVE: NAN ROCHE
Nan Roche's mokumé gané brooch illustrates the use of deep-cut text stamps.

LEFT: JACQUELYN K. HONG
Artist Jacquelyn Hong's clay-covered emu egg features stamping and highlighting techniques. (For more about highlighting textures with acrylic paint, see page 115.)

CREATING A POLYMER CLAY STAMP NEGATIVE

THE CRISPEST polymer clay texture or image is not achieved by pulling an impression from the original rubber stamp but when a polymer clay negative is used instead. In designing my own line of stamps I discovered that clay pulled from the original stamps lacked the sharpness and flat surface of the original stamp. The clay impressions had a round, soft appearance, when I really wanted the sharp edges of the original stamp, in reverse.

This occurs because the walls of the matrix plates (from which rubber stamps are made) of some stamps are not straight. If you inspected matrix plates in cross-section, from what would be the top surface of the stamp, you

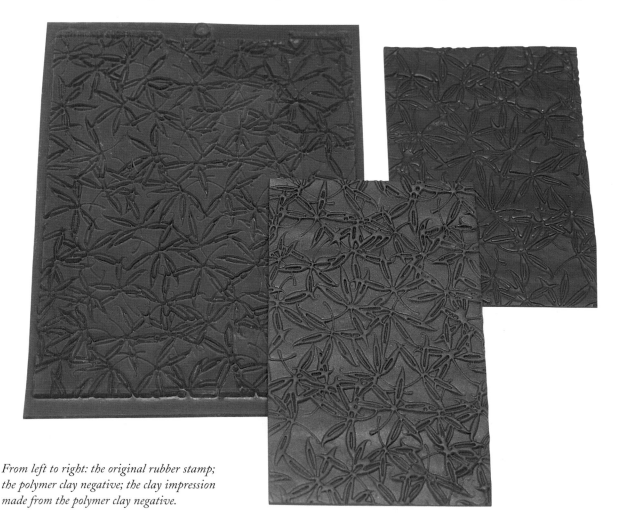

From left to right: the original rubber stamp; the polymer clay negative; the clay impression made from the polymer clay negative.

would see that the walls begin upright but, as they meet the bottom of the stamp, they curve away from the wall to the stamp bottom. The curve creates the roundness in the clay impression. There are stamps, such as those produced by Stamps Happen, that do feature straight walls, but most do not.

When you reverse the stamp with polymer clay, you are reproducing the sharp edges that appear in the top surface of the stamp, and any impressions made from these reproductions will, in kind, yield the original detail and sharpness of the stamp itself. For this reason, I reverse almost all of my stamps in polymer clay, using them instead of the rubber stamp. So, when choosing your stamp, picture how they will look as clay because that's what you'll end up with when you make and use a polymer clay negative. Note that you can't reverse text stamps; if you do, they will read backward.

1 Spray the stamp liberally with water or apply another resist agent.

2 Place the clay onto the stamp and spray the back of the clay. Roll over the clay with an acrylic rod, making sure that the rod is clean. Roll only once across the clay, bearing down on the clay as you roll.

3 Lift the polymer clay from the stamp and let it dry. Trim the sides of the clay and then bake for 1 hour. Repeat these steps to pull the raw clay positive image from the clay negative you just created.

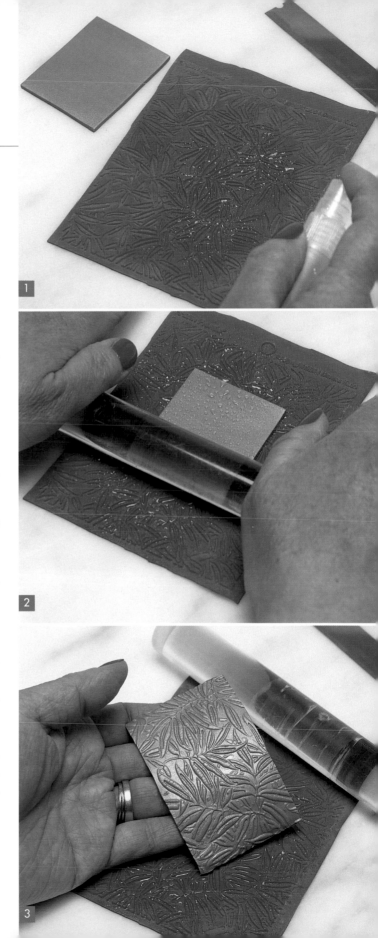

TEXTURE PLATES

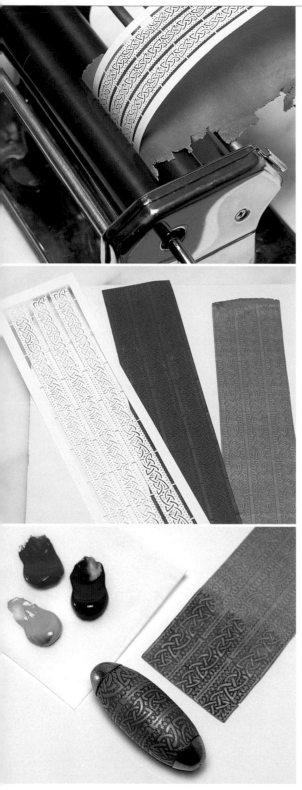

IN ADDITION TO USING purchased plastic texture plates to texturize polymer clay, you can also make your own texture plates out of polymer clay.

MAKING TEXTURE PLATES FROM PAPER

When I found these laser-cut paper designs, my heart skipped a beat! My only question was this: Was the paper thick enough to make a decent texture plate? Would the clay pulled from a plate made from a paper original be deep enough to use in faux brocade paint techniques and the like? Happily, the answer was yes, and the impressions made from these beautiful papers have become some of my favorites. Generally, I allow others to use my supplies, but this is one exception; these papers will only last so long, and in the event I lose a clay plate, I want to be able to make another from a good paper original.

To make a texture plate from paper, roll a sheet of scrap clay through a medium-thin setting of a pasta machine. Liberally dust the clay with cornstarch (in this case, water is unsuitable). Do not press the paper into the clay; we'll let the pasta machine make the impression.

Reset the pasta machine to the next thinnest setting. Roll a bit of the clay through the machine. Add the paper and roll both through. Remove the paper from the clay. Trim the sides of the clay and bake for 30 minutes at 300°F.

CREATING INCISED TEXTURE PLATES

You can also create texture plates that feature your own designs. One way is by incising lines into a sheet of clay. These lines may be shallow or deep. The leaf-shaped piece on the next page was created from a texture plate with deeply incised curves and spirals.

TOP LEFT: *Rolling the paper and the clay through the pasta machine to transfer the pattern to the clay.*
CENTER LEFT: *Here you see the original paper on the left, the cured plate in the middle, and gold clay textured with the plate on the right.*
BOTTOM LEFT: *Here is a bead made from the same gold clay, highlighted with turquoise, phthalo green, and red oxide acrylic paint.*

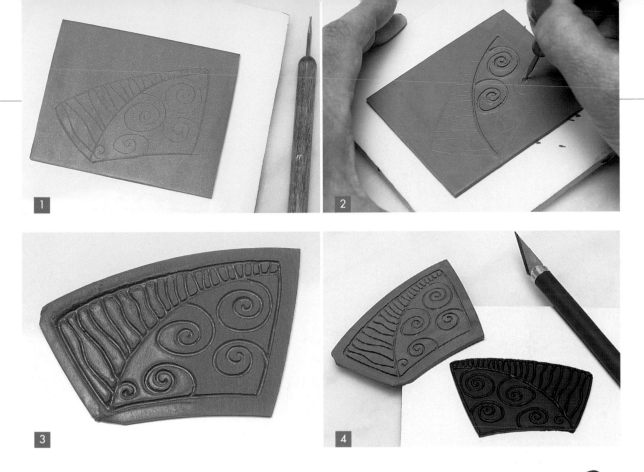

1 Roll a sheet of scrap clay through the thickest setting of a pasta machine. Press the sheet to a ceramic tile, forcing any air pockets from between the clay and the tile. With a small-diameter ball stylus, draw a pattern lightly on the surface of the clay.

2 Following the pattern, lightly incise into the clay with the ball stylus. Repeat, incising deeper and deeper into the clay. Try to incise the lines to the same depth. The ball stylus will not cleanly cut into the clay; there will be shreds of clay on the surface, so lightly roll them off the clay with your fingers. Make sure there are no bits of clay in the incised lines; they will affect the quality of the mold and the clay pulled from the mold. Bake at 300°F for 30 minutes.

3 Leave the clay on the tile and sand the surface of the clay with a coarse-grit sanding block. Here I have sanded the right half of the plate. Following the incised lines, sand with the edge of the block to remove any undercuts that might trap raw clay. You can also use a pointed metal file.

4 Here is the incised plate (left) and clay that was pressed into the plate and trimmed with a craft knife (right).

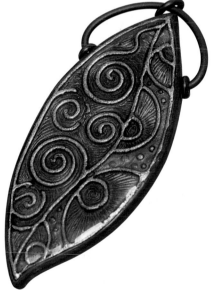

DONNA KATO

This piece was created from a texture plate I made from polymer clay with deep incised curls and lines. I tinted the finished piece with Perfect Pearls pigment powders and filled the depressions with Kato Clear Medium.

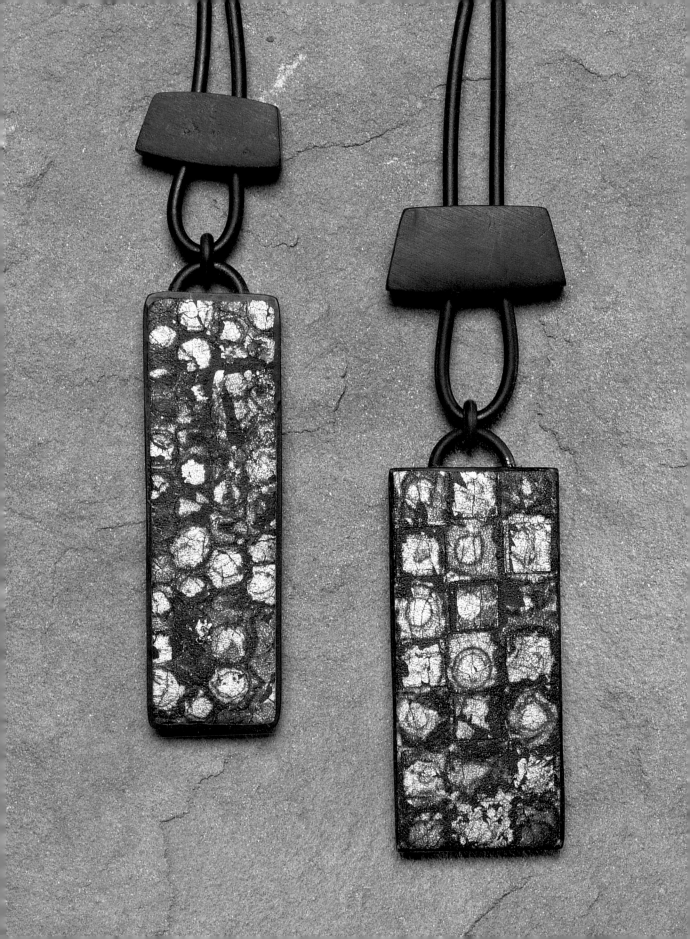

PAINTS, INKS, AND PIGMENT POWDERS

It was Elise Winters who opened the door to the potential of acrylic paint as something other than a simple means of antiquing the surface of polymer clay. Her unique approach and fantastic results inspired others to experiment, to stretch out and try dyes, airbrushing paints, and stamping inks, to name just a few. Thanks to the experimentation (and knowledge of chemistry) of Tony Aquino, even lowly tempera paint, long thought to be unusable with polymer clay, can work. In this chapter, I touch on just a few of the materials that can be used with polymer clay. Experiment! Try combining materials. I know you'll soon be making discoveries of your own.

PIGMENT POWDERS

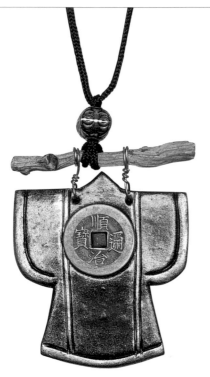

ONE OF THE MOST common materials used to enhance a raised impression in clay is mica powder. This powder also imparts a metallic sheen to the clay. There are three primary brands in the marketplace today: Pearlex by Jacquard, Julia Andrus's Perfect Pearls from Ranger, and Polished Pigments by LuminArte. Pearlex is an extremely finely ground powder, and when applied it gives the brightest metallic sheen. It is available in many colors. The downside is that the powder must be glazed after curing to prevent the powder from rubbing off. Perfect Pearls was originally manufactured for stampers. The particles are larger but resin coated. Once the powder cures on the clay, some fusion occurs, making it unnecessary to glaze. The larger particle size also reduces the mess that the finer powders create.

Pearlex and Perfect Pearls colors are both created by adding pigment to a mica base, while Polished Pigments begin with the pigment and add the mica. As a result, Polished Pigments feature the most intense, dazzling colors. This results in more concentrated Polished Pigments colors. Any of these can be used to tint liquid clays. Polished Pigments require less powder to achieve deep, intense color.

ABOVE: EMI FUKUSHIMA
Emi Fukushima used a product called Rub 'n Buff to apply a metallic finish to this kimono. Rub 'n Buff (from American Art Clay) is a mixture of carnauba wax, metallic powders, and pigments. It can be applied with your finger, like pigment powders, then buffed to a lustrous finish.

RIGHT: DONNA KATO
Here is an array of pieces "painted" with acrylic paint. The fine spindly curls are black clay on which Perfect Pearls pigment powders were applied.

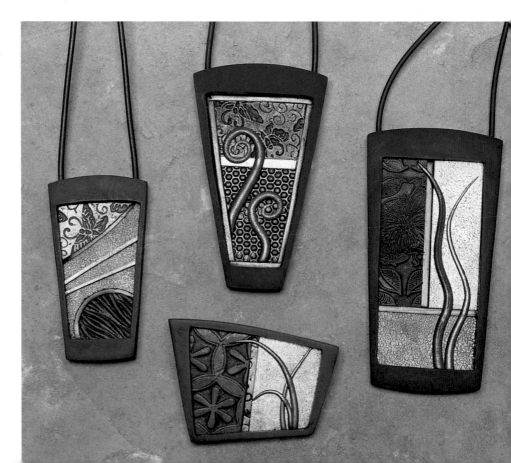

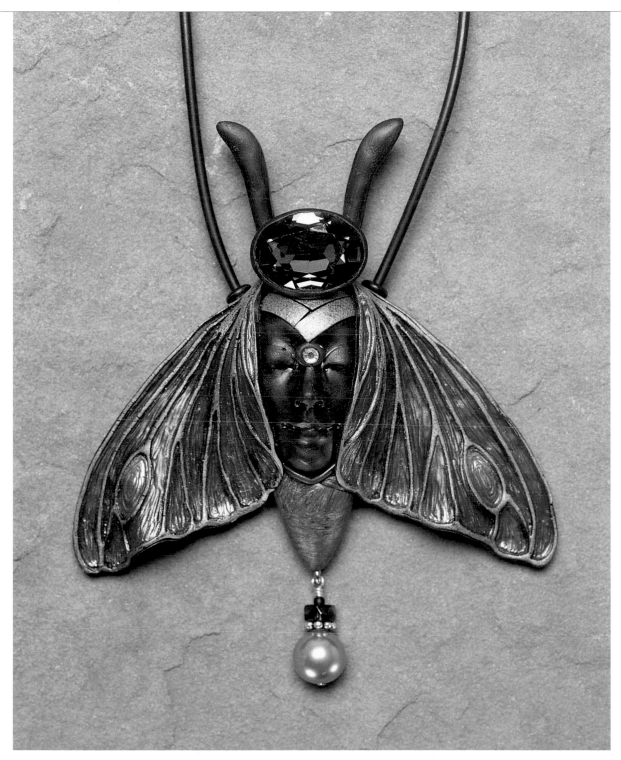

DONNA KATO
The wings of "Madame Butterfly" have been tinted with Perfect Pearls. The "cap" above her face is gold acrylic paint on black clay.

ACRYLIC PAINT

ELISE WINTERS
Artist Elise Winters was the first person I am aware of who did not use acrylic paint simply as an antiquing medium or to impart surface color. She manipulated dried paint on raw clay to create her "crazing" effects, as seen in her "Pentala" brooch.

ACRYLIC PAINT is another medium that may used to color the surface of your textured or smooth clay. I tend to use tubed acrylics, but craft-type acrylics in jars also may be used if their pigment load is heavy. Liquitex, Winsor & Newton, and Golden acrylics all perform beautifully with polymer clay. Jacquard markets a line of vibrant metallic acrylic paints under the Lumiere brand. Not only are they suitable for use on polymer clay, but they may also be used on wood, canvas, paper, and natural or synthetic fabrics. Artist Elise Winters recommends Rembrandt Paints as they have the longest "open" time—that is, they remain usable longer than other paints. There may be certain colors that are chemically unsuitable for use on polymer clay and will not dry, so before making the investment, you might consult some of the Internet chat groups on polymer clay to find out if anyone has had any negative experience with a specific color or brand.

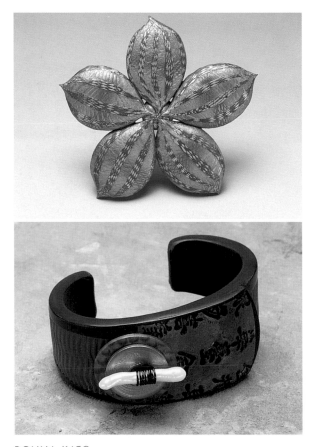

DONNA KATO
This cuff bracelet features mottled acrylic paint and highlighted text.

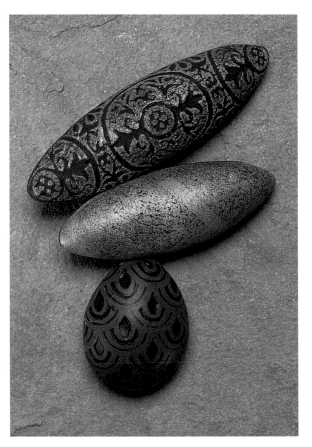

DONNA KATO
The three simple cabochons that make up this pin were embellished with acrylic paint treatments. A thick wire connects the three elements.

Application is easy: Simply open the tube and run your finger across, picking up a thin coat on your finger (do not pick up an excessive amount of paint, which will sink into any depressed parts of the piece). Dab the paint onto the clay. Paint applied in this way may require several applications. Let the paint dry between applications and gradually build up coverage. This is how I applied paint to "Madame Butterfly" on page 111.

If you wish to achieve a mottled effect, pick up another color of acrylic paint and dab it on top of the previously applied paint. Keep working in this way until you are satisfied with the effect. Note that acrylic paint dries very quickly. Sheets made using acrylic paint should be used within a week or so or the paint will peel from the surface of the raw clay and will not adhere when the clay is cured.

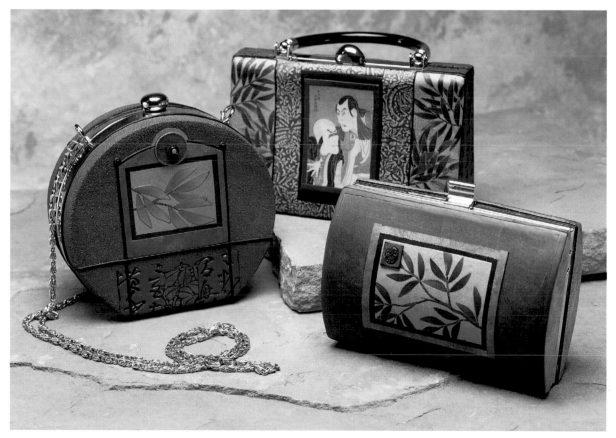

DONNA KATO

These three purses illustrate various applications of acrylic paint on clay. Highlighting can be seen in the Japanese text. The gold beneath the caned leaves is not leaf, but paint, and the patterned frame around the transferred image on the top purse was made using the brocade technique.

MAKING FAUX GOLD LEAF

Although you may use both composition metal leaf and genuine metal leaf to decorate your clay, a little gold paint can also be used to create metallic effects. One of the advantages of this faux "leaf" is that the acrylic paint adheres to the paint, whereas genuine and composition metal leaf do not form a permanent bond with clay and must be sealed after the clay is cured.

To create the look of gold leaf with acrylic paint, roll out a sheet of black clay. Dab a light coat of metallic gold paint on the clay with your fingers. When the paint is dry, apply another light coat. Apply two more coats of paint, letting the paint dry between applications.

In this photo you can see how adding successive layers of acrylic paint increases the metal leaf effect. From left to right: one coat, two coats, three coats, and four coats.

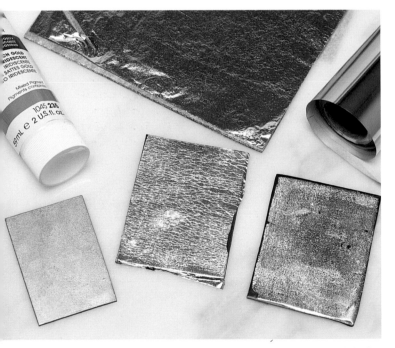

Here are three ways of making "gold" on black clay. On the left is the acrylic metal leaf. The piece in the center is made from composition gold leaf pressed to raw clay. The piece on the right is gold foil, not leaf, on clay.

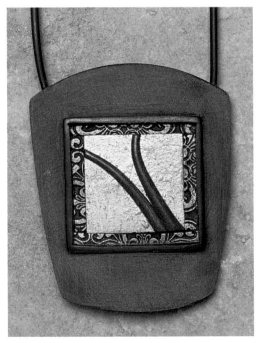

DONNA KATO
The gold "leaf" in the focal point of this pendant is acrylic paint.

HIGHLIGHTING TEXTURES AND THE SILKSCREEN EFFECT

Highlighting is simply applying pigment, such as pigment powders, stamping inks, or acrylic paint, to the raised areas of textured clay. To create this effect, roll a medium sheet of clay, and, following steps 1 and 2 of "Creating a Polymer Clay Stamp Negative" on page 104, roll the clay into a patterned stamp or texture sheet.

Lightly dab paint on the raised areas of the texture only. Build the color up with many light layers rather than one heavy one, letting the paint dry between applications. When the paint is dry, it can be used as it is or you can flatten it by rolling lightly in all directions to create the look of a silkscreen.

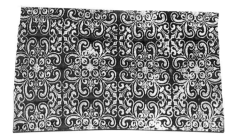

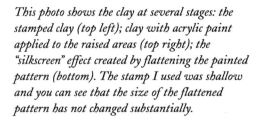

This photo shows the clay at several stages: the stamped clay (top left); clay with acrylic paint applied to the raised areas (top right); the "silkscreen" effect created by flattening the painted pattern (bottom). The stamp I used was shallow and you can see that the size of the flattened pattern has not changed substantially.

TIP

When stamping clay to highlight and then roll flat for a silkscreen or brocade (see page 116) effect, it's best to use a shallow stamp. When the impressed clay is rolled flat, a shallow texture will not enlarge as a texture from a deeper stamp would.

FAR LEFT: DARLENE CLARK
Darlene Clark's watch pendant features an impressed design highlighted with acrylic paints and pigment powders.

LEFT: CAROL HESS
Carol Hess used a combination of glazed pigment powders and highlighted textures on the surface of the whimsical "Doc's Teapot," so named for my Australian shephard Doc.

BROCADE EFFECT

The "brocade" effect is a variation on simple highlighting and the silkscreen effect. Rather than beginning with an unpainted sheet of clay, you apply paint or foil to the surface of the clay before impressing it. Roll a sheet of black clay through the thickest setting of the pasta machine and apply gold foil to the clay (see "Metal Leaf and Foil" on page 34). You can apply gold acrylic paint instead to make the gold base sheet. Following steps 1 and 2 of "Creating a Polymer Clay Stamp Negative" on page 104, roll the clay into a patterned stamp or texture sheet. (Note: A dry release agent such as cornstarch should be used, not water.)

Lightly dab phthalo green on the raised parts of the clay. Follow with red oxide then turquoise paint onto select areas of the raised parts of the clay. Set the clay aside and let the paint dry. This should take no more than 10 minutes. When the paint is dry, roll the sheet lightly in all directions with a clean acrylic or brass rod to flatten the raised parts of the clay.

These four pieces of clay show successive steps of the brocade effect. The first three pieces show each color of paint being applied; the clay at the far right has been flattened to complete the effect.

DONNA KATO
Each of these hollow beads features either, or both, highlighting and the brocade effect.

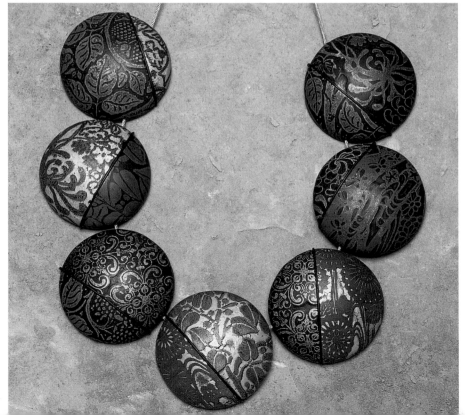

PATTERN OVERPRINTING

Pattern overprinting builds from the brocade technique. A brocade sheet is impressed again, the raised parts of the impression are highlighted, and the piece is flattened. If your brocade sheet is very thin, add a sheet of clay underneath to make it thicker. Select an overprinting color that will contrast with the brocade paint below. I chose very opaque parchment and applied only one coat so it would not completely mask the paint below.

1 Begin with a finished and flattened piece of polymer clay brocade. If necessary, roll a medium-thick sheet of scrap clay and press the brocade to the scrap clay sheet to make it thicker. Select a pattern stamp or texture plate. Dust the stamp or plate with cornstarch.

2 Turn the stamp or texture plate over and press it into the brocade sheet. Dust the cornstarch off with a clean, soft brush.

3 On the raised area, lightly dab a contrasting color of acrylic paint (top right). Roll the texture flat with an acrylic rod or brass tube (bottom). You can leave the clay as is or continue to add patterns and paint.

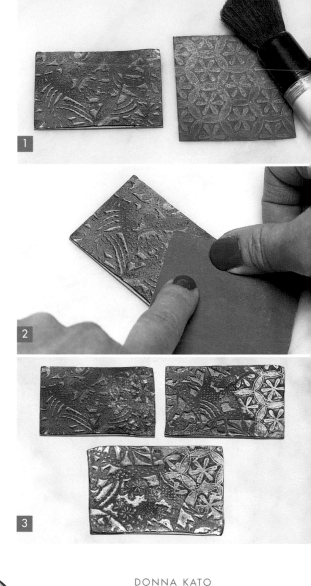

DONNA KATO

FAR LEFT: *The two curved elements that form this pin feature the overprinting technique.*
LEFT: *By using fine patterned stamps for this kimono, I achieved a more subtle overprinting effect than in the kimono pin project on page 118.*

Kimono Pin

TO MAKE ONE PIN, YOU WILL NEED:

Sheet of overprinted brocade clay (see page 116)

Acrylic rod or brass tube

Pasta machine

Polymer clay blade

Translucent polymer clay

Acrylic paint in the following colors: parchment (or white), gold, and red oxide

White polymer clay

Black polymer clay

Kato Clear Medium

Coarse-grit sanding sponge

MY FRIEND, artist Emi Fukushima, is the supreme master of creating kimonos in polymer clay. She's made them for years! The pin, which features highlighting and overprinting techniques, is my homage to Emi.

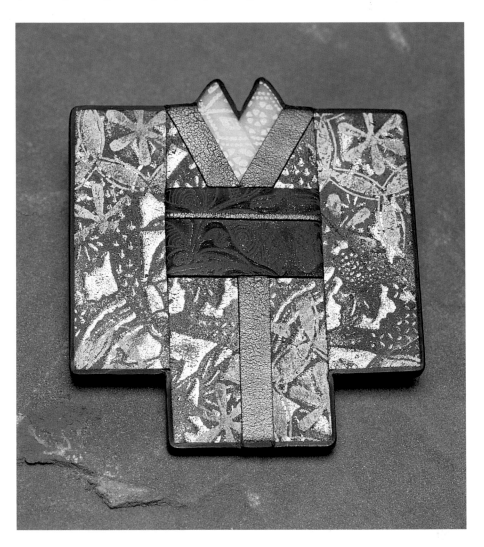

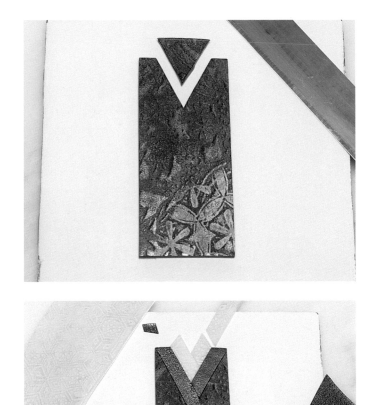

1 To make the kimono body, cut a rectangle 2³/₄ inches by 1¹/₄ inch from the overprinted brocade clay and press it to a ceramic tile. With a polymer clay blade, cut a notch from the piece as shown.

To make the undergarment, highlight a medium-thin piece of translucent clay with parchment or white acrylic paint. Roll the sheet flat. Back the sheet with white clay. The thickness of the translucent and the white backing clay together should be equal to the thickness of the kimono body. Cut a ¹/₄-inch-wide strip from the translucent/white sheet. Angle cut one end and fit it into the notch. Angle cut another piece and fit it across from the first piece. Trim the ends as shown.

2 Roll a medium-thin sheet of black clay and apply gold paint to its surface (see "Making Faux Gold Leaf" on page 114). When the sheet is completely dry, roll it through the pasta machine down to the thinnest setting. Rotate the sheet each time you roll it through a thinner setting. Cut a ¹/₄-inch-wide strip. Lay one piece next to the translucent V. Lay another strip beginning at the shoulder of the kimono, curving at the base of the V, and leading straight down to the bottom of the kimono body.

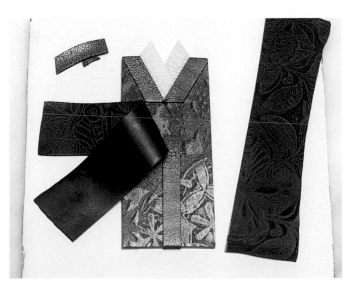

3 To make the obi sash, roll a medium-thin sheet of black clay. Following the instructions for highlighting textures on page 115, apply red oxide paint onto a texture. Roll the clay flat. This sheet should be very thin. Cut a strip 1 inch wide. Lay it lightly across the kimono body. Cut the gold pieces where they would sit under the obi. Remove them and lay the obi clay down on the body. From the gold sheet (step 2), cut a thin strip. Lay it on the obi and trim the excess away.

4 To make the sleeves, cut two rectangular pieces measuring ³/₄ inch by 2¹/₄ inches. Place them next to the body. Bake the kimono on the tile for 15 minutes at 275°F.

Roll a sheet of black clay for the backing. If you're making a pin, it can be quite thin. If you'd rather make a pendant, the overall thickness should be at least equal to twice the thickest setting of the pasta machine.

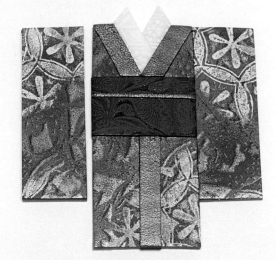

5 Slide a blade under the cured kimono and lift it from the tile. Brush a light coat of Kato Clear Medium or another liquid clay to the back of the kimono and press it to the black sheet. With a scalpel or craft knife, trim around the kimono. Bake the kimono for another 15 minutes at 300°F.

With a coarse-grit sanding sponge, sand the edges of the kimono. Apply a light coat of liquid clay to the sanded edges.

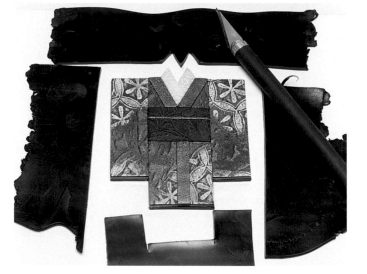

6 Roll a thin sheet of black clay. Cut a long strip, and, beginning at the V, cover the edge of the kimono. Work the strip around, pressing it to the edge. In areas where the shape is indented (such as the V), press and roll the clay with a needle tool. With a blade, trim and remove the excess clay from both the front and back of the piece. Bake the piece for the last time for 15 minutes at 300°F. Finish the piece by sanding the edging and the back with a fine-grit sanding sponge. Glue a pinback to the back of the kimono to complete the piece.

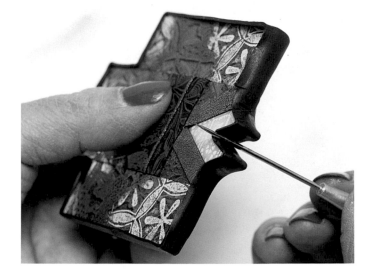

STAMPING INKS

RAW AND CURED clay may be stamped in the same way as paper, but all stamping inks do not work on clay. Some will interact with the clay and never dry. In my work, I use ColorBox pigment inks, StazOn (permanent) ink, and Archival Ink. For general tinting I find that ColorBox inks give me the best results. These inks work well with polymer clay and do not bead up on the surface. There are two main categories of ColorBox inks: pigment and chalk. The pigment-type inks may darken when the clay is cured, but they more or less maintain their original color. The chalk-type inks lighten and become chalky when cured. The color may be restored by a light application of liquid clay, which must then be recured.

ColorBox produces single pads and color selections. The color selections are particularly appealing, and each color may be removed from the palette and used independently. You can ink a rubber stamp and stamp a design on the clay, or just lightly dab the ink pad onto the surface of the clay, overlaying color as you wish.

For stamping details and text I prefer StazOn inks or Archival Ink. These are permanent inks. Of the two, StazOn dries the fastest and, when layered with liquid clay, does not bleed. Archival Ink takes longer to dry and will bleed when a coat of liquid clay is applied over it and cured. Unlike ColorBox inks, once stamped, you cannot remove StazOn inks or Archival Ink.

Bear in mind, my experience with stamping inks is limited—I have not tried all inks. So experiment with the inks you have. They may be perfect for clay.

BELOW LEFT: CATHY JOHNSTON
Artist Cathy Johnston has stretched polymer clay into the world of stamping better than anyone I know. Even simple stamped bookmarks become treasures when they're made by the master.

BELOW RIGHT: DONNA KATO
This box purse was made by draping clay over a pyramid-shaped form, then applying ColorBox pigment inks, StazOn ink, gold leaf, and acrylic paint.

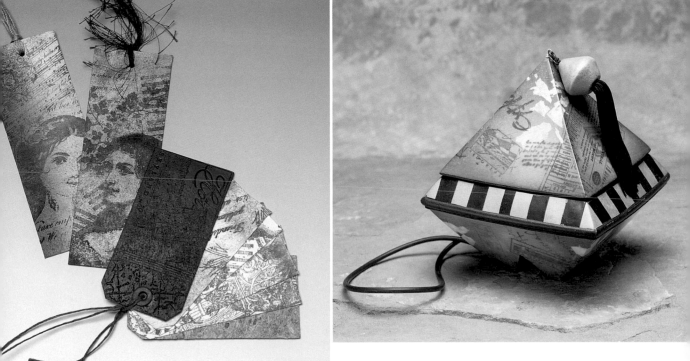

Simple Inked Bead

TO MAKE ONE BEAD, YOU WILL NEED:

Scrap clay

White or other light-colored polymer clay

Bamboo skewer

ColorBox Fluid Chalk inks

Archival Ink (black)

Text and small pattern stamps

Kato Clear Medium

Gold leaf

Translucent polymer clay

Fine-grit sanding sponge

400- and 600-grit wet/dry sandpapers

Electric buffer (optional)

Denim or polar fleece

THERE ARE SO MANY brands of inks and ink pads! For this project, I've used Fluid Chalk inks by ColorBox and StazOn permanent ink. Other ColorBox pigment inks may be used as well. This is a very simple inked bead. You can add more layers of stamping and leafing to further embellish it.

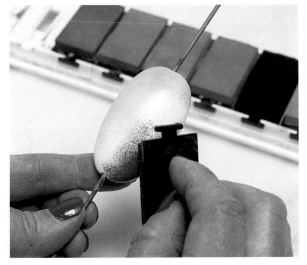

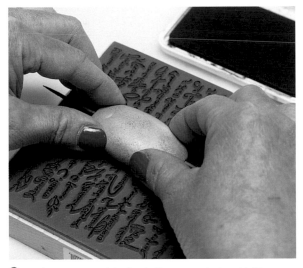

1 Roll a tight cylinder of scrap clay. Roll a thin sheet of white or another light-colored clay and wrap it tightly around the cylinder. Trim and close the ends to conceal the scrap inside. (See "Making Beads" on page 42 for more information.)

Shape the clay into the desired bead shape. Drill through the bead with a bamboo skewer to create the bead hole. Leave the clay on the skewer; this will make the inking process easier.

Dab the clay all over with Fluid Chalk inks. Bake the bead for 5 minutes at 300°F to dry the ink.

2 Apply permanent black ink (I'm using Archival Ink) onto a text stamp, then roll the bead against the stamp.

TIP

This stamp is large, so it was easiest to roll the bead against the stamp. If your stamp is small, it might be simpler to roll the stamp onto the bead.

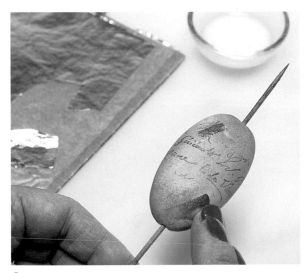

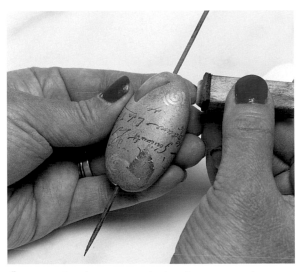

3 Apply Kato Clear Medium or another liquid clay lightly to places where you want to place gold leaf. Place pieces of gold leaf onto the moistened clay.

4 Stamp other designs onto the bead. Here, I tried something new—white ink. The effect of the white ink is very subtle. You might try red or rust, which would stand out more. Bake for 5 minutes at 300°F to dry the ink again and to set the leaf in place.

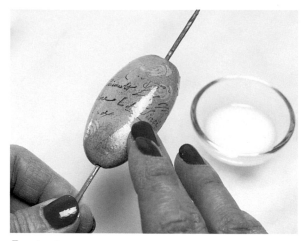

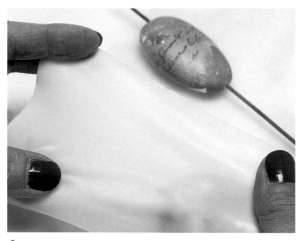

5 Dab Clear Medium over the entire cool bead. The medium will intensify the color and provide a good surface for the application of translucent clay. Bake the bead again for 5 minutes at 300°F to cure the Clear Medium.

6 Roll a thin sheet of translucent clay. With your fingers, stretch and thin it further. This sheet should be very, very thin. If minute holes appear, don't worry, you can fill them in with very small bits of translucent clay in the next step.

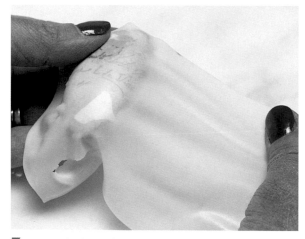

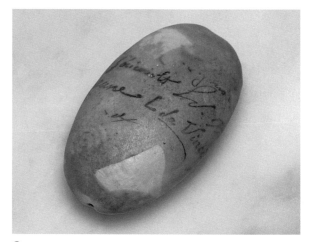

7 Remove the bead from the skewer. If it is stuck, heat the bead again for 5 minutes and remove the bead when it is warm. Wrap the bead with the translucent sheet. If it tears, just press the pieces together. If you find you have holes, apply bits of translucent clay to fill. The goal is to have a uniform layer of translucent clay covering the entire bead.

8 When the bead is covered with the translucent clay, inspect the surface. If you have any light spots, pierce them and try to expel the air. Bake for another 15 minutes at 300°F. (This photo shows the bead before it has been baked.)

Sand the bead with a fine-grit sanding sponge. Then sand in water with 400- and then 600-grit wet/dry sandpaper. Use an electric buffer for a high sheen or buff against denim or polar fleece for a soft sheen.

TIP

After the bead was baked and polished, I discovered that the subtle white spiral elements had disappeared. The opaque white stamping ink was simply not opaque enough for this application. White Genesis Heat-Set artist oils would have been a better choice. To use, dab the paint onto a stamp with your fingers, then press the stamp to the clay. Cure the paint in the oven or with a heat gun.

Inked Inro Box

IN THE CHAPTER on transferring images onto polymer clay, we created an inro box (see page 76). Here is a second method. The advantage of this method is that the lid is tighter fitting. The disadvantage is that it is more difficult to separate the top from the bottom after the initial curing of the decorative layer. At some steps, you will refer to the instructions for the other inro box and to the instruction for the simple inked bead on page 122. The decorative layer features both a toner transfer and ColorBox Fluid Chalk pigment inks.

TO MAKE ONE INRO BOX, YOU WILL NEED:

Tall cylindrical shape cutter
Gold polymer clay
Pasta machine
Polymer clay blade
Coarse sandpaper
White polymer clay
Image printed on a toner-based copier
Ceramic tile (for transferring image)
Bone folder (for burnishing image)
Repel Gel
Gridded quilting plastic
Kato Clear Medium
Coarse-grit sanding sponge
ColorBox Fluid Chalk inks
Archival Ink (black)
Text and small pattern stamps
Gold leaf
Translucent polymer clay
Deli paper
Rounded tool (to shape the top of the box)
Isopropyl alcohol
Fine-grit sanding sponge
400- and 600-grit wet/dry sandpapers
Paper towel and water
Needle tool
Pin vise, Dremel tool, or a simple drill bit
Soft cotton, denim, or polar fleece
Buna cord
Clasp

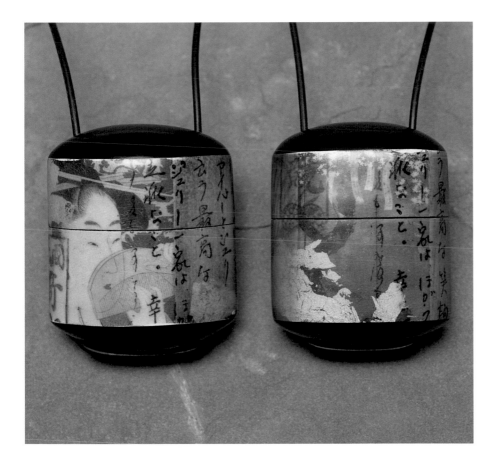

1 Cut a strip of paper wide enough and long enough to wrap around the sides of the cutter. Secure the ends of the paper around the cutter with tape.

Roll a sheet of gold clay through a medium setting on a pasta machine and wrap the clay around the cutter. Trim the ends neatly to make a butt joint. Trim and remove excess clay from the bottom and top (see step 2 of "Inro Box with Toner Transfer" on page 76).

Cut a strip of paper approximately ¼ inch wide. Align the paper with the top of the box and wrap the paper around. Hold it; do not tape it in place. With the blade, cut the gold clay around the edge of the paper: This is where the top and bottom of the box will separate.

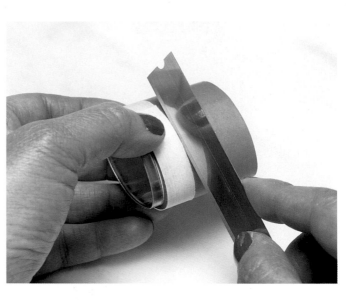

2 Cut a strip of coarse sandpaper. Lay it below the cut. Press the sandpaper into the clay below the cut to texture this area. Bake for 15 minutes at 300°F. Texturing this part will make it easier to separate the top and bottom.

To create the decorative layer, roll a sheet of gold clay through a medium setting, then roll a thin sheet of white. Lay the white on the gold and roll them both through a medium setting. Cut a strip ¼ inch wider than the clay on the cutter.

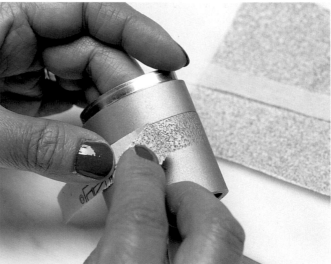

3 Following instructions for a direct toner copy transfer on page 74, transfer an image onto the white side of the strip.

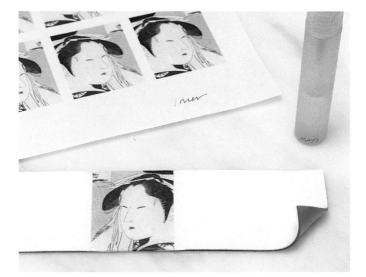

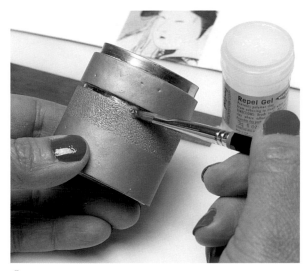

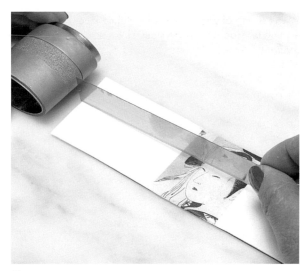

4 When the box is cool, recut the opening and separate the top from the bottom on the cutter. Brush Repel Gel along the cut edge and onto the textured part of the clay only. Each time you cure the box, you will need to apply Repel Gel to those areas.

5 Lay the clay-covered cutter next to the strip and decide where you'd like the point of separation between the top and bottom to fall. Indicate the point by making a cut at the edge of the strip—not all the way across the clay. The cut should be below the textured area on the gold clay.

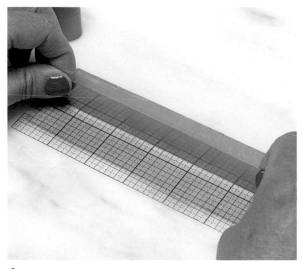

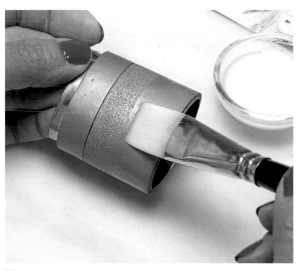

6 Turn the strip over. Find the cut point at the edge and cut the strip as shown. I've placed a piece of gridded quilting plastic onto the clay so the cut is straight across. Cutting from the back to the front will make the cut edges sharper on the front.

7 Brush Kato Clear Medium or another liquid clay onto the smooth clay below the textured clay. Apply Repel Gel to the textured part of the box. The Repel Gel will ensure that the clay covering the textured part will not stick, while the Clear Medium will improve the adhesion of the clay pressed to the bottom of the box.

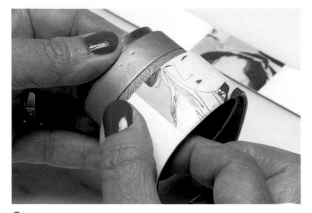

8 Press the bottom part of the strip to the box. Cut the strip at the side, wrapping the remainder around, and trim neatly.

9 Trim the excess clay from the bottom edge.

10 Brush Repel Gel along the cut edge as shown and on the textured gold clay. Brush Clear Medium onto the gold clay (the top of the box).

11 Align the clay with the image transfer and press it to the box. Trim and smooth the strip seam at the side of the box, then cut the excess clay away from the top of the box as you did for the bottom of the box (see step 9). Bake for 15 minutes at 300°F.

12 When the piece is cool, sand the white areas *only* with a coarse-grit sanding sponge. The smoother this surface is, the better the finished piece will be. Remove the clay from the cutter.

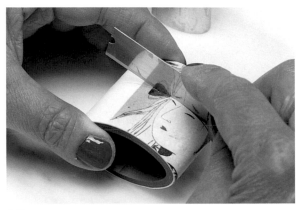

13 *Carefully* recut the separation of the top and bottom. It is best to do this applying medium pressure several times, rather than trying to cut through all at once. When you hear a crack, this means that the parts are almost ready to separate. Continue working around until the top and bottom separate.

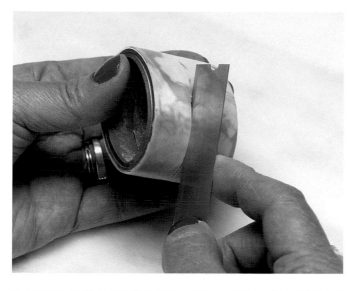

14 Follow the instructions for making the simple inked bead on page 122 to decorate the box with ink and gold leaf. After you've pressed the thin sheet of translucent over the entire box surface, carefully cut the sheet at the opening that separates the top and bottom with the blade. Bake for 10 minutes at 300°F.

With a medium-grit sanding sponge, lightly sand the surface of the box sides until smooth. Sand the top and bottom edges.

Follow steps 3 and 4 of "Inro Box with Toner Transfer" on page 76 to make the top of the box. Saturate a piece of paper towel with alcohol and wipe along the seam between the raw clay top and the sides to clean and remove any uncured clay. Make sure the box sides are clean.

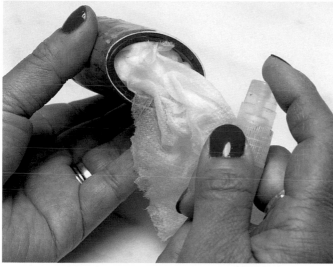

15 To prevent the collapse of the sides, wet paper toweling and gently stuff it into the box to provide support. The wet paper towel will also keep the interior clay cool, which will help maintain the original shape. Stand the box up and bake for 10 minutes at 300°F to cure the box top. (Note: From this point on, any time you cure the box, you should loosely stuff it with wet paper toweling.)

Separate the top and bottom and cover the bottom in the same way you covered the top. Apply Repel Gel to the textured part of the gold clay. Nest the box in batting and bake for 20 minutes.

Sand the top, bottom, and sides of the box with a fine grit-sanding sponge, then 400- and 600-grit wet/dry sandpaper. Open the box and sand the edge of the interior box. Wash the box with warm, soapy water. Rinse and dry.

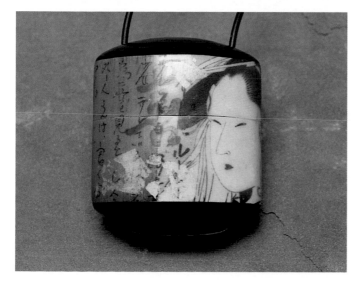

16 Drill holes in the top and bottom of the box: First pierce the place where the holes will be drilled with a needle tool, then drill through the cured clay with a pin vise, Dremel tool, or a simple drill bit. Don't drill them too close to the edges or you'll be drilling into the sides of the box and not the box interior. I placed my holes approximately ¼ inch from the edge. Buff lightly on soft cotton, denim, or polar fleece to bring up a satin sheen. String a cord through the holes in the inro, add a clasp, and you're done.

ALCOHOL INKS

TIM HOLTZ'S Adirondack Alcohol Inks, manufactured by Ranger, are wonderful with polymer clay. These vibrant, transparent colors can be used directly from the bottle or thinned with the addition of Tim's Adirondack Alcohol Blending Solution. The blending solution is also used to clean hands and tools. The colors may be mixed together to create additional shades. Keep in mind that using an excessive amount of ink may cause colors to become muddy.

ALCOHOL INK AND TRANSLUCENT LAYERING

Alchohol ink can be applied to translucent clay in many layers to create beautiful effects. I am not a painter, so you can just imagine the possibilities if you can paint! In this case, I've used only alcohol inks and metal leaf; you might also decorate the clay with pigment inks or gel markers or mix glitter or embossing powder into the clay.

Begin by rolling a thin sheet of translucent clay. Press it to a ceramic tile. Onto the clay, paint alcohol ink. Roll another thin sheet of translucent clay. If necessary, thin the clay further by gently stretching it with your hands. The clay should be very thin. Press this clay onto the first sheet, pressing air pockets out

RON LEHOCKY
Artist Ron Lehocky's colorful brooch features alcohol inks applied directly to clay, stamping on clay, and texturing.

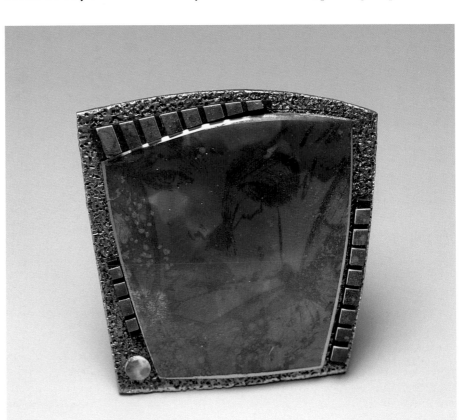

The square sheet of clay shows the process in stages. First, a sheet of translucent clay was painted with alcohol inks (left). A very thin sheet of translucent clay was pressed onto the painted layer. Strips of gold leaf were placed on this layer, which was also stamped with StazOn ink (middle). Finally, a very thin sheet of translucent was added to seal it all in (right). The pieces at the top show the same clay pressed onto a slab of white clay, trimmed into a triangle shape, then baked. On the far right is a cured bead made with the decorated clay and the uncured clay from which it was cut.

as you work from one side to the other. Lay pieces of metal leaf or composition leaf onto this layer of clay. (The clay may turn a greenish blue where it contacts the leaf. The clay will return to its original color after curing.) You can also stamp onto this layer.

Roll another very thin sheet of translucent clay. Press it to the clay on the tile. You may opt to brush on more ink. If so, you will need to finish with a thin sheet of translucent clay.

Slide a blade beneath the translucent clay, lifting it from the tile. Roll it through a thick setting of the pasta machine. It may slide through, but it's best to begin at a thicker setting than a thin one. Reset the machine, rotate the piece 90 degrees and roll through. If you'd like the leaf to fracture more or if you wish to diffuse the color, roll through again, always rotating 90 degrees before each pass so the pattern spreads evenly. The clay is now ready to be used in a project.

(Note: The longer you wait to cure the clay, the more stamping ink it will absorb, so for crisp stamped images, use the sheet and cure it quickly.)

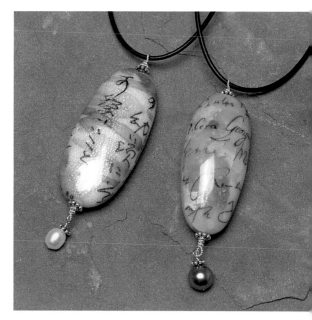

DONNA KATO
These beads were made by wrapping a sheet of clay painted with alcohol inks in translucent colors around a core of white clay. After baking, they were sanded and buffed to a high sheen.

ALCOHOL INK ON METAL LEAF

When alcohol ink is brushed and dropped onto a nonporous surface, such as metal leaf, the ink moves and spreads, making it possible to achieve unique "water spot"–type effects. As you apply more ink, the fresh ink spreads out, displacing the ink beneath. Spreading Tim Holtz's Blending Solution on the leaf or foil first will inhibit the movement of the ink for a more controlled finished effect. For the maximum ink movement, it is best to use metal leaf. You may also use foil but its surface is less slick so the ink will move less.

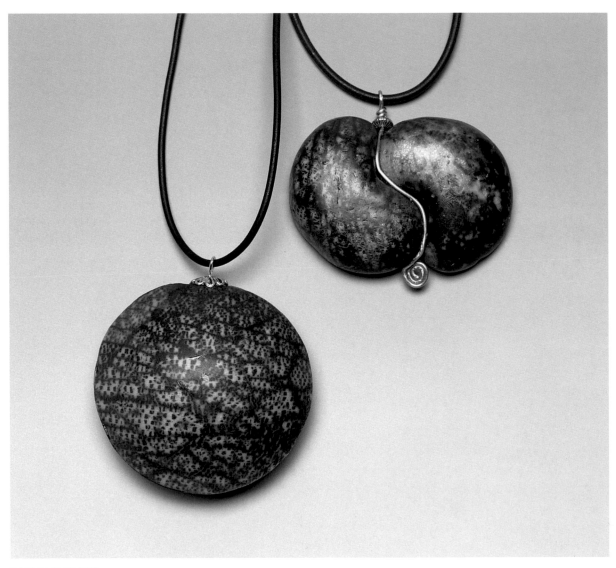

DARLENE CLARK
Artist Darlene Clark's hollow pendants were made with alcohol ink randomly placed on metal leaf. The clay was then stretched to create a crackle effect.

Inked Cabochon Pendant

FOR THIS PROJECT, I pressed gold leaf to polymer clay to serve as the canvas onto which I dropped and brushed various colors of alcohol ink. Gold metal leaf will result in warmer colors—for example, blue will take on a green tint. Silver metal leaf brightens the colors of the inks without altering them. Rolling across metal leaf with an acrylic roller produces a beautiful crackled effect. You can use any color of base clay for this pendant, but I like the contrast between black clay and the crackled metal leaf.

TO MAKE ONE PENDANT, YOU WILL NEED:

Black polymer clay
Pasta machine
Polymer clay blade
Metal leaf
Ceramic tile
Alcohol inks in various colors (Ranger)
Soft brush
Fine-tipped brush
Translucent polymer clay
Cornstarch
Acrylic rod
Coarse-grit sanding sponge
Fine-grit sanding sponge
400- and 600-grit wet/dry sandpaper
Denim or polar fleece (for buffing)
Kato Clear Medium
Scalpel or craft knife
Cotton swab and alcohol
Needle tool
Hand drill
Buna cord
Two small O-rings
One large O-ring
Cyanoacrylate (CA) glue

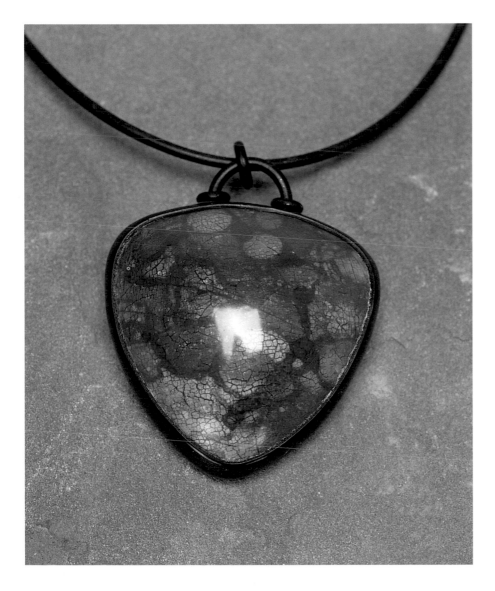

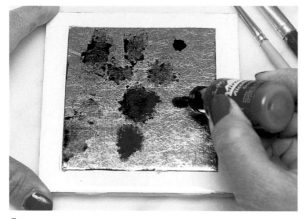

1 Roll a medium-thin sheet of clay and trim the edges with a polymer clay blade. Place the clay onto a sheet of metal leaf and then place the clay on a ceramic tile, metal leaf side up, and smooth the surface of the leaf with your fingers. Drop alcohol ink on the surface of the leaf.

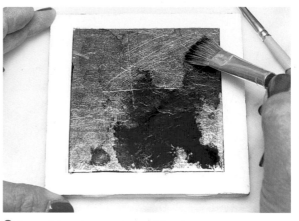

2 Spread the ink out with a soft brush.

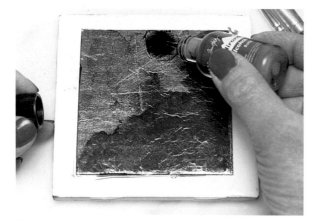

3 Drop various colors of ink onto the prepared surface. The ink will spread out.

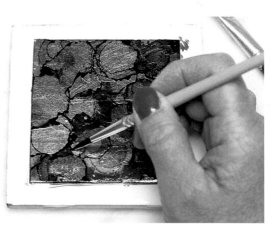

4 Saturate a fine-tipped brush with ink. Touch the metal leaf surface with the tip of the brush to open small spots in the ink, and draw lines with the brush to break up big spots of color.

5 Here is my finished sheet. If you wish, you can continue adding different colors of ink until you achieve the effect you desire.

6 Roll the translucent clay through the thinnest setting of your pasta machine. With your fingers, spread and thin the clay sheet further. Place the translucent sheet on the inked clay. Starting in one corner, press the translucent clay to the ink, pushing air pockets out as you go. Trim and remove the excess translucent clay.

7 Slide a blade beneath the clay, then pick it up and stretch it gently.

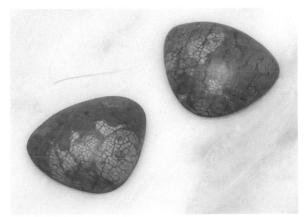

8 Dust the translucent surface with cornstarch. With an acrylic rod, roll the sheet in all directions to thin it and form a crackled pattern. The cornstarch will prevent the clay from rolling back onto the rod or the translucent clay from pulling away from the metal leaf.

9 Form a cabochon shape from scrap clay (see page 46). Drape the inked sheet over the cabochon and trim it to fit. Roll the surface with a smoothing tool, and then bake the cabochon for 20 minutes at 300°F.

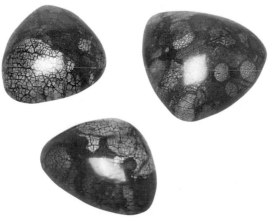

10 Sand the cabochon with a fine-grit sanding sponge, followed by 400- and then 600-grit wet/dry sandpapers. Buff the piece against denim or polar fleece to achieve a satin sheen.

The two smaller cabochons shown here were formed from the ink sheet I made above. The larger one was made from a different sheet with similar colors, but I added more small ink drops to the pattern.

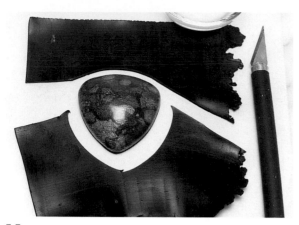

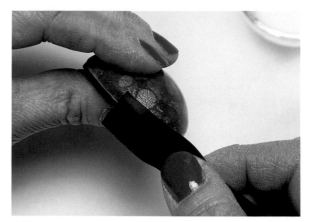

11 Sand the bottom of the cabochon with a coarse-grit sanding sponge. Roll a medium-thin sheet of black clay through the pasta machine. Apply a light coat of Kato Clear Medium or another liquid clay to the bottom of the cabochon, then press it onto the clay sheet. With a scalpel or craft knife, cut the clay from around the cabochon.

12 Roll a sheet of black clay through a thin setting. Cut a strip long enough to wrap around the cabochon. Lining up one edge of the strip to an imaginary line on the front of the cab, and wrap the strip around the cabochon. Cut the strip so that it does not overlap but forms a butt joint. Smooth the joint with your fingers.

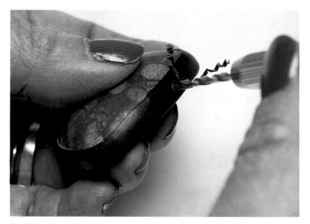

13 Turn the cabochon over and trim and remove the excess strip clay. Smooth the strip clay to the bottom clay. With a cotton swab dipped in alcohol, clean the top of the cabochon. Bake the piece for another 15 minutes at 300°F

14 With a needle tool, poke two holes in the top edge of the cabochon. Use a hand drill to drill two holes, each 1/2 inch deep, into the cabochon.

15 Cut a short piece of buna cord and place the ends of the cord into the holes to make sure the loop isn't too large or too small (this is a matter of personal preference). Onto the buna cord, place two small O-rings and between them a large O-ring. Glue the ends of the cord into the holes, pushing the small O-rings snug to the holes. Resand and polish the piece to restore the sheen lost when you cured the cabochon in step 12.

TIP

To make a bracelet of inked cabochons like the one shown on page 46, insert loops on two sides of each cabochon in the same way you made the pendant hanger. Join the pieces with O-rings.

TEMPERA PAINT

FOR MANY YEARS, we have ignored the lowly tempera paint, accepting what seemed to be true—that it would not work with polymer clay. Leave it to Tony Aquino (the formulator of Kato Polyclay) to figure out how to make tempera paint work with polymer clay. In his technique, tempera paint is applied to raw clay and allowed to dry. Liquid polymer clay is then applied on top of the tempera. Because the paint is porous, it absorbs the liquid clay and becomes "set" wherever the liquid clay is applied. In honor of Tony, we call the technique he developed "Tony's Special Tempera Technique"! Jazz brand tempera paints work well with polymer clay and are recommended for this technique.

1 Roll a sheet of black clay through a medium-thick setting of the pasta machine. Dab gold tempera paint onto the clay. Set it aside until the paint is dry. Reset the machine to a thinner setting and roll the clay through to crackle the tempera paint. Reset the machine to an even thinner setting, rotate the sheet 90 degrees, and roll through. Continue until you are satisfied with the crackle pattern.

Brush Kato Clear Medium or Fimo Gel onto the sheet. You can apply the liquid polymer clay in a pattern or coat the entire sheet. Wherever the liquid clay is applied, the paint will be sealed to the clay.

2 Bake the piece for 15 minutes at 300°F. When the clay is cool, wet it and brush away the tempera paint. Any unsealed tempera paint will wash away and leave just the liquid clay pattern.

> **TIP**
> If you are making a flat piece, cut out the shape before applying the liquid polymer clay. For a raised application, drape the sheet on your form and trim the excess away first, then paint the liquid clay pattern on the tempera paint.

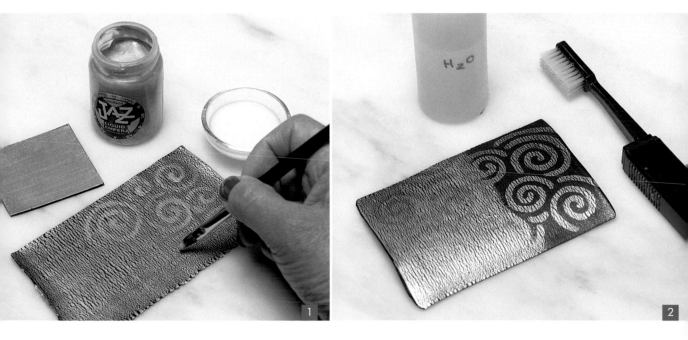

ANTIQUING POLYMER CLAY

THE MOST EFFECTIVE way to create the look of age and impart an "ethnic" quality to polymer clay is to antique your finished pieces. Artists such as Karen Lewis ("Klew") have mastered the technique using acrylic paint, but it can be tricky. If the paint is too wet, it beads up and slides off. If the paint is too thick, it dries too quickly and may end up looking thick and gunky. For those reasons, I used to avoid antiquing too many of my pieces, preferring to steer clear of the whole thing, until Leslie Blackford gave me a simple solution.

Leslie uses oil paint instead of acrylics! Unlike acrylic paint, which sits on the surface of polymer clay, oil paint penetrates the clay and stains the surface. Her preferred mix of burnt sienna and raw umber paints creates a convincing antiqued effect. Although paint alone works, she recommends adding a few drops of linseed oil to improve the consistency.

1 Apply paint with a toothbrush to a cured piece, working it into all the crevices.

2 Wipe the excess away with a cloth or paper towel. By working small areas at a time, you can minimize the mess. A heavy application of oil paint should dry in 24 hours. (See page 170 for instructions on making this bas-relief bead.)

OPPOSITE, TOP LEFT: LESLIE BLACKFORD
Leslie Blackford's unique style can be seen in these wonderful antiqued leopard and wombat pendants.

OPPOSITE, BOTTOM LEFT: JACQUELINE LEE
For her "Pre-Columbian" pieces, artist Jacqueline Lee favors Vintage Milk Paint. Manufactured and distributed by Aspen Art Stamps, this new formula of an old standby creates the look of what Jacqueline refers to as "instant dirt" and gives a piece a distinctively aged look. The finish is surprisingly durable, and the paint will not only adhere to polymer clay but will stick to metal as well.

OPPOSITE, RIGHT: DONNA KATO
This "bone" pendant has been antiqued Leslie-style, with oil paint.

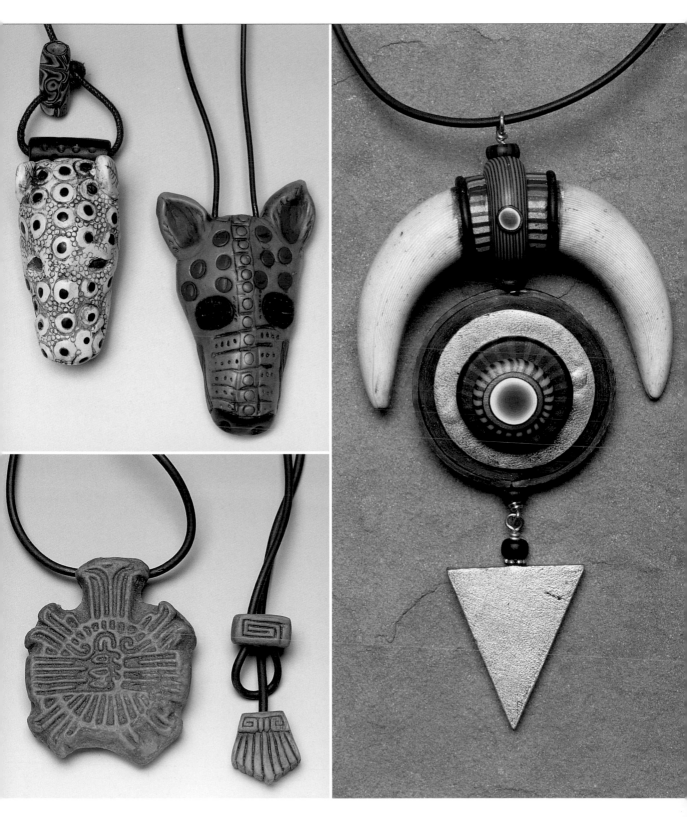

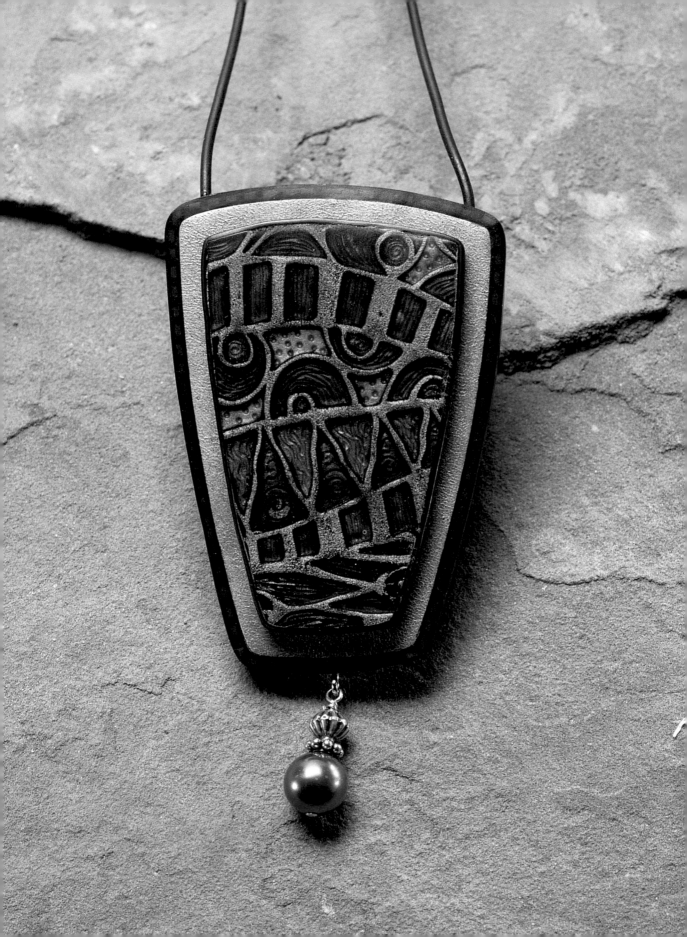

SPECIAL EFFECTS WITH LIQUID POLYMER CLAYS

Liquid polymer clay is basically transparent polymer clay in a bottle! Once cured, it changes from its liquid state to a solid, making it an extremely versatile material. As seen earlier in this book, liquid clay can be used to facilitate inkjet transfers, to improve the adhesion between raw and cured clay, and to seal tempera paint on clay to make it permanent. In this chapter, you will learn several more uses for this versatile material, including using it as a glaze; layering with inks, metal leaf, gel pens, and other materials to create pieces that exhibit great depth; and simulating glass enamel. Hopefully, these techniques will serve as a springboard for your own explorations with liquid polymer clay.

WORKING WITH LIQUID CLAYS

DONNA KATO

Here are four polymer clay wings I colored with polymer clay enamel (see page 148). The cells in the ones on the top and at right have been textured, which gives them an impression of depth. The other two, which have not been textured, appear flat.

THERE ARE THREE brands of liquid clays on the market: Kato Polyclay Clear Medium, Liquid Fimo Decorating Gel, and Liquid Sculpey. Of the three, Kato Clear Medium and Fimo Gel are the clearest. Kato Clear Medium is the thinnest, and Liquid Sculpey is the thickest. Although any of the liquid clays will perform equally well in many techniques, they are different formulations and some work better than others for specific applications. For example, when used thickly, Kato Clear Medium and Fimo Gel are preferred for maximum clarity.

You can apply liquid clay with a brush. As the clay remains liquid until it is cured, the brushes need not be completely cleaned between uses. Just cover the bristles with plastic wrap to keep them clean. When you do clean brushes, swirl them in isopropyl alcohol to dissolve the clay and dry them completely before use.

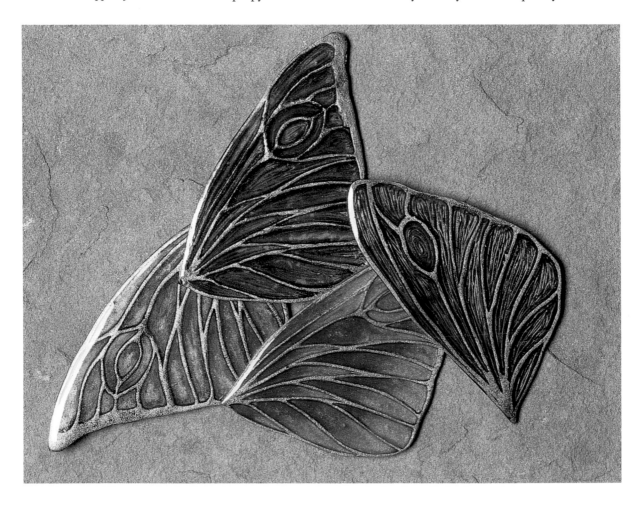

When working with liquid polymer clays, avoid contact with water: They do not mix, and the clay will bubble and foam. It is best to work only with clean dry tools, especially brushes.

If you will be pouring liquid clay from the bottle into a bowl, unscrew the cap and pour, rather than squeezing it through the applicator; this will minimize bubbles.

In the techniques and projects in this chapter, I have used Kato Clear Medium. I would encourage you to try other brands of liquid polymer clay, following manufacturer's instructions for curing. To achieve maximum clarity of Kato Clear Medium, it must be cured at a temperature of approximately 320°F. Rather than heating at that elevated temperature in my oven, I prefer to first cure the medium in the oven at 300°F, and then use a heat gun. Remember to use caution when using the heat gun. Place the piece on a tile, and then place the tile on a phone book. This will ensure that you do not damage your table or other surface. Do not heat Fimo Decorating Gel and Liquid Sculpey at these elevated temperatures as they may burn.

A strong fan in an oven will move the medium, so it is best to cure thick coats in an oven without a fan. Likewise, a strong heat gun will move the medium, so bake thick coats in an oven first and then finish with a heat gun. Thin coats may be cured with the heat gun alone. Liquid clay can be sanded and buffed after it is cured.

Should you find after curing that your piece has large bubbles, cut out the bubble with a sharp craft knife or scalpel. Fill the hole with liquid clay and cure again. If you find small pits in the surface, dab liquid clay into the pits and stroke a thin coat over the entire piece. Cure, and the surface should be smooth. Remember, you are not limited in the number of coats of clay you may apply.

Brushing on a thin coat before pressing raw clay to raw or already cured clay will improve and strengthen the bond between the pieces.

There is an accessory pack available for use with Kato Clear Medium and other liquid clays. It includes an accordion bottle, a stainless steel tip, and two fine plastic tips. Just pour the liquid clay into the bottle and place a tip on the adaptor to dispense fine drops and lines of liquid clay.

DONNA KATO
The focal pieces of these boxes were created flat, then curved around and adhered to raw clay. Stamping, painting, and adding metal leaf between thin coats of Kato Clear Medium produced a multilayered effect (see page 145 for instructions).

GLAZING

LIQUID POLYMER CLAY can be used as a glaze on polymer clay pieces. It is helpful to apply it with a wide brush that doesn't introduce air bubbles into the medium. I use Silverado brushes, which are distributed by Yasutomo.

To glaze a piece, pour liquid clay into a bowl. With the brush, pick up and then spread the clay evenly across the piece. Tamp the bottom of the piece to dislodge air bubbles, then pull them to the nearest edge and off the piece. Set the piece aside to allow the liquid clay to level. Bake at 300°F for 30 minutes. If the surface is not level or there are pits in the surface, apply another coat and bake again. If the clay is not totally clear, heat it again with a heat gun (only cure Kato Clear Medium with a heat gun; the other brands will burn). Follow the manufacturer's curing instructions for other brands.

DONNA KATO
This fan-shaped pendant has been glazed with liquid polymer clay to produce a high sheen and to protect its 23-karat gold leaf.

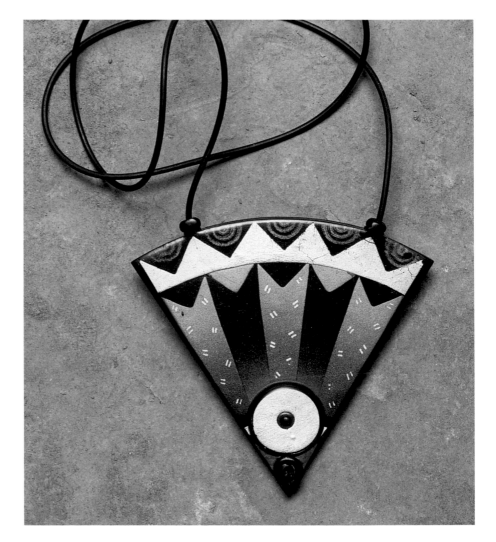

MULTILAYERED EFFECTS

IN THIS TECHNIQUE, we will create sheets of clay by alternating layers of liquid clay with paints, inks, and metal leaf. You'll need a clean ceramic tile or a piece of tempered glass. You'll be building a pattern from the bottom to the top in layers. Each layer must be cured and cooled before moving on to the next. You can cure the layers by placing the tile in your oven or by heating it with a heat gun. Best results are achieved when the liquid clay is applied with a good quality flat brush. Once again, I use Silverado brushes because they do not create bubbles in the clay. For this technique, we'll be using Genesis Heat-Set Artist Oils, ColorBox pigment inks, composition leaf, and StazOn ink. You could also use other paints and inks. Experimentation is half the fun! The sheets you make can be cut and should be backed with light-colored clay.

KIM CAVENDER
Artist Kim Cavender's clock face is a wonderful example of stamping and multilayering in liquid clay.

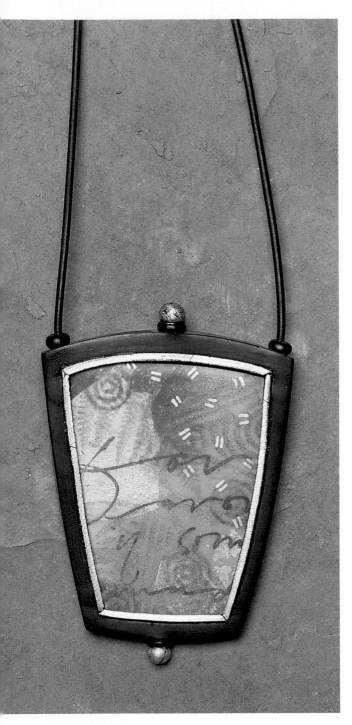

DONNA KATO

This pendant was made with liquid clay layered with Genesis Heat-Set Artist Oils, StazOn ink, Yasutomo gel pens, and composition leaf.

1 Stroke a light coat of liquid clay onto a clean ceramic tile.

2 Lay pieces of metal leaf onto the liquid. Cure for 5 minutes at 300°F or heat with a heat gun until the clay is cured. Let the tile and liquid clay cool before adding another layer.

3 With your fingers, dab Genesis paint onto the clay. I used the following colors (in this order): red, orange, magenta, and white. Cure the paint with a heat gun,

4 Stroke a light coat of liquid clay onto the cured paint and heat with the heat gun (or the oven for 5 minutes at 300°F) to cure. Let cool.

5 Stamp the clay with permanent ink (StazOn or Archival Ink). Besides being permanent, this ink dries quickly. If you use pigment inks, such as ColorBox inks, you will have to dry them by baking in the oven or with the heat gun.

6 After the ink is dry, dab liquid clay over the ink with your fingers to seal it. The ink must be sealed because, although it is dry, it will still smear if you brush liquid clay over it.

Continue applying layers as you wish. Finish with three coats of liquid clay, curing and cooling between each application. Heat the entire piece with a heat gun to achieve maximum clarity.

7 With a blade, lift a corner of the piece. Remove the cured piece from the tile.

8 Here is the finished piece, which may be cut with scissors. If you will be using it as a laminate, bear in mind that the backing clay will be visible as the layered piece is transparent.

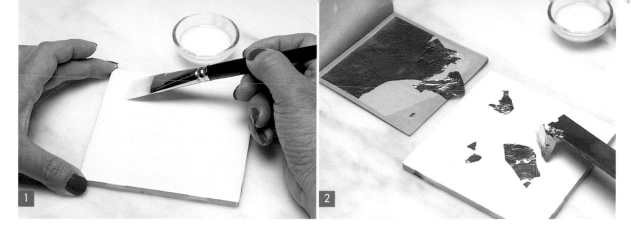

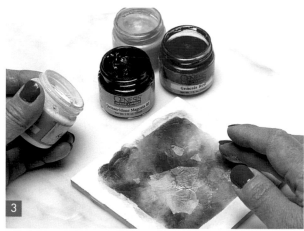

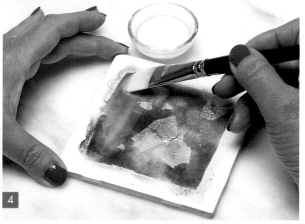

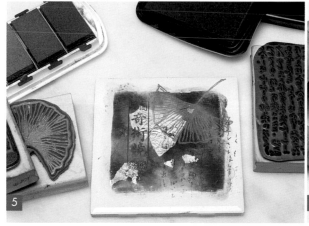

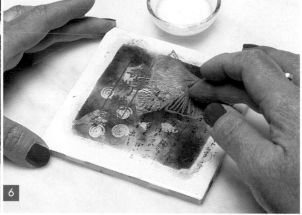

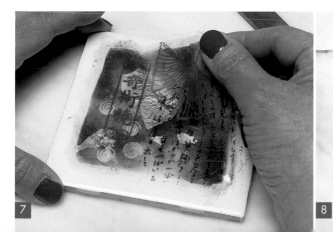

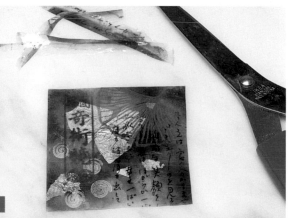

POLYMER CLAY ENAMEL

DONNA KATO

The wings and the leaves to the right and left of the face of this dragonfly pin were colored with polymer clay enamel.

YOU CAN SIMULATE the look of glass enamel by applying liquid polymer clay over pigment powders. Perfect Pearls is ideal for this technique because its binder contains resin. The resin actually melts and fuses the powder to the clay. I have tried the same technique with PearlEx pigment powders and have not had the same result. For this technique, I would recommend either Liquid Fimo Decorator Gel or Kato Clear Medium. (If you use Fimo Gel, follow the manufacturer's instructions for curing.)

Begin by rolling a sheet of black clay through a medium-thick setting on a pasta machine. I like to use black clay for this technique because pigment powders applied to black clay create the most intense colors. Cut out the shape of your piece, thin the edges, and refine the shape with your fingers. Lightly incise the surface with a ball stylus. This will increase the appearance of depth. Brush on pigment powder. Dab gold acrylic paint along the edge of the piece.

Bake the piece in the oven at 300°F for 10 minutes to set the powder. Remove it from the oven and let cool. Brush a light coat of Kato Clear Medium onto the powder. Bake again for 10 minutes at 300°F or cure with a heat gun. Allow the piece to cool, then brush another coat of liquid clay onto the piece and bake for 20 minutes at 300°F. Finish by heating with a heat gun to achieve maximum clarity of the liquid clay.

DONNA KATO

FAR LEFT: *I applied polymer clay enamel with autumnal shades of pigment powders to these leaf pendants.*
LEFT AND ABOVE: *Two pairs of polymer clay enamel feather earrings. Using different shades of pigment powders adds subtle variety to the enamel.*

Cloisonné Heart Pin

IN TRADITIONAL CLOISONNÉ, metal cells (usually created with soldered wire) are filled with glass enamel and the enamel is fired. This project imitates the cloisonné by creating cells from polymer clay and filling them with pigment powders and liquid polymer clay. You can limit each cell to a single color, but a more interesting effect can be achieved by layering colors. For this project, you'll need a texture plate or a polymer clay stamp negative created by reversing a rubber stamp (see page 104) to create the pattern and cells in your raw clay.

Because the clarity of the cured clay is so important for this effect, I would recommend either Kato Clear Medium or Liquid Fimo Decorating Gel. If you use Fimo Gel, follow manufacturer's instructions to cure.

TO MAKE ONE PIN, YOU WILL NEED:

Black polymer clay

Texture plate or polymer clay stamp negative

Acrylic rod

Ceramic tile

Scalpel or Kato NuBlade

Ball stylus

Perfect Pearls pigment powder

Gold acrylic paint

Kato Clear Medium or Liquid Fimo Decorating Gel

Fine-grit sanding sponge

Pinback

Cyanoacrylate (CA) glue

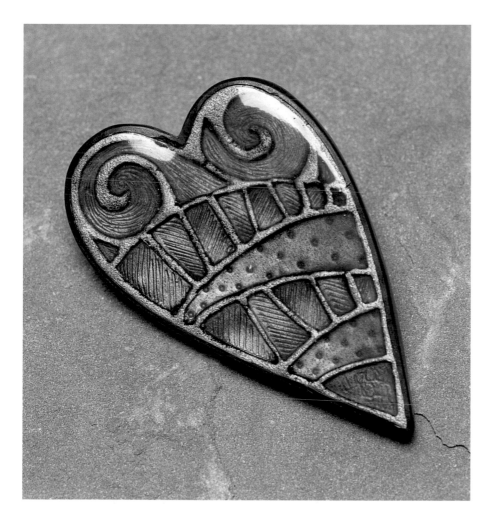

1 Roll a medium-thick sheet of black clay. Lay the texture plate or stamp negative on your work surface and spray with water. Lay the clay on the texture plate, and then spray the back of the clay with water. Using firm pressure, roll the clay into the plate with an acrylic rod. Roll one time only. Lift the clay from the plate. Set the clay aside and let dry.

Place the dry clay on a ceramic tile and trim to desired shape with a scalpel or NuBlade.

With a ball stylus, incise the clay lightly in the indented areas of the texture. Incising is important; it will make the depth more apparent as it provides something for your eye to focus on.

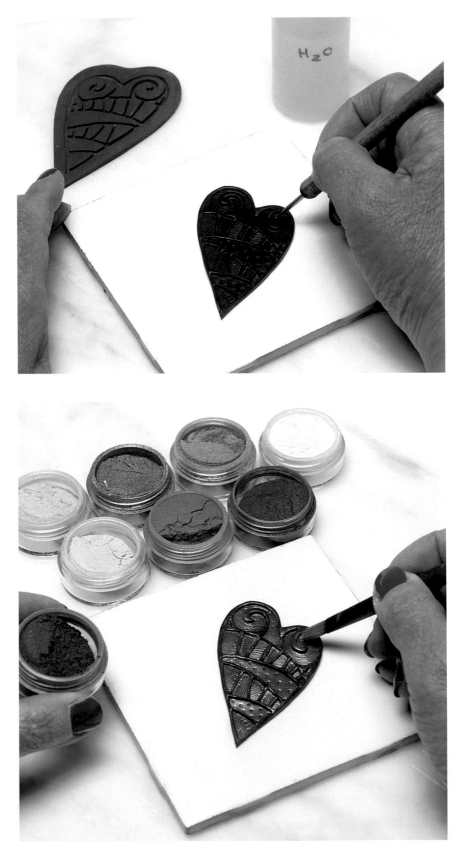

2 Into the cells, dust Perfect Pearls pigment powder. Don't worry if you find powder on the raised part of the impression—you'll take care of that later. Bake the clay for 15 minutes at 300°F to set the pigment powder. When it is cool, lightly sand the raised area of the clay.

With your fingers, dab gold acrylic paint on the raised areas only. Set aside to dry. Pigment powder on dried paint will not be a problem—just dust it off. If necessary, touch up spots with acrylic paint. If you find paint on the pigment powder, simply wipe it off with a damp cotton swab.

TIP

If your impression is shallow, you might find it easier to apply the gold acrylic paint before incising and dusting the clay with pigment powder.

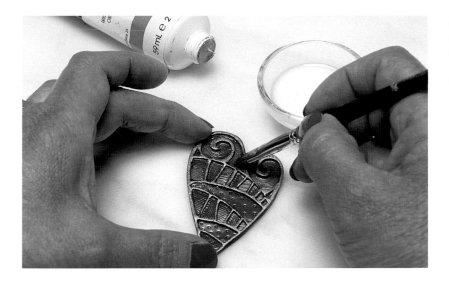

3 With a clean brush, apply a light coat of liquid polymer clay on the pigment powder. Bake for 10 minutes at 300°F. This step will minimize and/or prevent air bubbles in the liquid clay.

4 When the clay is cool, fill the cells with the liquid clay. Tamp the bottom of the piece to dislodge any air bubbles in the medium. Set the piece aside for 30 minutes to allow the surface to even and to let any air bubbles float to the surface. Should they appear, move them to the edges and off the piece. Kato Clear Medium looks milky but will clear after curing; Fimo Gel looks clear.

Cure the piece for another 20 minutes at 300°F. If your oven has a fan, turn it off—the air will move the liquid and the piece will not be flat.

5 Heat the liquid clay with a heat gun to reach its maximum clarity. If the surface is pitted, fill it with a thin coat of liquid clay and heat again. With a fine-grit sanding sponge, sand the sides and back of the piece. Attach a pinback with CA glue to complete the piece.

SCULPTURE AND MOLD MAKING

Polymer clay is an ideal material for creating figures, dolls, and other sculptures. Like earth clays, it can be sculpted into almost any shape imaginable. Making a sculpture from polymer clay is a great way to try out the many surface effects described in this book. In this chapter, we'll discuss how to use armatures to create large pieces or to make a piece lighter and more durable and methods for making polymer clay molds, which allows you to produce multiples of a piece without having to recreate it from scratch. We'll finish with a look at the delicate art of bas-relief.

USING ARMATURES

OPPOSITE, CLOCKWISE FROM TOP LEFT:

CONNIE DONALDSON

The three figures of "Radiant Women" emerge from a polymer clay box constructed over armature material. The front of the piece features canework embellishment.

LYNDA STRUBLE

These delicate fairies by artist Lynda Struble are formed around wire support armatures. The wires maintain the shape and balance of these freestanding pieces.

DAN CROWLEY

Artist Dan Crowley's sculptures have been featured in the window displays of Tiffany and Co. These sculptures were formed over armature material. The standing figure was then painted.

DONNA KATO

To create this large vessel, I embedded a metal mesh called Wireform between two sheets of clay. I was then able to shape and curve the clay. The mesh strengthens the vessel walls and offers support during the curing process.

AN ARMATURE IS a nonclay material or form used to bulk up a piece. In some cases, it may also make a finished piece more durable, and it will usually make it lighter. It provides support during the curing process to keep the clay from collapsing under its own weight and guarantees that the desired shape remains true and free from distortion. The interior form also makes it possible to achieve shapes that might otherwise not be possible. You should also use an armature when the walls of a sculpture or other solid piece would otherwise exceed 1 inch, because if the piece is too thick, the clay in the middle might not cure.

Common armature materials are aluminum foil, wire mesh, and wire. Foil used as an armature should be compressed and compact; it should feel solid, not loose. Wire is used to strengthen and support limbs and fingers and to create a basic skeleton for a figure.

Armatures can also be existing items that you cover with clay, such as Christmas tree ornament bulbs, bottles, rocks, and eggs, to name just a few. When covering such items and foil forms, attention must be given to the presence of air pockets between the armature and the clay covering. Heating will make air pockets expand and enlarge. When I wrap a form with a sheet of clay, I gently stretch the clay as I wrap and this seems to help minimize them. In foil armatures, I press clay into crevices before wrapping.

Temporary armatures can also be used. The Skinner Blend purse on page 152 is an example of a purse formed over an emu egg, which was later removed. The mica shift cuff bracelet on page 67 was formed over a temporary armature—a brass cuff. You can also make temproary armatures or draping forms from polymer clay itself. When creating these forms, it is helpful to texture the surface with coarse grit sandpaper before curing, which will make it easier to remove the clay from the form. You must also apply a coat of Repel Gel.

Depending on the shape of your piece, you might find you also need to support the walls from the outside. This is when a "sagger" box comes in handy. A sagger box is a box that will withstand the heat of curing. It can be aluminum or even cardboard. Loosely fill the box with polyester batting and nest the item in the batting. The batting will support the sides of the piece during curing.

A foil armature (far left) and a similar armature covered with polymer clay (left). Using an armature like this makes a piece lighter and more durable.

MAKING A SIMPLE MOLD

SCULPTING THE PERFECT face or making a perfect cabochon can be time consuming. Once those perfect forms are made, creating a mold from them will save you time later. The pulled reproductions may need cleaning up, but it's still easier than beginning from scratch. As it is somewhat difficult, we'll make a mold of a face. (Instructions for making a face are included in my first book, *The Art of Polymer Clay*.) There are other books that offer excellent instruction on making faces. They include the books of Maureen Carlson and Katherine Dewey. It is helpful if your original face has a flat back, rather than being fully rounded. When I make faces to be molded, I sculpt the faces on a ceramic tile, not in the round.

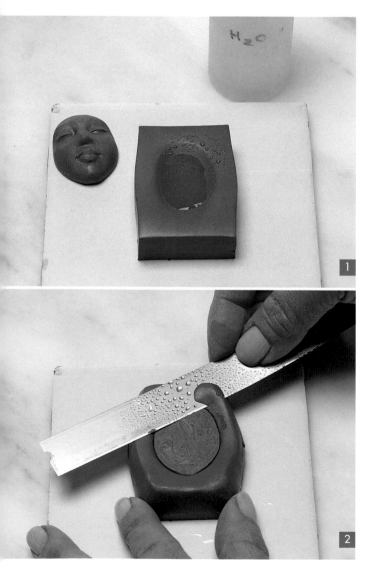

MAKING THE MOLD
This technique to make molds was taught to me by Jacqueline Lee.

1 Begin by inspecting the surface of the original for any imperfections. Fill undercuts (indentations that will trap clay) such as the nostrils with raw clay. Roll a sheet of scrap clay through the thickest setting of a pasta machine. Cut and divide the sheet until you have a block of clay approximately 1/4 inch thicker than the piece to be molded.

Place the block on a ceramic tile and indent the center of the block with your fingers. When making molds, you'll need a release agent so that the original can be easily removed from the mold without distortion. Water is the best release agent for mold making. Flood the indented area with water, then push the original into the indented area. If the clay pulls away from the original at the sides, push the clay so it is snug against the face.

2 Slide a blade across the flat back of the cured face to even up the clay around the face. Gently lift the face from the clay. Trim excess clay from around the face, leaving a margin of at least 1/2 inch. Cure the mold in the oven for 1 hour.

USING YOUR MOLD

Once your mold is made, you can press raw clay into it to recreate the original. Polymer clay molds also can be used with metal clay, paper clay, or any other modeling material. When you use a polymer clay mold, first spray the mold with water or apply another release agent, depending on the material you are using.

1 Roll a ball of clay and press it into the mold. If you're using a face mold, reshape the ball into a round teardrop shape and press the tip of the teardrop into the nose. Press and spread the clay from the center to the perimeter of the mold.

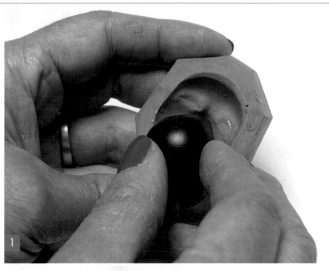

2 Carefully slice the blade across the back with a blade. I use a back and forth motion as I move the blade to remove the excess clay.

3 Carefully remove the clay from the mold. Here is the original piece, the cured mold, the clay pulled from the mold, and another impression that was refined.

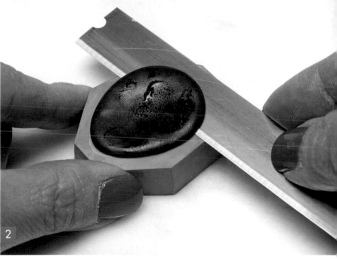

TIP

The way the clay is cut before removal from a mold requires a steady hand. To make a mold easier to hold and manage, roll a sheet of scrap clay through the thickest setting of the pasta machine. Fold the sheet in half. Apply a thin coat of Kato Clear Medium to the back of the cured mold. Press it lightly to the sheet of raw clay and cut around it. Bake the piece for 20 minutes at 300°F. The additional thickness of the mold will make it easier to hold and manage.

TIP

Once the mold is made, you may find it much easier to identify if you pull an impression from the mold, then press it to the back side of the mold itself. Bake it again and you will know exactly what that mold represents.

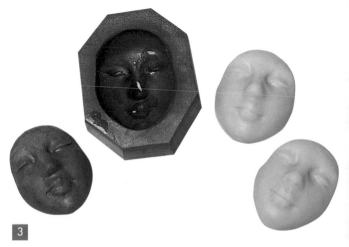

CREATING A MOLD
FROM A STENCIL

SOMETIMES the solution to a problem leads to new ideas. I wanted to make a butterfly with a face as the body and the wings wrapped around the face. The challenge was figuring out how to make the left and right wings symmetrical. I could have tried to form them separately, but they wouldn't be exactly the same. The solution I came up with was to cut a stencil of a wing, make a mold from it, and make two wings from that mold. This technique would also work well for stained-glass patterns. Use a strong clay to make the stencil, because it will be stressed. This type of mold is similar to the simpler incised texture plates made earlier in this book (see page 106), but for a stencil mold, you cannot have

DONNA KATO

ABOVE: *This piece is an example of polymer clay cloisonné (see page 149). The original mold from which the piece was pulled was made from a stencil-cut clay piece.*

RIGHT: *The wings in this piece were pulled from a mold that was formed from a stencil I cut. Because they were made from the same mold, they are perfectly symmetrical.*

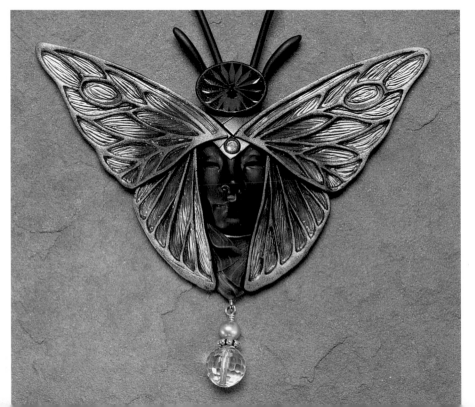

independent elements; everything must be connected so that the piece, when lifted, is one. Artist Maggie Maggio has used a similar technique, cutting out geometric shapes in a sheet of thin clay to create her own stencil plates.

The thickness of the stencil is important. If the clay is too thin, the mold made from the stencil will have very thin walls. If it is too thick, the mold walls will be too deep and the stencil will be difficult to cut. Experiment first with a simple stencil. When you know the proper thickness, cut your detailed pieces.

1 Roll a thin sheet of scrap clay and place it on a clean ceramic tile. Push any air pockets out from between the polymer clay and tile. With a ball stylus, lightly draw your wing.

2 Holding a scalpel or craft knife at a 90-degree angle to the tile surface, cut next to a line you've drawn. In my experience, it is easier to hold the scalpel stationary and move the tile—much the same way that decoupage artists move the paper, not the scissors.

3 Keep cutting the sides of that cell. With the tip of the scalpel, lift the clay from the interior of the cell and remove it.

4 Continue cutting around each cell and removing the clay cutouts. Finally, cut the perimeter of the wing. After cutting is complete, you will have a "skeletonized" wing. Bake the clay on the tile for 30 minutes at 300°F.

Do not remove the clay from the tile. When the clay is cool, sand the surface of the wing smooth with a medium-grit sanding sponge. You need not sand the other side of the wing; because it is against the tile, it will be perfectly flat.

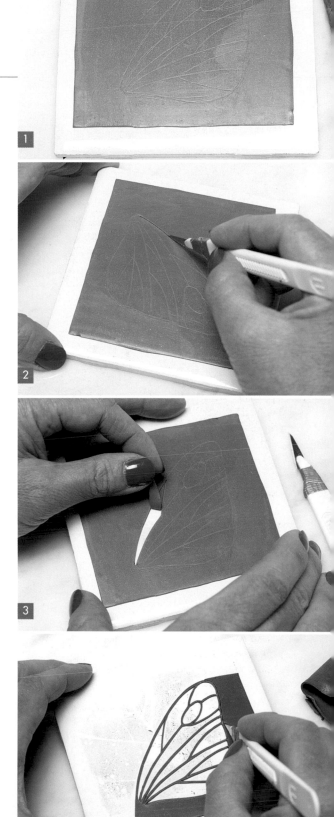

5 Lightly sand and smooth each cell with a fine metal file. To make the wing mold, roll a sheet of scrap clay through the thickest setting of a pasta machine and press it to a ceramic tile.

6 Spray water on the surface of the clay. Place the wing stencil on the clay and then roll it into the clay with an acrylic rod until the wing is embedded in the clay. Carefully lift the wing from the clay.

7 Turn the wing stencil over and repeat the molding process, embedding the wing from the other side. You have now molded both the right and left wings.

8 Lift the cured wing from the clay and put it in a safe place; as long as you have the original, you can always make additional molds.

9 Trim the excess clay from around the wing impressions. Bake the mold at 300°F for 30 minutes.

10 When the mold is cured and cool, sand the surface smooth with a coarse-grit sanding sponge. Inspect the impressed lines; if they need to be widened, scrape the tip of a metal file through the lines. The mold is now ready for use.

11 To use the mold, roll a sheet of clay (your choice of color) through a medium thickness of the pasta machine. Liberally spray the mold with water and lay the clay on the mold. Spray the back of the clay with water; this will prevent the clay from sticking to the acrylic rod.

Roll the clay firmly and evenly into the mold with an acrylic rod. Lift it from the mold and lay it out to dry. Place the dried clay on a piece of deli wrap or a ceramic tile. With a scalpel or craft knife, cut around the outside of the wing and remove the excess clay. This photo shows two wings that were made using the mold.

TIP

I always try to make both wings in the same sheet of clay. It is more difficult to make the second impression without damaging the first, but I am less likely to lose one of the molds. If this is too difficult, simply make two separate molds.

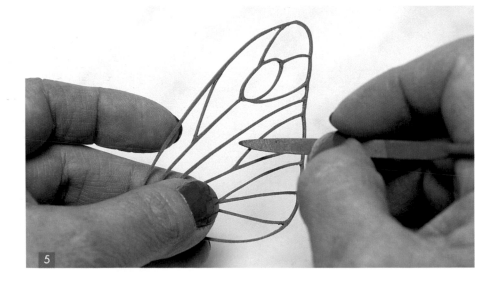

5

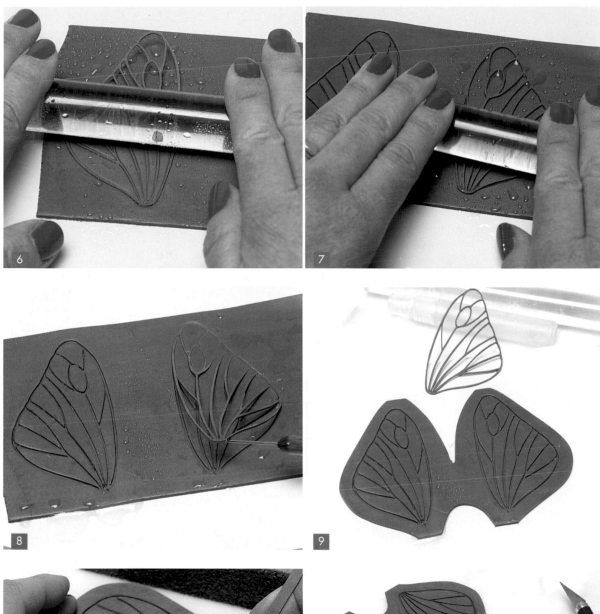

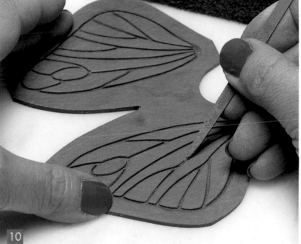

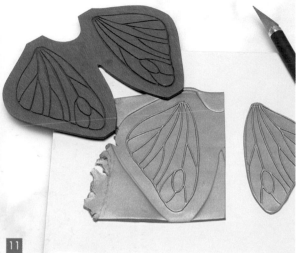

Art Nouveau Butterfly Necklace

**TO MAKE ONE
NECKLACE, YOU
WILL NEED:**

Polymer clay wing
 mold (follow
 directions on
 page 158)

Black polymer clay

Ceramic tile

Scalpel or craft knife

Scrap polymer clay

Polymer clay blade

Pasta machine

Gold foil

Bone folder (for
 applying foil)

Kato Clear Medium

Brush for applying
 liquid clay

Medium-gauge wire

Spray bottle and water

Acrylic rod

Ball stylus

Perfect Pearls

Gold acrylic paint

Paintbrush

Crystal

Deli paper

Coarse- and medium-
 grit sanding
 sponges

Pin vise or drill bit

Buna cord

O-rings

Cyanoacrylate (CA)
 glue

THIS PIECE REQUIRES that you have made a wing stencil, and from the stencil, a wing mold (see "Creating a Mold from a Stencil" on page 158). The piece will be constructed on a ceramic tile. Rather than directing you to use the exact colors I did to decorate the wings, I'd rather you experiment with your colors. I would recommend overlaying colors, instead of using single colors in each cell, to create greater visual interest.

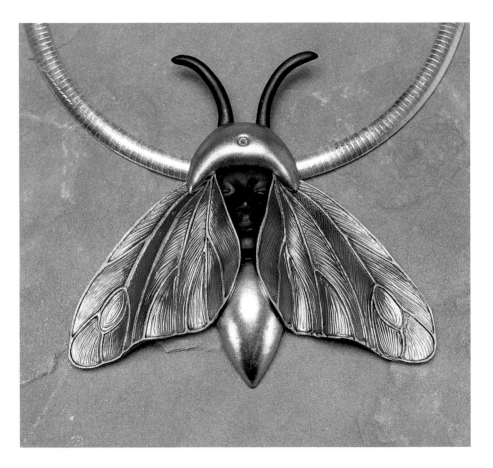

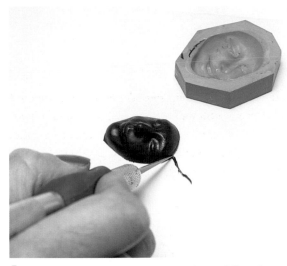

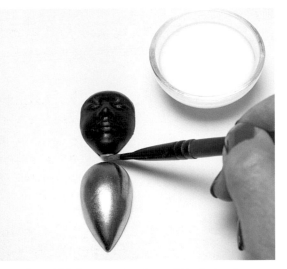

1 Sculpt a face from black polymer clay or follow the instructions on page 157 to pull a clay impression from a face mold. Press the back of the clay face to a ceramic tile and, with a scalpel or craft knife, cut away any clay from around the face. Make a scrap clay cabochon approximately the same size as the face (see "Cabochon Shaping" on page 46). Reserve the other scrap clay half for use later in the project.

2 Transfer gold foil onto a thin sheet of black clay (see "Metal Leaf and Foil" on page 34).

Drape the cabochon with the gold sheet, then trim the excess away. Reserve the remaining foil-covered clay for later use.

Brush Kato Clear Medium below the chin of the face. Press the cabochon onto the tile and against the face.

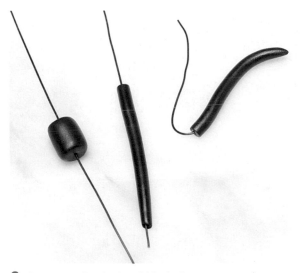

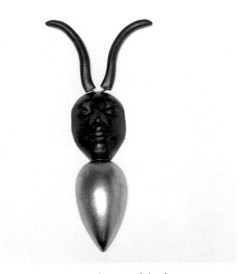

3 Place a small cylinder of black clay onto a medium-gauge wire (left). Roll the clay out onto the wire until the diameter is approximately ¼ inch (center; see "Tube Beads" on page 45). Bend another piece of wire into the shape of the two antennae. Cut a segment of clay from the wire. Slide it off the wire and onto the antennae wire. Pinch the ends of the clay at the antenna tip to taper and conceal the wire (right). Repeat, covering the other half of the antenna.

4 Place the antennae against the top of the face, pressing the clay at the antennae base to the ceramic tile.

5 Roll a medium-thick sheet of black clay. Spray the wing mold with water. Place the clay on the mold and spray the back of the clay. Roll once across the clay with an acrylic rod, bearing down as you roll. Remove the clay from the plate and let dry.

Lightly press the wing to a tile. With a scalpel or craft knife, cut around both wings. Lightly incise into each wing cell with a ball stylus (see "Tip" below). Dust the cells with Perfect Pearls and apply gold paint to raised wing lines. Slide a blade beneath each wing to remove them from the tile.

Slide the end of a paintbrush beneath the wing where you wish it to softly bend. As you lift the brush, gently push the wing down on either side. Lay the wing onto the body. Apply the other wing in the same way and adjust the wings so they are symmetrical.

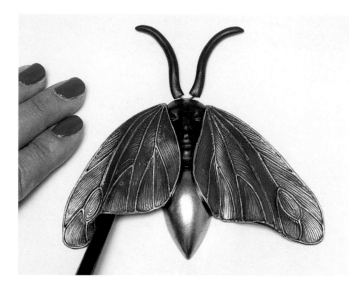

6 Roll the scrap clay into a ball and then form a thin almond shape. Cut the clay in half lengthwise and wrap one half with the reserved foil-covered clay. Trim the excess away with a blade. Curve the clay into a crescent shape and press it over the top of the head, covering the antennae.

Place, and, with the end of a paintbrush, press a crystal into the crescent. Press it deep enough so that the clay forms a bezel around the crystal. Bake the butterfly on the tile for 30 minutes at 300°F. Let the piece cool on the tile.

Gently slide a blade beneath the cured piece. Brush a light coat of liquid clay onto the back of the entire piece.

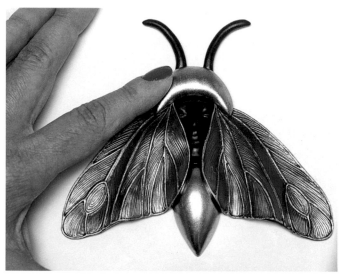

7 Roll a sheet of black clay through a medium-thin setting. Place the clay on a sheet of deli paper. Place the cured piece on the clay and cut around it with a scalpel or craft knife. Peel the paper from the back of the piece. Cut behind the antennae. Smooth the clay onto the antennae.

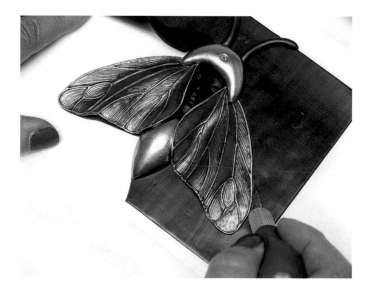

TIP

When you are incising the individual cells of the wings, it is easier to work the same cell on each wing at the same time, moving from one wing to the other, rather than trying to complete one wing at a time.

8 Turn the piece over. Gently push the clay into the back of the furled wings and into any indented areas.

9 With the scalpel or knife, trim around the entire piece to remove any excess clay. Smooth the clay from the back onto the edge of the cured piece so that it appears that it is one sheet of clay, not two. Cure the piece again for 30 minutes at 300°F.

Sand the entire back and the edges with a coarse-grit sanding block. Follow with a medium-grit block.

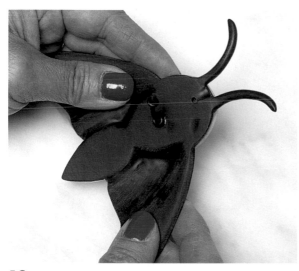

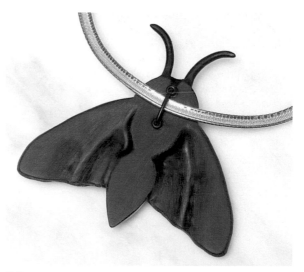

10 With a pin vise or drill bit (do not use an electric drill for this), drill two holes into the back of the piece, but do *not* drill through the front of the piece. Cut a piece of buna cord to make a hanger. Slide two O-rings onto the cord. Glue one end of the cord into one of the holes, and glue one of the O-rings to the back of the piece to provide additional security.

11 Glue the other end in the second hole and glue the other O-ring to the back. This photo shows the back of the finished piece with a wide omega necklace strung through the hanger. One of the advantages of this type of hanger— as opposed to a solid clay piece—is the ease with which it may be strung on many types of chains, buna cord, or even fiber or ribbon.

BAS-RELIEF

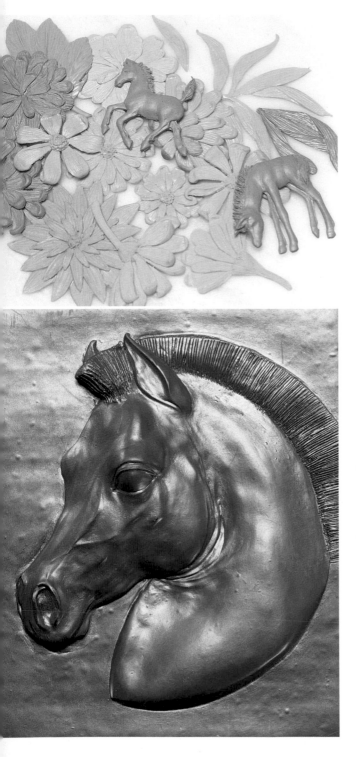

BAS-RELIEF IS a type of sculpture in which the design protrudes only slightly from the surface and there are no undercuts. You can think of it as flattened sculpture. It can be challenging as it requires the ability to create three dimensions in clay when what you are making is actually closer to a two-dimensional piece. The tools I use for sculpting bas-relief pieces from polymer clay are a metal dental spoon and a ball stylus. The back of the spoon is used to push the clay while the front of the spoon is used to scoop out and remove any excess clay. The surface is smoothed by gently stroking it with the back of the spoon and rubbing it with your fingers. The ball stylus is used for surface texture and detailing. The instructions below show how to make a bas-relief daisy bud and then how to make a mold from the bud.

DONNA KATO

TOP LEFT: *Here are some bas-relief pieces I made, including two small colts in celebration of recent additions to our farm.*
LEFT: *Horses are my other passion. Here is one of my bas-relief horse heads, onto which I applied Pearlex pigment powders for a metallic sheen.*

OPPOSITE, TOP LEFT: LESLIE POLINKO

The bas-relief design encircling Leslie Polinko's "Faerie Ring" box was inspired by the folk belief that mushroom faerie rings were the dancing places of faeries.

OPPOSITE, TOP RIGHT: JANIS HOLLER

Artist Janis Holler's work often showcases Native American themes. Few can match her meticulous attention to detail and the skill with which she sculpts even the smallest face or buffalo head.

OPPOSITE, BOTTOM LEFT: JACQUELINE LEE

Artist Jacqueline Lee is a master at bas relief art. This intricately detailed inro box was the inspiration for the bas-relief flower bead project on page 170.

OPPOSITE, BOTTOM RIGHT: LORIE O. FOLLETT

Master sculptor Lorie Follett's beautiful bas-relief mermaids have been embellished with Austrian crystals.

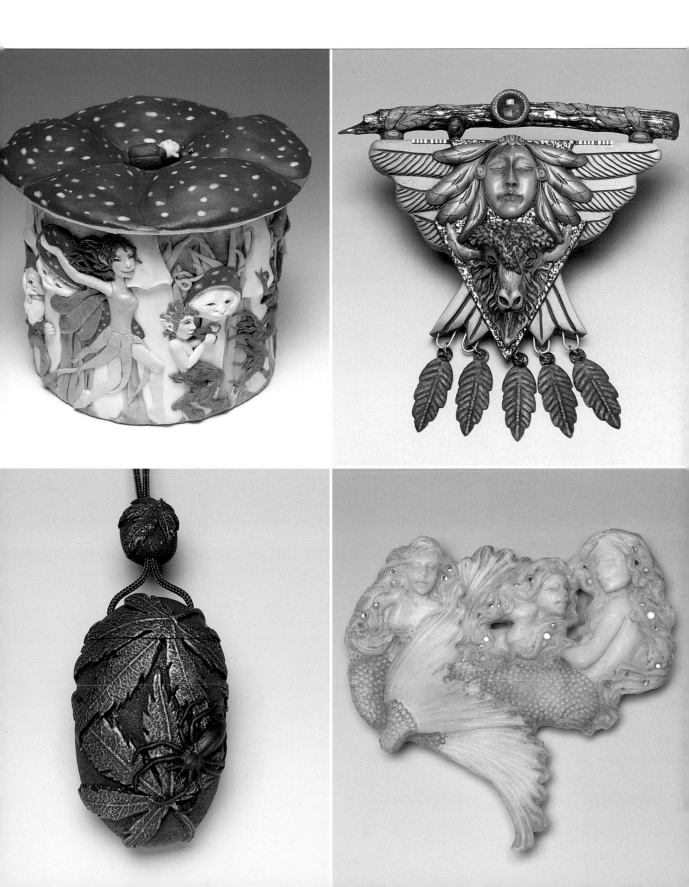

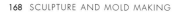

1 Roll a cylinder of scrap clay. Cut five slices from the cylinder, one for each petal. Reshape each slice by first rolling each into a ball and then a short cylinder. Then roll out a point to create long tapering pieces. On a ceramic tile, arrange the five pieces so that the points meet, and then and flatten them with your fingers.

2 With the back of the dental spoon, push clay from the point toward the rounded tip of a petal to create a folded tip. I have created folded tips in several but not all of the petals.

3 With the front of the tool, scoop and remove clay beginning at the middle of a petal, scooping toward the pointed base. This will thin the flower at the base. Do this for each petal.

4 With the side of an arrow-shaped tool (this is on the other end of my spoon), cut between the petals to separate them.

5 Incise the petals as shown with a ball stylus. This step is optional; you may wish to create a smooth petal instead. Make five more petals as you did in step 1, but do not join and flatten them.

6 Place the new petals on the first row and flatten them with your fingers. If necessary, incise the lines in the first row of petals again.

7 Roll a barrel-shaped piece of clay and press it to the bottom of the petals. Cut excess clay from both sides as shown.

8 Flatten the sides of the base piece to the tile. To form a stem, add a thin snake of clay and blend it to the base. Incise the base and the stem. Here is the finished basic daisy bud. If you wanted to make a full flower, you could simply form a full ring of petals at the beginning and create a center from a flattened ball of clay.

Bake the piece for 20 minutes at 300°F. Do not remove it from the tile.

9 To make a mold, roll a sheet of scrap clay through the thickest setting of a pasta machine. Fold it in half to double its thickness. Spray water on the cured flower (still on the tile) and lay the clay onto the cured flower. Spray the back of the clay with water. With the acrylic rod, roll over the clay one time, pressing it onto the flower.

Lift the polymer clay from the flower and tile. Trim the piece and bake for 20 minutes at 300°F. When the mold is cool, sand the surface flat with a coarse-grit sanding block.

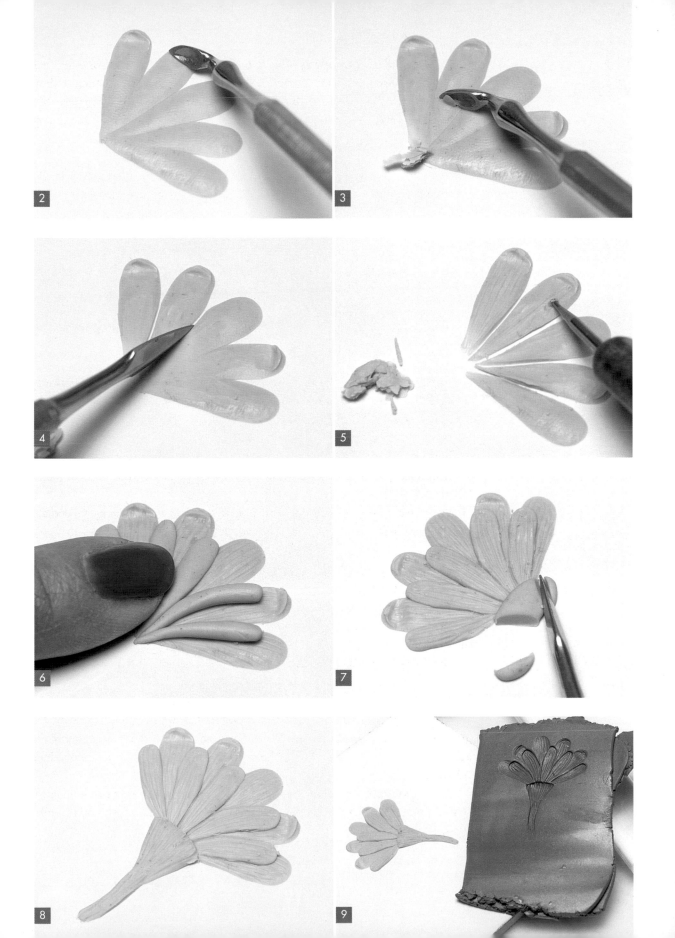

Bas-Relief Flower Bead

**TO MAKE ONE
BEAD, YOU WILL
NEED:**

Black, red, and
 ultramarine blue
 polymer clay

Bamboo skewer

Coarse sandpaper

Flower mold (see steps
 on page 168)

Polymer clay blade

Ceramic tile

Scalpel

Kato Clear Medium

Raw umber oil paint

Toothbrush (for
 applying oil paint)

MY FRIEND Jacqueline Lee makes the most incredible beads and inro boxes featuring perfectly detailed, delicate flowers, leaves, and even spiders! Her incomparable, impossibly lovely work (see page 167) inspired this project. To make this bead you will need to have created one or more molds of bas-relief flowers and flower buds. You could create each flower individually, but making molds will save you time and you will be able to use them over and over.

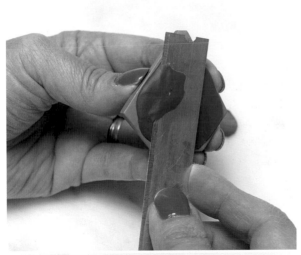

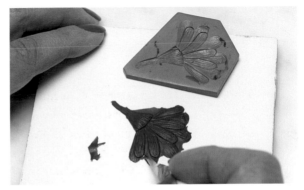

2 To remove the clay from the mold without ruining the flower, press the clay to a ceramic tile, then lift the mold. Trim around the flower with a scalpel. Slide a blade beneath the flower. It is now ready to be pressed to the cured bead. Make several more flowers in the same way.

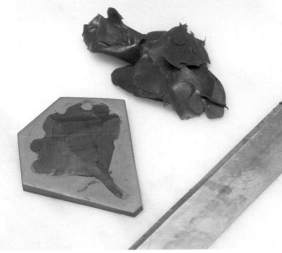

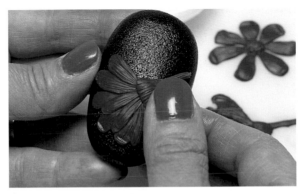

3 Apply a light coat of Kato Clear Medium to half of the bead; you will be working on one side at a time. Lightly press the prepared flowers to the bead, making sure that the edges of the flower are secure against the base bead.

1 Make a black, flattened bead, and drill the hole with a bamboo skewer. While the clay is on the skewer, texturize its surface with coarse sandpaper. Remove the clay from the skewer and bake it for 20 minutes at 300°F.

Mix some red clay with a bit of ultramarine blue to make a deep crimson color. Roll a ball of crimson clay, then flatten it with your fingers.

Spray water liberally into the flower mold. Place the crimson-colored clay on the mold and press it into the mold from the center, working to the perimeter.

With a blade, slice excess clay away, beginning at the middle of the clay. I "walk" the blade through the clay, rather than cutting a clean slice. Hold the piece so that, should you slip, you will not cut yourself. This trimming requires great caution. Work slowly and carefully. Continue slicing the excess clay away until the edges of the petals are clearly visible.

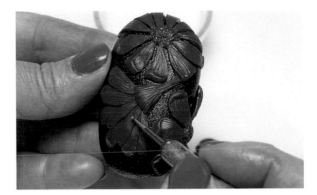

4 Inspect the flowers and, if necessary, restore details to the petals. Bake the bead for 10 minutes at 300°F. When the bead is cool, add flowers to the other side. Bake for 20 minutes at 300°F. When the piece is cured and cool, antique it with oil paint in raw umber (see "Antiquing Polymer Clay" on page 138). Let the paint dry for 24 hours before handling.

CONTRIBUTING ARTISTS

DEBBIE ANDERSON
San Jose, California
page 173

JUDY BELCHER
St. Albans, West Virginia
pages 18, 176

JANA ROBERTS
BENZON
Salt Lake City, Utah
page 48

JENNIFER BEZINGUE
Carol Stream, Illinois
page 174

CAROL BLACKBURN
London, England,
United Kingdom
page 50

LESLIE BLACKFORD
Munfordville, Kentucky
pages 8, 139, 176

KIM CAVENDER
St. Albans, West Virginia
pages 8, 145

MAJ-BRITT CAWTHON
Lakewood, Colorado
page 173

LANI CHUN
Honolulu, Hawaii
page 20

DARLENE CLARK
Woodland Park, Colorado
pages 115, 132, 176

LOUISE FISCHER COZZI
Brooklyn, New York
page 176

DAN CROWLEY
Chicago, Illinois
page 155

KATHLEEN DAVIS
Garden Grove, California
page 13

MARIA DEL PINTO
Fountain Valley, California
page 172

KATHERINE DEWEY
Maxwell, Texas
page 13

CONNIE DONALDSON
Lawrence, Pennsylvania
page 155

MARGARET DONNELLY
San Jose, California
page 19

KATHLEEN DUSTIN
Contoocook, New
Hampshire
page 56

LORIE O. FOLLETT
Sandy, Utah
pages 11, 167

JAN FRAME
Denver, Colorado
page 174

MARLA FRANKENBERG
Pittsburgh, Pennsylvania
page 173

EMI FUKUSHIMA
Sunnyvale, California
page 110

GEORGANA GERSABECK
Berkley, Michigan
page 84

DOROTHY GREYNOLDS
Waterford, Michigan
page 173

LINDLY HAUNANI
Cabin John, Maryland
page 52

CAROL HESS
St. Petersburg, Florida
page 115

ELLIE HITCHCOCK
San Diego, California
page 54

JANIS HOLLER
Berthoud, Colorado
pages 83, 167

JACQUELYN K. HONG
Houston, Texas
page 103

KYLE INO
Kaneohe, Hawaii
page 74

SUZANNE IVESTER
Knoxville, Tennessee
page 22

DEBBIE JACKSON
Columbus, Ohio
pages 14, 87

CATHY JOHNSTON
Pasco, Washington
pages 19, 102, 121

SUE KELSEY
Ypsilanti, Michigan
pages 8, 15

DEBBIE KRUEGER
Magnolia, Texas
page 174

JOHNNY KUBORSSY
Mountain View, California
page 176

LISA PAVELKA

SUSAN MUELLER

PAM PIERCE

TRINA WILLIAMS

MARIA DEL PINTO

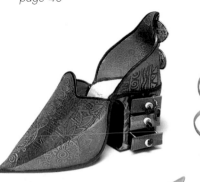

DEBBIE
ANDERSON

MARGARET SCOTT

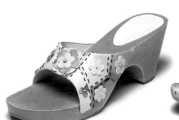

GAIL RITCHEY

MARLA
FRANKENBERG

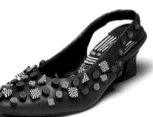

MAJ-BRITT
CAWTHON

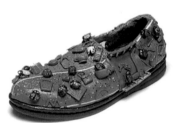

DOROTHY
GREYNOLDS

SUPPLIERS

Listed below are the manufacturers and suppliers of many of the materials used in this book. Most of these companies sell their products to retail and online stores, which are the most dependable source for polymer clay supplies. Contact the companies listed directly to find a retailer near you.

AMACO, INC.
6060 Guion Road
Indianapolis, IN 46254-1222
800-374-1600
www.amaco.com
Fimo clays, polymer clay tools, molds, Genesis Heat-Set Artist Oils

CLEARSNAP, INC.
P.O. Box 98
Anacortes, WA 98221
888-448-4862
www.clearsnap.com
ColorBox inks, stamps, stamping supplies

CRAF-T PRODUCTS
www.craf-tproducts.com
Decorating Chalks

HOUSTON ART, INC.
10770 Moss Ridge Road
Houston, TX 77043
800-272-3804
www.houstonart.com
Composition leaf

KEMPER ENTERPRISES
13595 12th Street
Chino, CA 91710
909-627-6191
www.kempertools.com
Needle tools, shape cutters, other clay-related tools

LAZERTRAN
650 8th Avenue
New Hyde Park, NY 11040
800-245-7547
www.lazertran.com
Lazertran paper

POLYMER CLAY EXPRESS
9890 Main Street
Damascus, MD 20872
301-482-0399
www.polymerclayexpress.com
Polymer clays and clay-related products

POLY-TOOLS, INC.
P.O. Box 10
Woodson, IL 62695
800-397-5201
www.poly-tools.com
Poly-Tools Pro Bead Rollers and Pro Bead Rack

PRAIRIE CRAFT COMPANY
P.O. Box 209
Florissant, CO 80816
800-779-0615
www.prairiecraft.com
www.katopolyclay.com
Kato Polyclay, Kato tools and videos, Foredom buffer

RANGER INDUSTRIES, INC.
15 Park Road
Tinton Falls, NJ 07724
732-389-3535
www.rangerink.com
Perfect Pearls pigment powders, Archival Inks, Tim Holtz's Adirondack Alcohol Inks

TSUKINEKO, INC.
17640 NE 65th Street
Redmond, WA 98052
425-883-7733
www.tsukineko.com
StazOn inks

WALNUT HOLLOW
Dodgeville, WI 53533
800-950-5101
www.walnuthollow.com
Makin's clay machine, motor, and extruder; clay-related tools

YASUTOMO
490 Eccles Avenue
South San Francisco, CA 94080
650-737-8888
www.yasutomo.com
Silverado brushes, gel pens

CASSY
MURONAKA

JENNIFER BEZINGUE

DEBBIE KRUEGER

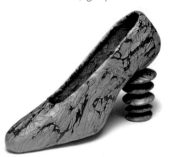

JAN FRAME

INDEX

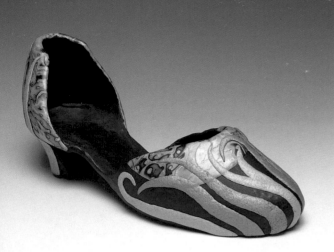

JOHNNY KUBORSSY

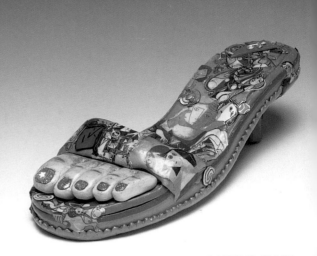

DARLENE CLARK

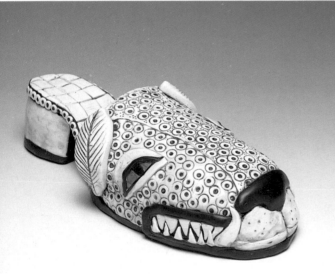

LESLIE BLACKFORD

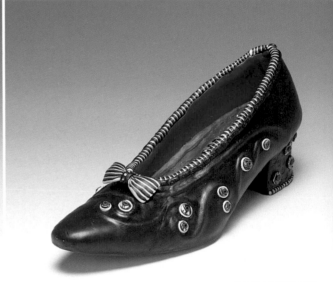

MARTY WOOSLEY

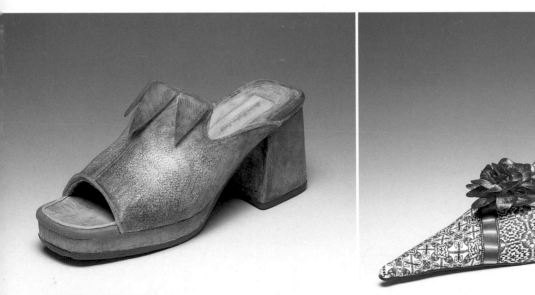

LOUISE FISCHER COZZI

JUDY BELCHER